Radical Aesthetics and
Modern Black Nationalism

THE NEW BLACK STUDIES SERIES

Edited by Darlene Clark Hine
and Dwight A. McBride

*A list of books in the series appears
at the end of this book.*

Radical Aesthetics and Modern Black Nationalism

GerShun Avilez

UNIVERSITY OF ILLINOIS PRESS
Urbana, Chicago, and Springfield

Library of Congress Cataloging-in-Publication Data
Names: Avilez, GerShun, 1980– author.
Title: Radical aesthetics and modern Black nationalism /
 GerShun Avilez.
Description: Urbana, IL : University of Illinois Press, [2016] |
 Series: The new Black studies series | Includes bibliographical
 references and index.
Identifiers: LCCN 2015041928| ISBN 9780252040122 (cloth :
 alk. paper) | ISBN 9780252081613 (pbk. : alk. paper) | ISBN
 9780252098321 (ebook)
Subjects: LCSH: African Americans—Intellectual life—20th
 century. | Black nationalism—United States—History—20th
 century. | American literature—African American authors—
 History and criticism. | Black Arts movement. | African
 American arts—20th century.
Classification: LCC E185.89.I56 A85 2016 | DDC 320.54/60973—
 dc23 LC record available at http://lccn.loc.gov/2015041928

To Corey

Contents

Acknowledgments

I had no real understanding about all the labor and time it took to write a book, and I would never have been able to accomplish the task without the unwavering support and kind words of friends and family. Each member of my dissertation committee provided a model for the kind of teacher-scholar I work toward being. Thadious M. Davis has been a genuine inspiration. Her patience, generosity, thoughtfulness, and sweeping intelligence have made her an ideal mentor. She always believed in this project even at moments when my own belief was shaken. Herman Beavers pushed me to think about *how* to write about the contemporary period, and this consideration has come to define almost all of my scholarly endeavors. Nancy Bentley demonstrated to me that it is possible to be both critical and kind. Her advice also made me a better writer.

I have had friends along the way who have seen this book at every possible stage. I met Salamishah Tillet as I was beginning a doctoral program at Penn and she was finishing one at Harvard, and she has been a draft reader, advice giver, consoler, congratulator, and general brainstorming buddy about all of life's questions. I think of her as mentor, confidante, and sister. Tshepo M. Chéry has been my constant source of sanity and laughter. She made me feel like we were "in this together" no matter how far apart we were. Michael L. Wright and Jennifer Patterson are two of my oldest friends who have kept me eating well for years. I treasure their friendship. Marcus Hunter got me through tough times and offered me enduring friendship even when many miles separated us. Wendy Lee is my favorite conspirator. We helped each

other to figure out so much about our lives over meals, which were always filled with laughter and sometimes tears. Meta DuEwa Jones has been a trusted mentor and a constant source of support, wisdom, and fun.

A wonderful group of friends made the experience of graduate school not only bearable but also really enjoyable: Ed Brockenbrough, Jasmine Cobb, Stephanie Elsky, Damien Frierson, Mearah Quinn-Brauner, Riley Snorton, Mecca Sullivan, and Brandon Woods. La Marr Bruce, Ashon Crawley, Alexis Pauline Gumbs, Larry Lyons, and Darnell Moore were important interlocutors who gave me a community outside of my home institution. Nadia Ellis and Marques Redd helped me to feel welcomed in the Bay Area when I spent a year at Berkeley completing my dissertation. Many people have listened to and given valuable feedback on my work and my many flights of fancy, including audiences at the University of Houston, University of California—Los Angeles, University of Texas—Austin, Loyola University at New Orleans, the Center for LGBTQ Studies in New York City, and Penn State University. Maxe Crandall, Greta LaFleur, Kyla Schuller, and Sarah Schulman generously read the entire manuscript and offered incisive feedback. Charles Rowell has been a wonderful resource at every stage. Alice Hines was my first mentor, and in many ways, I am still writing to her. Joyce A. Joyce stoked my interest in the Black Arts Movement, and I have yet to put that flame out.

The Frederick Douglass Postdoctoral Fellowship at the University Rochester offered me a supportive postgraduate school environment and gave me time to begin my revisions. Johanna Almiron's genuine love for life got me through that cold Rochester winter. Yale University was my first professional home, and the three years I spent there shaped me in ways that I am only starting to discover. I learned so much from so many people. Elizabeth Alexander, Alicia Schmidt Camacho, George Chauncey, Ian Cornelius, Wai Chee Dimock, Crystal Feimster, Jacqueline Goldsby, Inderpal Grewal, Amy Hungerford, Shital Pravinchandra, Anthony Reed, Joseph Roach, Robert Stepto, and Michael Warner were all crucial elements to my life in New Haven.

When I decided to move to the English Department at the University of North Carolina, Chapel Hill, an amazing group of colleagues from across the university greeted me warmly: Neel Ahuja, Bill Andrews, Andrea Benjamin, Rich Cante, James Coleman, Jane Danielewicz, Florence Dore, Rebecka Rutledge Fisher, Laura Halperin, Jennifer Ho, Sharon Holland, Randall Keenan, Heidi Kim, John McGowan, Todd Ochoa, Pat Parker, Eliza Richards, Jamie Rosenthal, Beverly Taylor, Matt Taylor, Jane Thrailkill, and Ariana Vigil. I am so happy that I got to join the department at the same time as Gabrielle Calvocoressi and Stephanie Elizondo Griest; their talents humble me. Bren-

dan Thornton and Ron Williams started with me making my social life immeasurably better and my intellectual life richer. I have been lucky enough to have a support network that extends throughout the Research Triangle. Gabe Rosenberg and Harris Solomon helped to make North Carolina feel like home. I feel very lucky to have met Lamonte Aidoo. He makes me feel as if I fit in this profession.

A research leave from the University of North Carolina gave me time off at a critical juncture of the work. The University Research Council supplied funds that made the book possible. The editorial staff at the University of Illinois Press have been wonderful in their treatment of this first-time author. Larin McLaughlin worked with me early on, and Dawn Durante closed out the process. Along the way both of them offered insightful feedback that showed me that they respected the project and me. I will be forever grateful for that. The entire editorial and marketing staff was incredibly helpful and professional; I cannot imagine having a better experience publishing a book. The two readers the press chose to review this book greatly strengthened the project. I am also indebted to Darlene Clark Hine and Dwight McBride for allowing this book to be a part of their exciting series.

I gratefully credit the following individuals and institutions for allowing me to quote material in this book: "How I Got Born," "My Heart," "The Law," and "Why I Am Not a Woman" all from Cornelius Eady's *Brutal Imagination*, copyright © 2001, used by permission of Penguin Random House; "Race" from Jayne Cortez's *Pissstained Stairs and the Monkey Man's Wares*, copyright © 1969, and "African Night Suite" and "Watch Out" from Cortez's *Festivals and Funerals*, copyright © 1971, all used by permission of Mel Edwards; and "living as a lesbian underground: a futuristic fantasy" from Cheryl Clarke's *Living as a Lesbian*, copyright © 1986, used by permission of the author. An early version of one part of chapter four appears in my article "Cartographies of Desire: Mapping Queer Space in the Fiction of Samuel Delany and Darieck Scott." This article was first published in *Callalloo* 34.1 (2011), 126–42. Reprinted with permission by Johns Hopkins University Press.

In some ways, this book is a long letter of appreciation to the critics doing work that I really admire: Margo Crawford, Phillip Brian Harper, Gene Andrew Jarrett, Meta DuEwa Jones, Keith Leonard, Robert Reid-Pharr, Evie Shockley, Hortense Spillers, and Darieck Scott. Their works continue to inspire and intrigue me. I hope my respect for their scholarship shines through in the following pages.

My mother taught me everything I needed to know to write this book. It just took me a long time to figure that out. My brother Antwoine and my sister

Oneshia are two of the best people I know; their commitments to kindness and generosity of spirit make me strive to be a better person. My brother Joseph died unexpectedly as this book was nearing completion. I miss him.

My partner Corey has been the constant source of light in my life. He is still my biggest cheerleader and best critic. He keeps me grounded and keeps me from taking myself too seriously. I do not know how I would navigate the world without him. His love and support are on every page of this book. I dedicate this book to him.

Introduction
The Art of Revolution

"The Black Arts Movement proposes a radical reordering
of the western cultural aesthetic."
—Larry Neal, "The Black Arts Movement"

"Pervert the language!"
—Marlon Riggs, *Anthem*

There is a commitment that aligns the writing of Larry Neal with
the filmmaking of Marlon Riggs: a commitment to revolution. For both Neal
and Riggs, the goal of "revolution" is to disrupt traditional artistic strate-
gies—as their calls for "reordering" and "perverting" suggest. The goal of
disruption represents a shared adherence to progressive politics and social
critique rooted in Modern Black Nationalism, which frequently emphasized
revolution. Nationalist demands for overhauling the social world provide a
vital point of reference for these artists' differing projects. That being said,
Neal and Riggs might be considered an unexpected pairing by many schol-
ars of African American cultural studies. The first was one of the architects
of the Black Arts Movement, and the second was a highly influential Black
gay documentary film director. These two cultural producers are rarely con-
nected: Neal's commitments to seemingly prescriptive ideas about literature
and essentialized conceptions of Blackness are viewed as distinct from Riggs's
consistent critiques of limiting ideas about the role of art and constructions
of Black identity. They generated work primarily in different historical set-
tings and genres (essays and poetry for the first and films for the second),
but Neal and Riggs together demonstrate that artists have responded to the
nationalist rhetoric of social revolution with innovative methods meant to
transform the world of cultural production. The Neal-Riggs coupling sheds

light on a pattern of attending to nationalist rhetoric within contemporary African American expressive culture and sets the stage for the argument of this book: Modern Black Nationalism functions as a source for the language and methods of experimentation in African American artwork in the late twentieth century and into the twenty-first. *Radical Aesthetics and Modern Black Nationalism* reveals the connection between nationalist thought and artistic experimentation.

Neal's 1971 thought experiment "Some Reflections on the Black Aesthetic" and Riggs's 1991 short film *Anthem* flesh out this point. Neal's piece expresses his contention that the Black Aesthetic entails a "radical reordering of the western cultural aesthetic" and is a conscious artistic parallel to the social demands that Black Power Movement activists made.[1] The piece is an outline that emphasizes the multifaceted nature of Black identity.[2] Although published in a collection of critical essays, the outline of ideas about the Black Aesthetic is typed up and arranged in three columns and five rows.[3] However, this ostensible listing takes on a poetic sensibility as Neal details impressionistic sensory experiences that constitute the aesthetic, while also advancing specific arguments about the importance of form and historical sensibilities. The piece is a generic curiosity. It exists between the boundaries of an essay and a poem, and its formal presentation reflects Neal's desire for aesthetic "reordering." The provisional essay-outline is printed horizontally in the collection so that the reader must turn the book ninety degrees to read it. Through this text and its arrangement, Neal manipulates the reader's expectations for a printed essay and effectively inverts (or at least resituates) the process of reading to demonstrate the symbolic and material modifications he believes Black art should take as its objective. The "revolution" that Neal champions is realized through his innovations on the pages of "Some Reflections."

Neal's textual inversion prepared the way for Riggs's strategy of "perversion" in *Anthem*. Riggs's eight minute and eighteen second film is a cinematic collage of images of traditional African cultural dance, contemporary dance, men embracing, scenes of political rallies, and slogans from AIDS awareness campaign. All of these images are superimposed on each other against a score of chants, monologues, poetry recitations, and beat-laden house music.[4] *Anthem* is nonnarrative and associational in structure. The film relies almost exclusively on the linking of contrasting images. The motif of revolution emerges visually and sonically throughout *Anthem*, providing the conceptual basis for the film's structure and thematization. The "revolution" that the film describes is rooted in perversion, which Riggs uses simultaneously

to introduce ideas about homosexuality as well as to invoke conceptions of restructuring, which the collage technique materializes. Riggs weaves the phrase "pervert the language" throughout the film, and this refrain provides the basis for the chaotic juxtaposition of images of Black queer intimacy with those of Black nationalist political activism. The images that Riggs relies on indicate that the language he seeks to pervert or, more precisely, transform is the language of Black nationalism. He establishes a conceptual and methodological connection between his work and that of Black Arts era artists—with a revision. The "radical reordering" that Neal describes is taken up and recalibrated from a Black queer perspective in *Anthem*. The collage-like technique strategically functions as a reworking of a more recognizable linear or normative filmic narrative. Riggs's goal of queering Black nationalist rhetoric requires an experimental genre. The revolution in thought that the ideology calls for is taken up and made present in the film's form. Riggs does not offer a refusal of narrative per se; instead, his work indicates that nationalist radicalism requires different narratives and new means of interpretation. As much as Riggs's method might be read as a signal of the filmmaker's participation in new queer cinema,[5] his tactics also reflect an identifiable engagement with nationalist discourse.

The Black Arts Movement was the nationwide surge in African American artistic production that took place from 1965 to 1975. The movement has often been understood as the premier site for investigating the artistic manifestation of Modern Black Nationalism, because it stood as an artistic parallel to the Black Power Movement.[6] However, an eclectic group of artists engaged Modern Black Nationalism during the 1960s and 1970s whether or not they had a direct affiliation with the Black Arts Movement. The use of Riggs to help frame this discussion demonstrates that the focus here extends beyond the traditional terrain of Black Arts material and Black nationalist thinkers. Accordingly, I refer to the period as the *Black Arts era* in order to signal that many writers and thinkers understood the artistic potential of nationalism as well as the problematics it engendered.[7] The investigation of the revolutionary rhetoric and social critique that constitute nationalist discourse remains an important method for artists into the twenty-first century, because it continues to have a discernible impact on African American culture well beyond the Black Arts era.

The focus on the aesthetic manifestations of nationalism in this study creates the opportunity to track two specific transformations, which together set the course for the argument. The first is the complicated movement of political imperatives into the artistic world during the Black Arts era. This

led to what I call *aesthetic radicalism*, a critical term that describes how artists incorporated nationalism and created opportunities for experimenting with form as well as extending the reach of political rhetoric. The second movement pertains to how contemporary writers and artists convert the engagement of nationalism during the 1960s and 1970s into their own radical artistry. Thus, underconsidered connections between the recent past and the present become legible through the lens of nationalism as well as that of artistic methodology. *Radical Aesthetics* shows the creative opportunities that artistic involvement in political rhetoric offered—and the experimental strategies it encouraged—during the Black Arts era and beyond. A primary goal of this book is to locate the unexpected and surprising developments that result from the artistic probing of nationalism. In the following sections, I define Black nationalism as a historical phenomenon, explain the background and critical significance of aesthetic radicalism, outline my methodology, and sketch out the movement of the chapters.

Black Nationalism as Context and Conduit

Black nationalism is a political philosophy that has played an integral part in African American social thought from the nineteenth century forward. There are two main threads of this philosophical tradition: classical and modern. Classical Black Nationalism, as Wilson Jeremiah Moses explains, is a political framework guided primarily by concerns with (1) the creation of a sovereign Black state (often involving the emigration to Africa) and (2) uplifting and "civilizing" the race (including the goal of emulating European and White American cultural production). The classical strain tended to emphasize the contributions of elite and educated Black Americans and offered little cross-class consideration.[8] Important figures that helped to define this school of thought include priest and professor Alexander Crummell; writer and priest James T. Holly; diplomat and educator Edward Wilmot Blyden, later known as the father of pan-Africanism; minister and educator Henry Highland Garnet; and physician and novelist Martin Delany.[9] These thinkers had political and economic goals for Black populations, but they were also interested in the cultural elevation of all Black peoples to bourgeoisie respectability.[10] They generally had little interest in mass culture, which was too readily associated with the imposed culture of enslavement (i.e., illiteracy, dependence, subservience, lack of social influence, and no illustrious past). The Emancipation Proclamation taking effect in 1863 began an effective wane of Black nationalism's influence in the nineteenth century, because an inde-

pendent Black state began to seem less necessary. There is a sharp decline in the articulation of nationalist ideology at the end of the nineteenth century that continued into the twentieth. The loss of traction in the desire for a Black state did not carry with it an interest in mass culture; the abiding faith in respectability as a means for group improvement remained an important component in this thinking as well as in cultural organizing through the turn of the twentieth century as Evelyn Brooks Higginbotham establishes.[11]

When we talk about Black nationalist thought in the twentieth century, two moments loom large: Marcus Garvey's Universal Negro Improvement Association (UNIA) in the 1910s/1920s and the Black Power Movement in the 1960s/1970s. Garvey is sometimes thought of as the father or predecessor of Modern Black Nationalism, but he is perhaps better understood as the key transitional figure between nineteenth- and twentieth-century Black nationalist thinking, reviving the classical version while also setting the stage for the shifts that would define the modern one.[12] William Julius Wilson considers Garvey to be the tail end of what he calls the "Golden Age of Black Nationalism."[13] Garvey's UNIA was one of the most important nationalist organizations of the early twentieth century, and it became "the largest secular organization for people of African descent in the world" by the 1920s.[14] It sought to unify Black people throughout the African diaspora and provide the means for community autonomy. Through this organization, Garvey attempted to unite "all the Negro peoples of the world into one great body and to establish a country and government absolutely their own."[15] He maintained an investment in a sovereign Black state and championed emigration to African countries, recalling earlier expressions of nationalism. However, Garvey was vocally critical of bourgeoisie conservatism, as his public disagreements with W. E. B. Du Bois make evident, and his writings and speeches reflect a commitment to empowering working-class Blacks without relying on uplift strategies.[16]

There is little advancement of nationalist ideology in the decades following Garvey's organizing.[17] That being said, there are several sites that one can consider to appreciate the redirection of nationalist energies in the early to mid-twentieth century: the Nation of Islam, the Communist Party, and civil rights activism. Wallace D. Fard founded the Nation of Islam (NOI) in 1930. This Islamic religious movement stressed Black community development as an extension of religious doctrine. As the name indicates, the organization framed its teachings around the territorial investment in a separate Black state. Elijah Muhammad took control of the organization in 1934 and led it until his death in 1975. He was very successful at attracting new members

and extending the reach of the NOI.[18] Although it is a religious organization, and not an explicitly political one, the NOI would become an important site of Black political radicalism during the late 1950s and 1960s, particularly because of Muhammed's protégé Malcolm X, who was a crucial element of the organization's unprecedented growth.[19] Throughout the twentieth century, an important component of the NOI's creed was Black economic self-sufficiency, ostensibly as a way to prepare for the rise of an independent Black state.[20] Such ideas indicate how the NOI responded to Black Americans' dissatisfaction with the social world by turning inward and shoring up Black spiritual identity, kinship structures, and economic stability through the framework of religious belief instead of political critique.[21]

Much Black political radicalism during the middle of the twentieth century gets drawn to leftist groups, specifically the Communist Party of America (CPUSA).[22] Robin Kelley explains that in 1928, the Communist International Congress decreed that Black Americans concentrated in the "black belt counties of the Deep South" constituted an "oppressed nation."[23] This declaration, which sought to encourage Blacks to join the party, would have sounded familiar to many Black Americans because of Classical Black Nationalist frameworks that circulated in the popular imagination. Unfortunately, this statement would not mean that African Americans would feel constant support from the CPUSA or its affiliates.[24] In 1945, journalist and Black communist Claudia Jones challenged the seeming retrenchment of the CPUSA on the question of Black self-determination and echoed the earlier 1928 declaration about Blacks constituting an internal oppressed nation.[25] Her work attempted to cement the relationship between nationalist thought and communist activism, and it demonstrates the extent to which Black nationalist concepts continued to be attractive to thinkers well into the century even outside of nationalist organizations. Many African Americans would leave the Communist Party—particularly in the 1950s in the context of Joseph Stalin's oppression and the seeming lack of attention to antiracism, as Alan Wald and Mary Helen Washington explain.[26] However, these artists and activists took the communist philosophical principles and mobilizing strategies that they had helped develop to groups committed to the Black Freedom struggle, supplying some of the political frameworks for radical organizations that would emerge in the 1960s.

It is also important to recognize that the emergence of the modern Civil Rights Movement attracts activity and attention that might have gone into refining nationalist thought. Organizations such as the National Association for the Advancement of Colored People and the Congress of Racial Equal-

ity and later the Southern Christian Leadership Conference and the Student Nonviolent Coordinating Committee provide the institutional backbone for the advancement of the movement.[27] Collectively, they made available another conduit for desires for self-determination and proposed the possibility of realizing social change. They did so through ideological investments in civic integration and legal and judicial reform, which stand in contrast to traditional Black nationalist thought. Civil rights organizing is characterized by the development of new communication networks that provide outlets for Black radicalism. The waning in the development of nationalist thought has much to do with the refinement of civil rights strategies and the ostensible dismantling of Jim Crow and state-supported discrimination through legal reforms and court victories such as *Hansberry v. Lee* (1945), *Brown v. Board of Education* (1954), and the historic Civil Rights Act of 1964. To some extent, the Civil Rights Movement represents the historic enterprise that separates Classical Black Nationalism from the modern version.

Modern Black Nationalism achieves its fullest expression during the Black Power era (1966–1975), which is part of the reason I focus on it. Following the passage of the Civil Rights Act of 1964, one of the most celebrated achievements of the Civil Rights era, there was frustration with the lack of social change. In the context of this disappointment, a reinvigorated nationalist ideology emerged.[28] It radicalized Black social critique and made the argument that the long history of African Americans being denied citizenship protections even in the midst of social and legislative change meant that Black-controlled organizations and spaces were vital to African Americans surviving in the U.S. environment. Modern Black Nationalism is characterized by two specific shifts away from the foundational ideas that governed the classical form. It departs from its predecessor first in the general lack of an explicit emphasis on an independent Black nation-state. Because of advances in legislation and ostensible social progress, less public discussion of a need for an independent Black state emerged during the twentieth century—although such discussion did not disappear. However, ongoing discrimination, segregation, and inequality in the socioeconomic world fed the feelings of disenfranchisement that were the basis of the historical investment in Black nationalism.[29] This way of thinking adapted to the changing nature of the social and political spheres of African Americans, as historian Peniel Joseph details.[30] The second major distinction between the classical and modern forms pertains to the shift of attention to mass culture and Black working-class life. This revision reflects the influence of post-Marxist economic thought and postcolonial theory on Black political discourses in

the mid-twentieth century, as the writings of Frantz Fanon, Stokely Carmichael, Angela Davis, and Elaine Brown attest.[31] There is a rising critique of the alignment with reactionary, bourgeoisie values and an attempt to locate revolutionary sentiment among the Black masses, imagined as a historically oppressed laboring class and colonized population. This adjustment in focus results in explicit desires to reappraise Black culture and the social meanings traditionally attached to it as well as to those who embody this culture.

Although there are discernible links between aesthetic innovation and Black nationalism throughout the twentieth century,[32] I direct attention to Modern Black Nationalism and the conversations that it enabled. I do so for three reasons. First, Modern Black Nationalism is ideologically distinct from the expressions of Black nationalism that precede it—as I have already explained and will revisit. My argument pivots around the unique elements of Modern Black Nationalism in the 1960s, and this distinctiveness encourages new lines of inquiry. Second, ostensibly innovative aesthetic and sartorial practices (e.g., the visual spectacle of Garvey's UNIA's militaristic apparel) are not equivalent to the construct of aesthetic radicalism.[33] The discussion in the subsequent chapters does not seek to track the formulation of transgressive aesthetic expressions of the Black body. My focus is on artistic strategies that attend to the political rhetoric of radicalism. Third, the discourse around and historical setting of Modern Black Nationalism make it an especially fertile ground for questioning normative expressions of Black gender and sexuality. This modern iteration roughly coincides with the development of second-wave feminism and the emergence of the sexual revolution in the United States. The challenges to conventional gender expression and sexual identity in the public sphere permeated the ideology and language of this nationalism. At times, late-twentieth-century nationalist thought upheld conventional conceptions of identity, but at other times, it pushed away from values of respectability that buttress such conventional understandings. This ideology prioritized the investigation of the social meanings of racialized gender and sexual identity as an intrinsic component of political radicalism. These concerns make Modern Black Nationalism an important site of inquiry for thinking about the juncture of social critique, artistic innovation, and gender analysis.

The transition from Classical to Modern Black Nationalism produces two conceptual drives that constitute the parameters of the latter version and that lay the foundation for my analysis: "closing ranks" and "revolutionizing the mind." These two drives provide the means for articulating radicalism in the social imaginary. The desire for a sovereign Black nation transforms into a

desire for solidarity among individuals of African descent across geographical and class lines—an imagined collectivity in place of the one materialized by a state. This move represents a figurative "closing ranks" to attend to the needs and desires of Blacks, mobilize for political action, and offer a group-derived self-definition. This nationalist investment finds expression in the flourishing of all-Black social, institutional, and political organizations during the time period: Ron Karenga's founding of the US organization in 1965; Don L. Lee (later Haki Madhubuti), Johari Amini, and Carolyn Rodgers's founding of Third World Press in 1967; and the establishment of the National Black Political Convention in 1972 and the National Black Feminist Organization in 1973.[34] There is a distinct increase in the number of institutional spaces concerned with art during this period. Many of these organizations represent active attempts to fuse cultural production with radical politics.[35]

As William Van Deburg argues, this process of institutional creation also reflects the parallel impulse for "revolutionizing the mind."[36] This idea points to the widely held belief that any political change must first begin with rearticulating the terms upon which value is assigned to Black cultural productions, social activities, and especially bodies. There was an underlying aesthetic sensibility to this political ideology. The celebration of phenotypic African features in the public sphere at this time—to which the pervasiveness of the phrase "Black is Beautiful" at political rallies, in social organizations, and in writing attests—embodies this rhetorical focus of nationalist thought.[37] Political activism during the period illustrates a recurring focus on these drives. Artists explore the anxieties at the heart of these two nodes of nationalist thought (closing ranks and revolutionizing the mind) producing aesthetic radicalism.

Throughout its history, Black nationalist thought has developed in the context of enslavement, segregation, and a dearth of legal guarantees of citizenship rights for African Americans. Nationalism came into being as a set of responses to the feeling of civic disenfranchisement. Given this historical context, it is especially important to explore the adherence to nationalist principles in public opinion *after* the Civil Rights Act of 1964. This landmark piece of legislation did much to move toward securing rights for African Americans and fully integrate them into the body politic. However, what one finds is that the interest in nationalism peaks following this advance. Its development in the context of such ostensible progressive social and political change makes Modern Black Nationalism diverge from the iterations that precede it. It is for this reason that this study concentrates on the Black Arts era and the period that follows it: they line up historically with the Post–Civil

Rights era—a period when rights have been seemingly obtained. Part of my goal is to examine the social traction that nationalist principles have in the context of watershed social change.

When most people think about Black nationalism, they do so in terms of organizations or significant figures—as the preceding discussion suggests; however, it is also important to consider this ideology in terms of public opinion. This contention undergirds Wahneema Lubiano's theorizing of nationalism as a cultural logic in African American thought.[38] For her, Modern Black Nationalism represents not only a prevalent political framework, but it also signifies a general way of thinking among African Americans that constitutes a "cultural logic" and a "common sense" informing Black self-consciousness, intimate relationships, and cultural productions. This formulation impacts how later critics, such as historian Jeffrey Ogbar, approach nationalism as a cultural phenomenon.[39] Part of the power of Lubiano's analysis is that it forges connections between political paradigms and artistic culture. She is talking about nationalism's decisive impact on public opinion, and in doing so, she sets the stage for examining how a political logic transforms into the basis for artistic practices. The consideration of public opinion, as opposed to the emergence and attraction of organizations or institutions, is valuable because from this perspective one can glean insights on the ideas that shape the social imaginary.

The philosophical principles that constitute Modern Black Nationalism still inform Black public opinion into the twenty-first century. As Katherine Tate explains, throughout the 1980s and 1990s, Black nationalist ideals continued to find "new credibility and support" among Black communities especially in regard to community organizing.[40] In talking about the late twentieth century, political scientist Michael Dawson insists, "Black nationalism has become a pervasive influence in black life. Black nationalism is embedded in the music, journals, magazines, and cyberspace networks of the black community. . . . Black nationalist rhetoric continues to be able to mobilize African Americans. Black nationalist themes still find resonance in black communities within the United States, as they have periodically throughout the twentieth century. This is true, though support for the more separatist strands has dissolved."[41] He points to a wide-ranging attachment to nationalism, but he also indicates that the investment is not necessarily uniform or even immediately recognizable as a primary influence. Dawson assures us that nationalism continues to impact Black public opinion, but not in a singular way. Relying on extensive focus group and statistical data and voting patterns, Melayne Price delineates how African Americans em-

brace nationalism to varying degrees in the political study *Dreaming Black-ness*. Price turns to two specific events in recent U.S. history to illustrate the social and political contexts that encourage an uneven investment in Black nationalism: Hurricane Katrina and its aftermath in 2005 and Barack Obama's 2008 nomination to and 2009 assumption of the office of U.S. president. The sense that the federal government failed to help the stranded and homeless citizens in New Orleans—especially those who were Black—encouraged many to question recent social gains and to ponder with renewed vigor the social location of the African American person. However, Obama's success, for others, indicates the extent to which people of African descent have been fully integrated into the nation-state. For Price, the near simultaneity of these events highlights "the instability of blacks' access to full citizenship rights" and promotes conflicting levels of identification with discourses of nationalism in the Post–Civil Rights period.[42] The extensive range of nationalist engagement in the social world also occurs within the realm of cultural expression, and this is the territory explored in this book.

Aesthetic Radicalism as Critical Framework

Through bridging the temporal and conceptual gap between artists such as Neal and Riggs, one can begin to track the manifestation of *aesthetic radicalism*. I use this term to characterize how cultural producers transform the nationalist imperatives redefining the public sphere into artistic projects. The concerted attempt to translate the ideological focal points of Modern Black Nationalism into the artistic realm results in a rethinking of art forms and the means of expressing subjectivity. This turning of political discourse into art reconfigures artistic strategies *and* transforms nationalist rhetoric. Generally the incorporation of nationalist paradigms into art is classified roughly as *cultural nationalism*.[43] This term describes a premium being placed on the cultural distinctiveness of ethnic groups. This uniqueness becomes the basis for asserting a new valuation of Black identity and for encouraging self-actualization and collective empowerment. Following this line of reasoning, "Black culture *was* Black power": "the subordination of culture to economics or politics would eviscerate the revolution by denying its supporters access to the movement's lifeblood."[44] Cultural products in general are the preferable means for effecting social change. As an organizing principle, cultural nationalism is capacious in that it encompasses naming practices, holidays, literature, art, and general social events. Rather than seeking to recognize how a group of texts exemplifies cultural nationalism or supports the idea

that culture is the basis for revolution, aesthetic radicalism identifies a set of literary and artistic strategies employed across genres that respond to nationalist discourse. Cultural productions are not just the conduits for political action in *Radical Aesthetics*; instead, these works show signs of artists' testing the limits of nationalist rhetoric. Aesthetic radicalism describes the artistic inhabiting and reconfiguring of political radicalism.[45]

The primary strategy of aesthetic radicalism is *disruptive inhabiting*. This phrase characterizes the purposeful adoption of political ideology because of its potential for progressive social analysis, yet this adoption is paired with the active attempt to unhinge the components of the ideology that threaten to constrain expressions of identity. It is a version of engaged critique that results in formal experimentation. Disruptive inhabiting moves beyond binaristic models of engagement or rejection to conceptualize strategic incorporation that is linked to reimagining. Aesthetic radicalism names a method that acknowledges the value of political frameworks rooted in collectivity (i.e., common racial circumstances) while also recognizing fragmentation within that collective. The lens of disruption characterizes the deft negotiation of the political ideology of Modern Black Nationalism by artists. Neal's strategy of inversion and Riggs's technique of perversion are both manifestations of the logic of disruption.[46]

From an interpretive standpoint, aesthetic radicalism offers a means for evaluating revolutionary nationalist politics, and it is a critical framework that I develop to contribute to the emerging interdisciplinary field of Queer of Color Critique (QOCC). Roderick Ferguson outlines QOCC in *Aberrations in Black*, a study that uses literature to appraise canonical sociological texts focused on African American racial and gender identity.[47] He insists that many of the dominant ways of evaluating the social realm—such as Marxism and revolutionary nationalism—are "ideologies of transparency," meaning that they prioritize one category as the single lens for assessing and the chief tool for making sense of social issues: such as, racial exclusion as the primary cause of civic inequality. A singular logic dominates these ideologies from this perspective and obscures the complex interactions of different sites of oppression and modes of identification. Building on the Black Feminist work of Patricia Hill Collins and Kimberlé Crenshaw, QOCC stresses an intersectional approach to addressing such social problematics.[48] The goal is to illuminate the interdependent relationship that racial, gender, and sexual formations have to each other and to society. Ferguson proposes QOCC as an alternative to ideologies of transparency; it does work that they fail to do. Rather than positioning this method as a challenge to revolution-

ary nationalism's apparent single-minded pursuit of racial formation, I use QOCC to reveal the embedded complexity of nationalist discourse, which I argue merged racial, gender, and sexual analysis—particularly in its expression as Modern Black Nationalism. I employ QOCC as a tool to illuminate nationalism's multidimensional nature rather than as an alternative to nationalist analysis.

The critical texts that help to constitute QOCC have most often highlighted positionality—the idea that examining the social location of queers of color offers special theoretical insights—as the defining element.[49] While I do explore the significance of this understanding,[50] I begin by first emphasizing that QOCC is an intersectional approach that elucidates how marginalized subjects can identify with *and* critique dominant ideologies, reflecting how queers of color must deftly negotiate competing demands made on their multiple identities (racial, gender, and sexual). In my assessment, it is a method that creates possibilities of reading for contradictory identifications, allowing for the disruption of a system of thought without necessarily evacuating it of meaning. In this sense, QOCC also shows how ideologies that give shape to social life contain the potential for their own destabilization. For example, late-twentieth-century nationalism rhetoric is often associated with the race-conscious regulation of sexual and gender difference. However, the rhetoric remains attractive to women and sexual minorities even in the face of these seeming impediments. This attraction emerges because the ideology's radical rhetoric presents avenues for undermining regulatory protocols. I deploy QOCC to call attention to the ways that dynamics of identification and antagonism exist simultaneously within a system of thought. This recognition reveals "unimagined alliances" that at first blush come across as diametrically opposed.[51] The pairing of Neal and Riggs that opens this book represents one such unimagined alliance, which an intersectional methodology makes apparent. One of the primary interventions of this book is the melding together of QOCC with the artistic engagement of Black nationalist rhetoric. My aim with this strategy is two-fold: (1) to diversify the archive of QOCC by analyzing literary, cinematic, and visual art attentive to nationalist paradigms and (2) to expand how we think about the conceptual terrain of nationalist thought.

Through prioritizing QOCC's ability to disrupt ideological parameters, this book recognizes the synthetic composition of Modern Black Nationalism. Attending to the combination of connections with and critiques of normative values enables perspectives that get beyond the idea that revolutionary nationalism is an ideology of transparency categorically. Revolutionary nationalism's

potential for different applications makes it attractive to different groups for dissimilar reasons. The wide variety of nationalist adherents shows the conflicting nature of the ideology. I examine the social imaginary that nationalist rhetoric created and the multiple ways this imaginary promulgated and manipulated that rhetoric. Cultural producers align themselves with revolutionary nationalism most often because of its demands to reimagine the social world and Black identity. However, they also cast aspersions on components of the ideology that they feel come up short: those that reinscribe normative notions of racial, gender, and sexual identity. Their translations of the political rhetoric into artistic projects become occasions to showcase the strengths and weaknesses of its political principles through offering critiques of them from a position of affiliation. In this light, aesthetic radicalism becomes legible as an outgrowth of QOCC.

There are two features of QOCC that I use to develop aesthetic radicalism: (1) QOCC understands culture as a site constituted by identifications with and antagonisms to normative ideals, and (2) QOCC interprets cultural fields from within those fields and not outside of them. Aesthetic radicalism approaches nationalism as a contested terrain that at times aligns with normative values and at other times rejects such affiliations in the process of censuring oppressive state actions. As a result, revolutionary nationalism appears less fixed and more flexible in terms of its implications. Artists and thinkers who take up the components of this ideology are sometimes at odds with each other or produce startlingly contrasting works because of the heterogeneous nature of nationalism. The framework uncovers critically minded alliances between cultural producers that often go unrecognized and underappreciated. These linkages emerge prominently through the lens of aesthetic radicalism.

The second feature, which concerns working from within, helps to clarify "disruptive inhabiting," which characterizes aesthetic radicalism. Ferguson—building on the work of José Esteban Muñoz—insists that working from inside social formations is crucial to QOCC because these formations shape queer of color identity development.[52] Shedding light on the realities of intersection requires acknowledging the forces that have shaped the dimensions of one's identity. State and cultural institutions might be oppressive or restrictive, but they still inform personhood. One can only undo their effect and undermine their power by first acknowledging the imprint itself and one's own intimate involvement with these institutions. This understanding of the insider's perspective is the basis for disruptive inhabiting. The second term of the phrase (*inhabiting*) indicates how the association with nationalist rhetoric

is a key component of the texts analyzed. Artists dwell within the rhetoric to acknowledge their investment in it and to understand the contradictory elements that constitute it. The qualifier *disruptive* (along with the notion of *disruption*) describes the critical appraisals of the rhetoric. The artists' objective is not merely to undermine the rhetoric, but rather to disturb its trajectory to push it in alternative directions. The inhabiting aids and abets this rethinking. The emphasis on inhabiting accomplishes two other tasks: (1) it illuminates how artists *occupy* forms in innovative ways, and (2) it accents notions of performance and embodiment.

Although this book is not an extended examination of queer life as such, the influence of QOCC on aesthetic radicalism does indicate a sustained consideration of gender and sexuality throughout this study of the impact of nationalist logics. QOCC recognizes how racism operates through the regulation of gender expression and sexual identity. Modern Black Nationalism challenges the historic and ongoing institutionalization of racism as well as the dominant place that race-based discrimination has in the public sphere. One finds that nationalist ideology often participates in gender regulation in its scrutinizing of racism. Such participation frequently appears as a prioritizing of race over any other dimension of identity or as overdependence on manhood as the key feature of radical analysis. Considering how racism operates from the QOCC perspective necessarily means coming to terms with restrictive conventions regarding gender and sexuality. Many artists that take up Black nationalist thought seek to uproot these conventions. I call attention to gender and sexuality as primary throughout this discussion of the artistic treatments of Black nationalism to show how this ideology focused on Black citizenship does not only seek to address the relationship of one group to the state. The translation of political rhetoric into artistic projects communicates a reconstituted Black subject and reenvisions the possibilities for individual gender expression. Black nationalism is a prime site for pinpointing the boundaries of contemporary gender expression, but it also can supply the terms for transgressing these boundaries. In investigating nationalism, aesthetic radicalism also elucidates the shifting terrain of Black gender and sexuality explored in the world of art.

Methodology and Overview of the Book

Radical Aesthetics stands alone in its sustained argument that Black nationalism lays the groundwork for contemporary African American artistic innovation. The ideology's political investment in disruption is the ground

upon which artistic experimentation is conceived. My tracking of aesthetic radicalism builds on, while also diverging from, recent work on Black Arts era material. James Smethurst provides an unmatched social history of the Black Arts Movement, and he demonstrates that it was a national phenomenon and not limited to a particular region.[53] While recognizing the value of this approach, I offer an aesthetic theory of the period instead of a social history. The critical contributions of Amy Abugo Ongiri and Margo Crawford have taken up the critical enterprise of a theory of the period more explicitly. Ongiri situates the Black Arts dominant paradigm, the Black Aesthetic, as primarily a literary conduit for the vernacular and mass culture, which she describes as the "urban vernacular."[54] Taking a different tack, Crawford explores how the complexity of the phallocentric thought circulating during the Black Arts era was manifested in ways so diverse and contradictory that this system of thought could undermine itself.[55] In contrast to both, my focus is on the method that characterizes Black Arts era work: disruptive inhabiting. In addition, Black nationalism is the conceptual backdrop for Crawford's and Ongiri's respective claims. This political framework is brought to the fore throughout my discussion.

The contention that the disruptive inhabiting of nationalist analysis yields aesthetic radicalism positions this work in a critical tradition that attends to Black radicalism and its impact on artistic production. Previous scholarly work that has considered the relationship between radicalism and Black art primarily reflects the investment in two particular theoretical frameworks: Marxism and (Post)Modernism. Both Barbara Foley and James Smethurst produce pioneering texts in which Black radicalism denotes an intellectual debt to leftist thought as well as an involvement with socialist activities.[56] Conversely, the important works of critics such as Aldon Nielsen, Kimberly Benston, and Fred Moten understand radicalism as a specific manifestation of African American writers' navigation of (Post)Modernist strains of thought.[57] Rather than prioritizing the significance of leftist engagement or the exploration of the different manifestations of a particular school of critical theory, *Radical Aesthetics* highlights Modern Black Nationalism as a source for innovation in artistic production. In this study, a specific African American philosophical tradition and political framework becomes a crucial means for formulating contemporary radical thought. Because this ideology conjoins formulating critiques of the public sphere with reimagining the racial and gender parameters of Black subjectivity, my emphasis on Modern Black Nationalism allows this book to track shifting conceptions of Black identity within the context of emerging radical sociopolitical analyses.[58]

The two drives at the heart of Modern Black Nationalism—closing ranks and revolutionizing the mind—and the accompanying rhetoric around them directed social and creative focus to four specific areas of disagreement and controversy: White innocence, Black kinship, reproduction, and sex. Each is a discursive site that encompassed one of the foremost-politicized issues during the Black Arts era and that provided the contours of nationalist rhetoric. Rather than solidifying Black communal affiliation, the pervasive emphasis on closing ranks introduces anxieties about Black intraracial intimacy *as well as* the place and meaning of Whiteness. For example, the Atlanta Project's divisive vote to expel White participants from the Student Nonviolent Coordinating Committee in March 1966 exacerbated rising concerns about the constitution of community under a Black nationalist banner. The vote to purge encouraged feelings of distrust and rancor among Black members and spurred a national conversation about White involvement in minority activist organizations.[59] The ideological premium placed on revolutionizing the mind was most often articulated in terms of a new consciousness of the Black body and its social significations within political dialogues. Vice chair of the Mississippi Freedom Democratic Party, Fannie Lou Hamer's critique of "Mississippi appendectomies" (her metaphorical designation for unnecessary hysterectomies performed on Black women without their permission) in 1964 reflected an emerging public campaign of excoriating discriminatory state health care practices as they related to poor Black women. The theoretical terrain of this evocative phrase and the ensuing debates provided the rhetorical tools for the later Black Panther Party medical clinic movement.[60] However, the activism surrounding this descriptor also contributed to conversations about the precarious nature of Black reproduction as well as the deleterious public attention being paid to the sexual activities of Black citizens. These four areas of ideological interest map the defining coordinates of Modern Black Nationalism.

White innocence, Black kinship, reproduction, and sex are not unfamiliar or new to artistic culture; they were not introduced with the advent of Modern Black Nationalism. Rather, they represent the central axes around which much of nationalist thinking aggregated during the 1960s and 1970s attracting the attention of cultural producers. The desire for Black political solidarity sometimes appears in terms of racial exclusivity or separatism. However, artists are especially interested in how conceptions of White innocence permeate the social logic of U.S. identity in general. The goal of remaking Black identity, which is a vital concern, requires taking on this grounding concept of racialized innocence in the artistic imaginary. That

being said, there is an expressed desire to understand the boundaries of Black unity within nationalist thought. Artists insist that the framework of kinship functions as the primary integer of such unity. The language and imagery of kinship dominates political, social, and creative thinking that proclaimed Black nationalist desires for solidarity and new expressions of identity.

Setting aside this more explicit focus on identity, the other two sites, reproduction and sex, promote an emphasis on a political concern with the body. The discourse on Black reproduction gains currency in nationalist thinking because it grounds the logic of kinship and because it functions as a means for refashioning the social realm. Reproduction's function as a figure for replicating the self and the community means that it has definite value within nationalist analyses. Public disputes about the birth control pill intensify the focus on the social meanings of Black reproduction. This emphasis on reproduction encourages a parallel concern with sex and its meaning outside of propagation: its culturally generative possibilities. Political liberation and sexual freedom become analogues. For writers and artists, the desire to express a modern, radicalized African American social position means assessing how this subject has been hypersexualized historically. *Thinking sex*, or determining the ways sex acts attain social value and threaten hierarchies of valuation, becomes a defining element of the nationalism.[61]

Each chapter of this book focuses on one of these sites to trace the movement from political rhetoric to artistic experiment. All four recur throughout nationalist texts whether they are social criticism or artistic projects; however, the recurrence does not mean that writers agreed on their meaning. Examining these sites reveals the diverging perspectives that constituted nationalism. White innocence, Black kinship, reproduction, and sex represent historical sources of political disagreement that led to larger questions about politics, ethics, and art. Each of these concepts stands as a source of debate within nationalist circles, and Black Arts artistic culture developed paradigms around them. Scrutiny of these four areas produced methods for artistic innovation. The post–Black Arts era artists I examine attend to these sites of nationalism and employ similar methods in evaluating them. Acknowledging the aesthetic connections between the recent past and the present makes visible a common pattern of engaging nationalism across art forms and reveals an underconsidered artistic genealogy of contemporary African American innovation that has developed out of the creative exploration of radical rhetoric.

The methodology of this study reflects the concept of Black nationalism as an artistic point of reference. All four chapters begin by elucidating work

from the Black Arts era, which is then put in conversation with work from the post–Black Arts period(s) to reveal artistic conversations about nationalism. The chapters all move from the 1960s to the turn of the twenty-first century and include examinations of several artists. Each chapter traces one paradigm of nationalism through the work of a few artists to demonstrate the continued engagement of radical political thought. This method advances two elements of the larger argument: the reader is regularly reminded of how nationalism gets explored over time, and the reader witnesses how strategies of disruptive inhabiting get manifested in multiple genres and in different forms.

Drama, fiction, poetry, film, and visual art are put in conversation to show that the analysis of political exigencies occurred throughout African American artistic culture. *Radical Aesthetics* also sheds light on the close relationship between the textual and the visual in Modern Black Nationalist theorizing. The connection I track between visual art and creative writing reflects the recurring investigation of the relationship between the visual and the graphic during the Black Arts era and the declared political goal of disrupting image making. The texts discussed consider the four discursive sites of nationalist attention and exhibit the characteristic of innovation—specifically formal experimentation, generic manipulation, and reformulations of traditional conceptions of Black racial and gender identity. Each piece of literary or visual art shows signs of both characteristics (nationalism and innovation). The link between these sites and such innovation is the defining terrain of the aesthetic radicalism. Some of the texts examined here are understudied, and part of the reason for this lack of attention is because it has not been made clear to the critical community that the texts' embedded political engagement is the context for their peculiar formal traits.

This move to put in conversation different genres and forms constitutes a queer method, which is part of the intervention of this project. Jasbir Puar understands queer method as highlighting "the unexpected, the unplanned irruptions, the lines of flight, the denaturalizing of expectation through the juxtaposition of the seemingly unrelated."[62] This strategy describes my approach of thinking across art forms and making unexpected connections. Moreover, understanding my method as queer makes manifest how my analysis of nationalism develops out of QOCC. Previously scholars have mainly understood the period under consideration in terms of linkages only to traditional boundaries between forms and genres,[63] but a major part of what a queer method allows *Radical Aesthetics* to notice is the collapsing of those exact boundaries or at least the merging of them in various kinds of

formal practices, especially those that emphasize speech, storytelling, and performance. It is not an accident that artists such as Amiri Baraka and Alice Walker work through multiple genres and others such as David Henderson, Gil Scott-Heron, and Faith Ringgold combine different forms connecting their formal practices across the grain of genre distinctions though at the same time preserving the format for presentation of the work so that its more traditional aspects are also recognized. This study divulges an interdisciplinarity that followed the art of the Black Arts era into the later period(s). The disparate art forms treated here offer a new way of reading across formal boundaries, because social boundaries (class, race, gender, sexuality) were the ones that were being simultaneously breeched and articulated so that the revolutionary messages would have real-world impact.

Again, each chapter traces one paradigm rooted in nationalist rhetoric from the Black Arts era to the present. I put in conversation 1960s-era artists with contemporary artists to demonstrate how ideas and artistic strategies endure, choosing three artists for each chapter. The work of the first artist demonstrates the Black Arts era technique of engaging the nationalism-derived paradigm under discussion. The analysis of the second text builds on that of the first while seeking to push it in different directions and often to different artistic forms illustrating the complexity of Black Arts texts. The third text explores how a contemporary artist takes up that complexity showing how the engagement of nationalism gets reformulated over time. Each trio functions as a conversation about the paradigm under consideration: its relationship to political discourse and how it surfaces in experimental art.[64]

This study of the artistic engagement of the rhetoric of Modern Black Nationalism has two sections: "The Question of 'Closing Ranks'" and "The Bodily Logic of 'Revolutionizing the Mind.'" Each section focuses on one constituting characteristic of Modern Black Nationalism as its organizing framework: the first examines the challenges that result from the emphasis on closing ranks, and the second shows the contradictions that emerge when the body becomes the preferred means for manifesting the desire to revolutionize the mind. The two chapters that make up part I, "The Question of 'Closing Ranks,'" demonstrate how artists scrutinize the desirability of a turning inward toward a Black collective. The chapters in part II, "The Bodily Logic of 'Revolutionizing the Mind,'" move from anxieties about Black solidarity to a sustained consideration of the many conflicts over the public meanings of the Black body. Each chapter builds on the one that precedes it. In the remaining pages, I provide a detailed outline of the narrative arc of the argument across the chapters to make clear the reasoning that underpins connecting dissimilar artists, the trios of unimagined alliances.

The first chapter, "The Claim of Innocence: Deconstructing the Machinery of Whiteness," tracks how artists inhabit the subjective space of Whiteness as a closing ranks move. This idea may seem counterintuitive, but for many thinkers, exploring Whiteness is useful in determining the conventional parameters of Black identity. The act of identifying and challenging these boundaries creates the opportunity for imagining a unity not plagued by restrictive conceptions of Blackness. Therefore, turning inward does not appear here as a mere rejection of Whiteness in favor of shoring up Blackness. The chapter highlights how the rhetoric of White innocence provides the foundation for both racial and gender frameworks in the U.S. social imaginary. Whiteness here is not simply a heritage marker; it describes a process of identification rooted in racialized social innocence that makes possible notions of access and privilege—basic elements to social inequality. The desire to generate a radical Black identity includes dismantling this rhetoric, which permeates media and popular thought. White innocence infuses every level of U.S. society, hindering attempts to debunk negative conceptions of Black identity. The chapter opens with a consideration of Black Arts dramatist Ed Bullins, because his plays provide an example of incorporating nationalist analysis into artistic strategies. His historically based piece of agitprop theater *JoAnne!!!* exposes the public exercising of White innocence as a legal right. By reenacting a court proceeding and a police investigation, the play provides a critique of the state and its institutionalization of White innocence. Following typical nationalist analysis, the state and its apparatuses are positioned as the primary obstacle to overcome in recreating Black identity. I next turn to the artwork of Adrian Piper because she shifts attention away from the state as the site of domination to the public sphere in attending to the rhetoric of White innocence. Throughout her graphic art series *Vanilla Nightmares*, Piper makes visual the nationalist contention that anti-Black racism lies at the base of the U.S. culture. However, she argues that racist thought is elemental to the public sphere, so she repurposes newspapers as canvases. This choice of material makes the sequence significant: it directs attention to the influential power of the media. Her drawings expose how newspapers rely on and circulate fear-fantasies about Blackness ("vanilla nightmares") while making claims of innocent objectivity.

Both Bullins and Piper are concerned with macrolevel critiques of the rhetoric of innocence (the state and the public sphere, respectively). I close the chapter by offering a reading of Cornelius Eady's poetic cycle *Brutal Imagination*. This work takes as its starting point a literal instance of the claim of White innocence as a way to show how this rhetoric filters throughout not only the state or public sphere, but also the individual imagination. The

cycle shifts perspective from a woman who murders her children to the Black man she invents to cover up her crime. Eady inhabits this persona and her racial creation to expose the acts of false attribution that enable the claim of innocence and serve as the foundation for securing White identity. The artistic deconstruction of White innocence across these texts functions as a manipulation of nationalist critiques of White social privilege. The chapter lays bare the idea that before Black unity can be realized, there is a need to exorcize the societal investment in White innocence that exists at institutional and individual levels and that continues to produce damaging conceptions of Blackness.

The disarming of White innocence, which chapter 1 tracks, does not result in a reconstituted and affirming space for Black subjects. The investigation of Whiteness produces the desire to rethink the parameters of identity in general including those relationships presumed to be categorical to Blackness. The trenchant deconstruction of Whiteness makes all racial categories in need of reconsideration. Given these ideas, many thinkers began to ponder: What happens after we deconstruct White privilege? Toward what exactly are we turning inward? Does turning inward necessitate losing the self? Might the need to turn inward to protect and build up one's racial identity endanger some other dimensions of the self? These questions map out the terrain of chapter 2, "The Suspicion of Kinship: Critiquing the Construct of Black Unity." Building on the discussion in chapter 1, this chapter clarifies how the impulse to close ranks raised concerns about the prioritizing of the collective over the individual. Black collectivity is expressed as kinship in the nationalist imagination, so there is an overriding anxiety about metaphors of family, which assume an intimacy or affiliation that might not be present. This chapter examines texts informed by nationalism that challenge this investment in kinship. A consideration of John A. Williams's Black Arts historical novel *The Man Who Cried I Am* opens the chapter. The novel seeks to unveil global circuits of anti-Black racism and the U.S. state's complicity in discrimination, but, in the process, it presents Black kinship as fraught and even fatal by exploring Black collectivity expressed as destructive male fraternity. I put this text in conversation with Alice Walker's debut novel *The Third Life of Grange Copeland*. Walker's family saga troubles the thinking apparent in Williams's text by foregrounding the gendered nature of imagined Black collectivity. Black kinship is dangerous here, but there is an explicit detailing of how patriarchy and misogyny inform structures of kinship. These two novels of the Black Arts era showcase the weaknesses of

the rhetoric of unity and its applicability, and they register this idea formally through fragmenting the unity of narrative structure.

Williams and Walker present unity figured in terms of kinship to destabilize it, but later writers use this destabilized unity to imagine new modes of connection through sociopolitical position instead of kinship. The suspicion of the logic of kinship does not do away with a recognized need for collective identity and action given the realities of race-based and class-based discrimination. The chapter next directs attention to the desire for solidarity without the trappings of kinship. I focus on Gloria Naylor's fictionalized memoir 1996 to illustrate this shift from kinship to social position as the basis for revolutionary action. Naylor inhabits the nationalist rhetoric of kinship to envision a different form of unity through a fragmented narrative structure. The premium on kinship is presented as a weak component of nationalist thought, so the novel offers a conception of civic solidarity rooted in positionality. Williams, Walker, and Naylor all acknowledge the need for closing ranks efforts within oppressive environments, but their disjointed narratives gesture toward alternative terms of unity.

The commitment to kinship that emerges here carries with it a concomitant investment in the literal and figurative significance of reproduction. It is reproduction, with its linkages to generation of the collective, which makes possible the family-as-community metonym driving the nationalist interest in kinship. The paradigm of reproduction becomes an important node of nationalist analysis because it is overinvested with conflicted meanings: reproduction is a trope of community, but it has functioned as a historical means of racialized control and manipulation. Accordingly, reproduction is imagined as being both the site of possible liberation and the source of potential reenslavement. Chapter 3, "The Demands on Reproduction: Worrying the Limits of Gender Identity," tracks how artists investigate this discourse not simply to explore these dual meanings, but rather to consider how the politicized concept of reproduction functions as a contested means for conveying gender identity. In her painted quilt sequence *The Slave Rape Series*, Faith Ringgold uses reproduction to establish a visual interrogation of Black gender identity and to probe the implications of the commitment to reproductive paradigms. Her paintings of the pregnant body create the opportunity to recast the images circulating in political discourse, which favor restrictive conceptions of gender expression, especially in regard to femininity. I link this series to Toni Morrison's novel *Paradise*, which traces Black nationalist impulses. Morrison moves the questioning of reproduction to the realm of narrative and enhances the exploration of masculinity. Whereas, Ringgold

sought to reimagine the social understandings of Black womanhood specifically (and motherhood generally) in her paintings, Morrison attempts to unsettle reproduction as the conceptual foundation for Black femininity *and* masculinity, and in doing so, she argues for a nonreproductive grammar for conceptualizing gender. The novel charts how controlling reproductive practices becomes the first step in redefining Black masculinity, highlighting that reproductive agency can act as a figure for manhood.

This association between controlling reproduction and formulating masculinity creates the context for Spike Lee's feature film *She Hate Me*. The chapter closes by explaining how Lee evokes nationalist strategies by offering an exploration of reproduction as a viable mechanism for resolving social anxieties about gender identity and for rearticulating Black social agency. Lee's explicit concern with masculinity creates the opportunity to rethink Black gender protocols. *She Hate Me* presents the argument that a specific visual rhetoric lies at the basis of social conceptions of gender identity, so his project refashions the visual presentation of gender expression, recalling the work done in *Slave Rape Series*. Ringgold, Morrison, and Lee all seek to give new life to Black gender expression by manipulating images of reproduction. The reliance on reproduction poses a problem for artists, because the emphasis on its value results in predictable and limiting conceptions of gender expression. However, the trio of artists examined in this chapter employs nationalist reproductive reasoning not simply to perpetuate it as a means for expressing collectivity, but rather to imagine new directions for Black identity outside of the logic of propagation.

The recurring anxiety about the possible meanings of reproduction produces an increase in attention to the social implications of the sex act. Sex appears as a highly disputed act in Morrison's and Lee's texts. The power attributed to reproduction offers a radical valence to sex in the nationalist imaginary. Because Black political liberation was expressed in terms of bodily freedom and because Black nationalist rhetoric often employed the language of intimacy, sex acts become appropriate mechanisms for querying the social realm. Therefore, sex comes to mark the boundary between private identity and collective consciousness. Chapter 4, "The Space of Sex: Reconfiguring the Coordinates of Subjectivity," shows how artists recognize this politicized reading of sex and use it to examine the social realm and the intimate realm simultaneously, ultimately illustrating a disintegration of the distinction between the two (the public and the private). I first discuss the work of Cecil Brown and Jayne Cortez, because both concentrate on public sexual mythologies and folklore to deconstruct the sexual stereotypes

plaguing Black embodiment. Brown's Black Arts novel *The Life and Loves of Mr. Jiveass Nigger* provides an extended look at hypersexual masculinity in hopes of exhibiting its flaws. On the other hand, Cortez's Black Arts poetry collections *Pissstained Stairs and the Monkey Man's Wares* and *Festivals and Funerals* turn their attention to limiting constructions of Black femininity and sexual minority existence that impede self-definition. Like Brown, she summons sexuality-based stereotypes to dispute their validity, but her poems move away from a primary focus on heterosexual masculinity. The shared method of disintegrating public sexual myths achieves the nationalist goal of reconceiving the public sphere.

The employment of sex as a vehicle for both social critique and spatial analysis becomes an important component of Black gay writers' cultural work. I highlight Darieck Scott's experimental novel *Traitor to the Race*, because it models this approach to sex and because it presents queer desire specifically as having the potential to disrupt social meaning. His narrative accentuates the spatial concerns intrinsic to nationalism while also critiquing limiting conceptions of gender and sexual identity. Scott manifests this critique through a genre-blending genre, inventing an innovative form that rethinks the coordinates of Black identity and the boundaries between art and politics. The artistic exploration of the social power attributed to sex in these texts reflects the movement of political concerns and anxieties into the realm of cultural production. I read these three artists as responding to the nationalist demand for new significations for the Black body through their moves to dislodge negative sexual mythologies and reveal the disruptive power of Black intimacy. This chapter offers a contribution to Black sexuality studies and queer theory by clarifying how articulations of Black sexuality seek to engage political radicalism to question recognizable parameters of identity expression.

This book uncovers the afterlives of Black Arts critical frameworks and the impact nationalist thought continues to have on artistic production. The conclusion, "Queering Representation," begins by elaborating this point. From here it shows the significance of the concept of representation to nationalist discourse. Representation in the political world and the idea of cultural representation both appear to demand a stable point of reference. However, cultural producers disruptively inhabit frameworks of representation as an element of their aesthetic radical practices. They "queer" representation. I briefly consider visual artist Howardena Pindell alongside lesbian filmmaker Cheryl Dunye, because they produce works in which Black bodies become visually inaccessible. The reluctance to represent is a vital component of

these artists' respective projects. The conclusion documents how cultural producers challenge the idea that social realities oblige African American artists to produce work engaged in progressive politics. That being said, they offer these critiques even as they uphold the value of such radicalism. The questioning of representation and the signification of Black identity is not a strategic rejection of nationalism. It is an outcome of the ambivalence toward nationalist rhetoric chronicled throughout the pages of *Radical Aesthetics*. This final move in the conclusion secures the cumulative effect of the book by unveiling a genealogy of innovative contemporary African American art rooted in nationalist paradigms and offering a methodology for analyzing twenty-first-century cultural productions. The reader will discover how contemporary African American artists create in the wake of nationalism.

The Question of "Closing Ranks"

1

The Claim of Innocence

Deconstructing the Machinery of Whiteness

In 1966, the Student Nonviolent Coordinating Committee published the "Position Paper on Black Power," which helped to solidify the "closing ranks" philosophy within Modern Black Nationalist discourse. This document emphasized that there was little to no space for White people within the Black radical movement: "Any white person who comes into the movement has the concepts in his mind about black people, if only subconsciously. He cannot escape them because the whole society has geared his subconscious in that direction. . . . Thus the white people coming into the movement cannot relate to the black experience, cannot relate to the word 'black,' cannot relate to the 'nitty gritty,' cannot relate to the experience that brought such a word into existence."[1] The writers go on to say that White people who desire change should direct their efforts to changing the attitudes of the White community. The argument presented here, which would become formative in its historical moment, contributed to the common understanding that closing ranks means ideological and social separatism.[2] Even if separatism became a doctrine for some groups, there remained a widespread interest in coming to terms with the exact factors that made such racialized unity an exigency in the first place. In part, this philosophical consideration involved examining the social and legal ideas that buttress Whiteness and make it the sole arbiter of meaning and value. In light of this recognition, deconstructing Whiteness became an important component of the closing ranks impulse, particularly in the artistic imagination. The nationalist desire to secure Black self-determination and social advancement yielded a persistent interest in anatomizing Whiteness to enable a radical articulation of Black subjectivity.[3]

Rather than merely rejecting or embracing Whiteness, artists engaging Black nationalism inhabit strategically the constitutive elements of this identity space to dismantle the racial and gender frameworks it generates. The artists I discuss at length—Ed Bullins, Adrian Piper, and Cornelius Eady—recognize that a rhetoric of innocence undergirds Whiteness as a framework, and they undermine the legal and social implications of this rhetoric. Each attempts to destabilize not only the racism that is embedded in White American identity, but also the asymmetrical power relations, which the rhetoric sets in place, that come to define U.S. racial identity. This move allows them to suggest the possibility for spaces of identity outside of these frameworks. Their creative works reveal that part of the closing ranks impulse to unite was to undo and remake the systems of thought that made the coming together necessary. These artists rely on innovative formal techniques that demonstrate reaching the limit of imagining modes of identity through inherited racial and gender categories. The linking of the disruptive inhabiting of White innocence to such formal experimentation reveals how aesthetic radicalism, the movement of nationalist rhetoric into the realm of art, unsettles the social logic of race.

Black Arts critic Carolyn Gerald provides a crucial framework for setting up this strategic employment of Whiteness. In the 1968 essay "The Black Writer and His Role," Gerald insists that the goal of the Black writer is to write against the "zero image" of Black people by offering alternative images.[4] Projection is fundamental to the essay. Gerald argues that White writers and thinkers project racialized images into the public sphere (352). That projection defines the visual symbolism and ethical terrain of the social and artistic realm and yields an abstracted image with which all Black artists must contend. Gerald explains the challenge these artists face because of this projection: "These images must be mythically torn down, ritually destroyed. We cannot bury our heads before the existing body of myth, nor before our own Europeanization. Therefore, we cannot return nostalgically to a past heritage and pretend that historical continuity exists in anything but fragmentary form. We cannot block out the black-white struggle for control of image and create a utopianized world of all-black reflections. Our work at this stage is clearly to destroy the zero and the negative image-myths of ourselves by turning them inside out" (354). She refuses the idea that Black artists can deny their indebtedness to the Western artistic tradition by simply asserting links to African cultural practices. Instead she insists that artists must engage negative images, reversing their polarity by turning them inside out. The only way to undermine the White-constructed images of their power is

to inhabit them and reconfigure them. This process entails occupying these key components of the social construct that is Whiteness. The only way out is in; one must occupy the theoretical space of Whiteness to undermine the world it has created and imagine other possibilities.

Given Gerald's argument, the notion of closing ranks, an elemental component of Modern Black Nationalist discourse, does not result in a repudiation of Whiteness. One finds artists employing it as a mechanism of social critique that can effect not only new images, but also new modes for articulating Black identity by interrogating its key rhetoric. Moreover, Gerald describes the process of disruptive inhabiting, which characterizes aesthetic radicalism. This use of Gerald's argument indicates a movement away from formations of Black subjectivity that merely position it in a dialogical relationship to White subjectivity. Instead, I emphasize how certain cultural producers explore the constituting elements of Whiteness to reimagine racial identity and artwork that attends to race.[5]

Through an engagement of Critical Race theory, this chapter evaluates the artistic employments of Whiteness during and after the nationalism-influenced Black Arts era. By *Whiteness*, I refer not simply to White people, but rather to the signifier for a specific set of symbols having to do with social access and agency that infuse and buttress U.S. White embodiment.[6] The question of what methodological function Whiteness offers to contemporary artists motivates this discussion. This chapter traces the interest in how the rhetoric of innocence functions as the constitutive element of Whiteness as a discursive framework for identity production. In fact, assertions of innocence make possible formulations of social agency and access. This key component of Whiteness has attracted a significant amount of critical attention. The work of legal scholar Thomas Ross informs my approach here.[7] Ross argues that White American identity should be understood as being rooted in the trope of innocence and as using this concept to define itself: being blameless when it comes to histories of racialized oppression, being ignorant of and lacking an involvement in ongoing discrimination, and refusing to acknowledge the social construction of the Black subject (as social Other) as always-already guilty and dangerous. These moves collectively form a special rhetorical device that makes White U.S. social identity possible. Whiteness here has little to do with heritage; instead it describes a process of identity formation rooted in the notion of racialized innocence.[8]

Black Arts era artists were particularly interested in this understanding of Whiteness. Carolyn Gerald's argument about projection anticipates Ross's later legal analysis because part of his point is that White subjects remap

the social terrain of meaning to claim proprietary rights to innocence. The claim of innocence involves a projection of meaning. Black artists inhabit the circulating rhetoric of White innocence to undermine it as a controlling social logic that limits Black subjectivity. Ed Bullins's drama, Adrian Piper's visual art, and Cornelius Eady's poetry all employ this method of deconstructing White innocence in a way that resonates with Black nationalist thought. Even if these artists are not all readily associated with nationalism, they take up the nationalist analysis of the rhetoric of White innocence and employ the strategy of disruptive inhabiting in attending to it. A common method prevails although each works in a different genre. Following Gerald's argument, this chapter demonstrates that only by exposing how Whiteness functions, what its mechanisms are, can the processes of image and identity creation be revolutionized.

Fantasies of Innocence

Ed Bullins was a key figure of the Black Arts era. Because he was one of the most productive dramatists of the time period and was invested in transforming political thought into artistic practice, his work provides a useful place from which to begin.[9] His important plays include *Clara's Ole Man* (1965), *In the Wine Time* (1968), and the short piece "The Theme Is Blackness" (1966). Notwithstanding these works, Bullins's 1976 play *JoAnne!!!* epitomizes the theatrical experimentation that characterizes all of Bullins's projects and has at its center a critical engagement of White innocence. Foregrounding the relationship between aesthetic practices and politics, Bullins translates the events surrounding the trial of Joan Little into the play *JoAnne!!!* He writes the play in defense of Black inmate Little who had been charged with first-degree murder for the 1974 death of White jailer Clarence Alligood. The play is important to this discussion of radicalism and formal innovation in part because it stands as an example of what literary critic Mike Sell terms an "agitprop closet drama," a form that Bullins invented. Sell describes this new genre as "a form of political theater that deconstructs the lines between theatrical representation and insurrectionary action, art as utilitarian means and art as end in itself."[10] The agitprop closet drama results from the attempt to translate political radicalism into art.

Joan Little's case was described as "the Civil Rights case of the decade,"[11] and for this reason, it was an ideal source for Bullins's new dramatic form. Bullins attended the trial, was moved by the story as well as by the courtroom statements, and incorporated much of the proceedings into the work. In his

mind—and in the opinion of many of the activists who supported her—Little had acted in self-defense because Alligood had sexually assaulted her.[12] The play's abiding interest in supporting Little and upholding Alligood's racism and sexism create a propagandistic tone. The character JoAnne proclaims in a monologue, "I didn't have time to kill myself because of that human outrage forced upon me; he was the only one in striking distance, so I had to off him for survival's sake, but I wouldn't have killed myself, neither. That's just not in me . . . and I'm not the enemy . . . he is" (149). JoAnne becomes a conduit through which Bullins allows Little—whom he sees as socially silenced—to enter public discourse and abrogate the legal parameters under which she could be rendered legally guilty.

Curiously, the play does not limit itself to giving voice to JoAnne's innocence; this Black Arts drama also rehearses the articulation of White innocence. The White jailer's character—here the allegorically ironic All Goode instead of Alligood—plays an important role in the structure of the play and is allowed to tell his own story of victimhood. He asks for a "moment in the true spotlight of history [and] men's minds" to tell his tale and prove his innocence (151). In recounting his side of the story, All Goode emphasizes dreams. He alleges that while on duty that fateful night he heard sounds coming from JoAnne's cell. Finding that she is having a sex dream, All Goode decides to participate in this reverie while JoAnne is in an entranced state:

ALL GOODE: excited: Ooooeeee . . . woman! There you was. Like I al-
 ways wanted. Just waitin' and wantin' me!
JO ANNE: normal: It was your dream, fool! Your dream.
ALL GOODE: Nawh . . . nawh . . . nawh nawh nawh . . . It was YOUR
 dream, Jo Anne, and you was dreamin' I was some black superstud,
 and that was okay with me, 'cause whether you was dreamin' or not
 . . . I was your man then and I was gonna have you like you wanted
 me to. (157–58)

He details a delusional encounter with a dream, one in which he is transformed into a "black superstud." It is not the White All Goode who sleeps with JoAnne, but rather this Black fantasy figure that she projects onto the jailer in his account. In reading or watching the play, one might wonder why Bullins decides to have All Goode insist that JoAnne was dreaming and rationalize his actions through the image of a dream. It is very easy (and tempting) to read All Goode's tale as a desperate and ridiculous attempt to justify his abuse of power. This reading aside, Bullins's embodiment of this character—one that is the epitome of Whiteness for all characters in the play

regardless of their racial or gender identity—depends upon constructing innocence through tropes of fantasy.

Bullins offers a creative manifestation of the exact connection between fantasy and White innocence that John Oliver Killens describes in his earlier Black Arts cultural criticism. A novelist and essay writer, Killens provided important assessments of the state of Black art and set himself apart by being an important source of support for other artists during (and after) the Black Arts era. His 1965 essay collection *Black Man's Burden* is one of the most important volumes of nonfiction published during the time period. In the title essay, Killens explains that the "burden" he references entails disrupting the legacies of enslavement and colonialism that still shape laws, public policies, social relations, and artistic tastes.[13] Part of the goal of the essays involves shifting how U.S. citizens think about the history of social oppression. To make this point, he discusses the recurring portrayal of enslaved Blacks as content, nonconfrontational, and willingly compliant. This romanticized view of the past obviates any sense of social responsibility on the part of Whites and becomes a frame for casting aspersions on present-day activism by making ongoing discrimination and social hierarchies seem exceptional or without precedent. This thinking reflects a kind of fantasizing that becomes an act of innocence creation. In commenting on this situation, Killens insists, "most white Americans cling desperately to these wish-fulfillment fantasies, but most of us Negroes have become unbelievers" in the context of the U.S. sociopolitical landscape.[14] The concept of innocence lies at the base of these "wish-fulfillment fantasies," and Killens positions it as an imaginative construction on the part of Whites. In making this statement about the investment in innocence, Killens is not simply setting up a dichotomy in which Whites believe and Blacks do not. His word choice suggests that it is not merely that Blacks reject the idea, but rather that they do not deem the larger framework that makes possible such ideas as viable. By describing them as unbelievers, he situates Black artists as divesting themselves from the apparatus that would create this racialized innocence. Bullins places at the core of his drama an expression of Killens's notion of wish-fulfillment fantasies in his artistic construction of Whiteness. In explaining the dream, All Goode makes JoAnne a compliant and willing participant in her own victimization thereby erasing the fact of his transgression. This reliance on fantasy functions as the creative assertion of innocence.

Through the request that All Goode makes to tell this dream-laden tale, the reader gains an understanding of how Bullins is exploring the machinery of Whiteness. All Goode's desperate plea for the right to tell his story or plead

his case represents a desire to establish publicly his innocence. The demand itself indicates the centrality of the framework of innocence to the crafting of this character. However, Bullins goes further. Part of the character's goal in declaring his innocence is to rescue and safeguard his reputation. "Reputation" here functions as a reformulation of the rhetoric of innocence. He insists, "I'm only trying ta [sic] get what's fairly mine. . . . My good name! . . . I demand justice!" (150).[15] Regardless of the brutality of his alleged private actions, he asserts a right to an unblemished public reputation that, in his mind, JoAnne has no right to claim. The statement represents a strategic move that assures him access to an intangible identity attribute that would supersede JoAnne's own right to protect herself and testify on her own behalf. This right to reputation, to this intangible, can be read as a claim to the property of Whiteness. In discussing how American law has created and perpetuated an actual property interest in Whiteness itself, legal theorist Cheryl Harris explains, "Whiteness is not simply and solely a legally recognized property interest. It is simultaneously an aspect of self-identity and of personhood, and its relation to the law of property is complex. Whiteness has functioned as self-identity in the domain of the intrinsic, personal, and psychological; *as reputation in the interstices between internal and external identity*; and, as property in the extrinsic, public, and legal realms."[16] In its guise of reputation, Whiteness moves the parameters of identity from the private to the public blurring the boundaries between the two. Asserting a right to reputation entails claiming proprietary access to the public realm itself. The fact that All Goode bookends the assertion of reputation with a reference to justice within a play that is about a trial and criminal prosecution means that the demand itself is also a legal claim. The account that he gives at the end of act 1—the version that he has been begging JoAnne to allow him to tell—develops out of his desires for innocence and his anxieties about his reputation. The defining components of Whiteness are presented through Bullins's artistic inhabiting.

The shift from inhabiting the rhetoric of innocence to a more explicit contestation or disruption of it is registered through the structural division of the performance. Act 1 of the play builds up to the fantasy-based assertion of innocence and the claim for reputation, but act 2 of the play disintegrates the foundation of this rhetoric, rendering it defunct. At the beginning of the second act, the prosecuting attorney coerces All Goode into telling him what happened off the record. Contradicting the description of events at the end of the previous act, All Goode shamefully admits that he cannot recall what happened on the night of his death: "I don't remember nary a thing except

mah Johnson gittin' hard, me wantin' some of that black girl . . . and eh wakin' up dead" (161). He follows this confession with another several scenes later that features a second revision of the story. He makes this second confession (the third telling) as the judge who is presiding over JoAnne's trial, Judge Hopgood. Bullins has this character (and the same actor) perform as this court official to suggest visually that All Goode's sympathizers and supporters (perhaps even family) would ensure JoAnne's conviction. The character doubling visualizes the lack of justice. In the second confession, All Goode/ Hopgood declares having full knowledge of his actions and says that he acted as he did because of his racial privilege. He avers, "That gal is a nigger. White folks have always been better than them. So what's all the fuss about now? . . . I'm white. And when you white, ya right, right?" (170). Because he makes this confession as a judge on the seat of legal and state authority, "right" here connotes legally sanctioned. Bullins's decision to have All Goode play the judge is key. By having the character All Goode also play the judge and utter these ideas, Bullins positions Whiteness as the arbiter of guilt and innocence. He is *not* not guilty, but his racial identity removes him from the reach of the law. Therefore, All Goode through his identification with a historically hierarchical conception of Whiteness has an originary right to the framework of innocence. Even as he admits to his crime, he enacts an access to a claim of innocence.

Although the characterization indicates control and agency for All Goode, Bullins's directorial notes about the performance in the scene work to undercut the idea of White agency. Bullins has the character lose control of himself in the performance of this utterance. In the process of making this second, candid confession, the character becomes increasingly drunk. His speech is slurred, and he is hiccuping and giggling. Bullins's directions to the actor playing the part are meant to create a delivery that is unstable. As the character asserts his power as a White man, the performance becomes chaotic and clumsy. These confessions simultaneously enhance and undermine the identity-defining intentional declarations to innocence and expose the racial logics that underpin the law.

Bullins also manipulates the staging in the play to weaken the White claim of innocence. Whether reading or watching the play, one becomes aware that Bullins's drama is filled with retellings and reenactments of All Goode's murder. Eight recountings populate this two-act play: four versions of the course of events are told in the play (149, 161, 170, 172–74), and the events are enacted four separate times (140–41, 142–45, 156–59, 171). Most often when the events are reenacted, they occur behind a scrim that is lowered onto the

stage. A scrim is a stage curtain made of a net material that through lighting effects can create depth and can become invisible to allow upstage scenes to "bleed through" for the audience's viewing. It can be used to break up the stage by creating a division of the space thereby suggesting different locations or moments in time. Bullins relies heavily on this theatrical element for these purposes. When the violent encounter between JoAnne and All Goode is represented on stage behind the scrims, the audience sees silhouettes. It is a past event, a memory, and during the performance, this technical device reminds the viewers that the actions they are watching have different spatiotemporal coordinates from the rest of the action on the stage. More importantly, it is precisely because of the disagreement about the actual events, the fact that the truth is in question, that drives Bullins to employ the silhouetted scrim: it introduces uncertainty into the play visually. The enactments place the audience as eyewitnesses to a crime that they could never have seen. As witnesses to the multiple scrim presentations, the audience becomes involved in and ultimately complicit with the fraudulent court proceedings that they watch on stage.[17] The use of the scrim becomes a material element in the blurring of the line between political involvement and theatrical representation that the agitprop closet drama form demands.

Beyond introducing notions of uncertainty and complicity, the scrim materializes the concept of projection that Gerald links to Whiteness in her essay "The Black Writer and His Role." The play can be read as a series of projections. All Goode projects his own sexual desires onto JoAnne, which results in her enacting his fantasy on stage. He then describes her as projecting her fantasy of a Black superstud onto him. The Black stud image is always All Goode's image that he has created and falsely attributed to JoAnne. He projects his projection back onto himself, cloaking himself *and* JoAnne in his fantasy. The scrim manifests the precise projective logic of Whiteness; it is a theatrical incarnation of how Whiteness operates in making claims to innocence. The silhouetted scrim can shroud actions and bodies and can be used to manipulate what the audience can see and when; it offers to the dramatist/director a different kind of agency over the action on stage. Similarly, All Goode is able to obscure his own actions and physical desires and fallaciously attribute them to someone else while claiming innocence and agency in the process. Thus, the set manipulations on the stage enrich the play's investigation of White innocence.

By finding fault with All Goode's claims of innocence, Bullins is then able to launch a critique of all of the activists who rally for JoAnne. The controversy surrounding Little's actual case led to the rise of the "Free Joan Little

Movement." Following Little's surrender after Alligood's death, the Free Joan Little Committee was formed. There was a parade through Washington, D.C., and a rally on the court steps of the Beaufort County Courthouse, which was supported by the Southern Christian Leadership Conference. Black Panther Party members and important civil rights activists, such as Angela Davis, became prominent participants in the movement, attended the trial, and did extensive fundraising. More than $350,000 was raised for Little's defense by these supporters.[18] Because of the controversial events that led to the trial, Little became an important icon for Black activists, feminists activists, and individuals fighting for reform of the U.S. justice system. These exact figures become key elements in *JoAnne!!!* The drama consistently launches an acerbic assessment of these activists and their methods through negative allegorical portrayals:

> BLACK ACTIVIST, *rhetoric*: There are nearly a hundred people on death row here. JoAnne is only one case among many. Don't forget the thousands of other oppressed black and other female prisoners. It's one more step in the political process of oppression of black people, yes. But it is only one case.
> [...]
> WHITE ACTIVIST, *militant*: Women's Rights is the main issue here! If it had been a white women in this position, she may not have been brought to trial, true, but nonetheless, the Women's Rights issue is the supreme . . .
> BLACK ACTIVIST, *speechmaking*: The rape of the black female and its national political justification are tied to the image of the portrayal of the nigger man as bestial animal raping and taking white meat!
> [...]
> WHITE ACTIVIST, *saluting*: Power to the Bitches!
> BLACK ACTIVIST, *saluting*: Right on! (152–53)

For the Black activist character, JoAnne represents the hundreds of incarcerated Blacks and stands as an iteration of an embodied reimagining of public perceptions of the Black male. For the White activist figure, the title character is a means for advancing a conversation about women's rights and gender inequality in the social and legal spheres. Through these caricatures, Bullins finds fault with nationalist and feminist political activism. JoAnne all but disappears behind the empty rhetoric these stock characters employ. Because of these sentiments, Bullins has JoAnne declare "Don't make me a symbol" in the last moments of the play (175). The presentation of the femi-

nist activists in particular has encouraged readings of the play as being sexist.[19] Bullins may attempt a sympathetic view of JoAnne, but other women characters in the drama do appear as mere sexist stereotypes. He denounces the activist characters, who would use JoAnne's predicament for their own purposes, by rendering them flat, oversimplified, and arguably offensive. Part of what is remarkable (and perhaps ironic) about the disparagement of the activist figures is that Bullins's own artistic work also makes Joan Little a symbol through JoAnne. In doing so, he participates in that which he finds fault. Accordingly, Bullins self-consciously forces the reader to call his play into question. He uses *JoAnne!!!* as a means of critique and arguably situates it within the gaze of that same critique.

Bullins struggles in his play to disintegrate the rhetorical structure of White innocence, but in the process, he puts his work up for potential censure. Turning the civil rights case of the decade into art does not create a work that is without shortcomings. Ironically, the play approaches objectifying Joan and relying on stereotypes in its attempt to undermine an apparatus that creates distorted representations. Bullins inhabits Whiteness to deconstruct it but finds that he challenges the basis of his own artistic project, signaling the dangers of the technique of inhabiting. The dramatic project, like the rhetoric of innocence, is on the verge of collapse in *JoAnne!!!*. The terms of his assessment threaten to invalidate his dramatic method. One finds that the nationalist mission of inhabiting White innocence to critique it can participate in chauvinistic ways of thinking. Through the layers of theatrical experimentation in this play, Bullins defines Whiteness as a process of public fantasizing, and he situates the dismantling of this hegemonic process as a crucial political endeavor, to which other artists would also attend.

Media as Mirror

The Black Arts era strategy of inhabiting and disrupting the rhetoric of White innocence is a project that is attractive to different kinds of artists. I turn to philosopher and performance artist Adrian Piper to begin a discussion of how post–Black Arts cultural producers also employ this strategy. Piper is rarely discussed in relationship to the Black Arts era.[20] I situate her prominently in this discussion because much of her artistic output has concerned itself with undermining the social investment in racial hierarchies, challenging the circulation of White innocence within the public sphere, and exposing fantasy as the means to the formation of this innocence. Piper begins producing work during the 1960s, and there are many connections between her projects and

those of Black Arts era artists. Her work expands our understanding of the parameters of Black Arts material. The strategies that Killens and Gerald describe and Bullins enacts during the era find expression in Piper's work during and after this period. Two of Piper's art series are relevant to this contention: the *Mythic Being* (1973–1976) enactments and the *Vanilla Nightmares* (1986–1990) drawings. Including her art in this discussion advances the larger claim of this book that one can locate strategies of aesthetic radicalism in the work of artists one might not link to the Black Arts Movement. The move to discuss Piper's work also means putting in conversation different kinds of artistic productions: transitioning from drama to visual art. This step does not represent an ignoring of the real differences between genres or of the fact that distinctive kinds of art work differently. Instead, this move unveils the common methodologies that a range of artists employs in addressing radical political critiques. Considering multiple genres creates the possibility of gaining a deeper understanding of artistic culture as a whole. In the process, I attend to generic distinctions and formal dissimilarities that arise from artists' respective engagement of political discourse.

Piper's early 1970s *Mythic Being* series sets the stage for the work that she does in the 1980s *Vanilla Nightmares* discussed at length later. From 1973 to 1976, Piper performed and circulated photographs of a fictionalized persona that she called the "Mythic Being." In the performance, Piper walked down streets, rode buses, and sat in parks in New York City (and later in Cambridge, Massachusetts) wearing a mustache, Afro-styled wig, sunglasses, and sometimes smoking a cigar. In describing her presentation of this stylized persona, Piper explains, "My behavior changes. I swagger, stride, lope, lower my eyebrows, raise my shoulders, sit with my legs wide apart on the subway, so as to accommodate my protruding genitalia."[21] It is evident that this presentation self-consciously taps into popular conceptions of minoritarian masculine gender expression.[22] Accordingly, the *Mythic Being* project puts on display a specific and restrictive expression of minority (often Black) male gender embodiment. However, Cherise Smith points out that some of the Mythic Being ads portray the figure as an "androgynous, liminal, or third sex" being (53). By utilizing these male visual cues on the androgynous body, the performance calls into question the social reading practices that identify and characterize gender identity. One can understand this engagement of stereotypical representation not simply as a strategy of undermining a stereotype, but also as an attempt to expose the process of reading bodies. The audience for these exposing performances, to the extent that there was a specific audience, consisted of the people on the street or out in public that happened to cross the path of the Mythic Being. Piper submitted images of

the Mythic Being often with air-bubbled dialogue to the *Village Voice* newspaper that were printed on the advertising page so that the reading public as a whole became part of the target audience. These performances of stereotypes in urban, public spaces defy White innocence in a parallel way to Black nationalist confrontational attacks on White privilege and complacency.

The *Mythic Being* enactments and their newspaper presentations reflect the idea of confronting the zero image of Blackness that Carolyn Gerald elucidates. In regard to this zero image, Gerald says, "When we consider that the black man sees white cultural and racial images projected upon the whole extent of his universe, we cannot help but realize that a very great deal of the time the black man sees a zero image of himself" (352). Her argument is that the public sphere is populated with exteriorized White fear-fantasies of Blackness instead of images of Black people that are rooted in the complexity of emotions and experiences of this heterogeneous group. She employs the term *zero image* to indicate that this image is empty of any real reference to Black interiority; there is nothing there. Piper's creation is a crafting of public perceptions and expectations of racialized masculinity that has little to do with actual male identity. Stereotypical public conceptions about Black masculinity loom large in Piper's performance. Piper elaborates, "The Mythic Being is an abstract personality, a folk character. His history constitutes the folktale used to explain some current social phenomena, namely myself, my behavior, my relationships. As such it is a part of the common folklore and folk consciousness of all who read the *Village Voice*" (112). In calling the image an element of folklore, Piper indicates that it is a widely circulating and historical belief system that informs majoritarian perceptions of and encounters with minoritarian populations. The series forces the artist as well as the different audiences to confront this embodied perception. The *Mythic Being* project entails inhabiting the space of this zero image, becoming the White projection in order to make sense of its functioning and weaken its power, demonstrating the strategy of disruptive inhabiting. Piper extends a Black Arts conversation about the nature and function of Black art.[23]

The series of charcoal drawings that constitutes Piper's *Vanilla Nightmares* series picks up where the *Mythic Being* series leaves off and provides a deeper exploration of the rhetoric of White innocence. This later series focuses on "the deep fears, anxieties, and fantasies about blacks that lurk beneath the surface of rational concept formation and language in racist consciousness" (253).[24] The series visualizes the nationalist contention that anti-Black racism lies at the base of U.S. public culture, as the Student Nonviolent Coordinating Committee 1966 position paper on Black Power indicates. The title "vanilla nightmares" derives from the term *vanilla sex*, which Piper defines

as a phrase used by those on the sexual margins to describe conventional heterosexual sex acts between two consenting adults. Ostensibly, the series stands as the visual representations of the fears of those who have vanilla sex. The adjective *vanilla* is meant to evoke conceptions of Whiteness along with heteronormativity. That being said, the immediate context for the series is the 1980s Reagan era with its embrace of corporate investment and Wall Street–focused capitalist culture in which unrestrained greed is a socially sanctioned dictum, which the 1987 Oliver Stone film *Wall Street* exemplified in popular culture.[25] The series of drawings reflects a response to an economic environment that encouraged social segmentation and widespread economic disparity. Such social inequality was often expressed in racial terms in the media, and Piper makes visual the link between economic anxieties and racialized sexual fantasies.

In creating *Vanilla Nightmares*, Piper selects pages out of the *New York Times* to use as a canvas. She chooses to use this paper because of the fact that it is held in high esteem, because of its authoritative sense of itself and what it covers, and particularly because of its high circulation.[26] This treatment of the newspaper page is an outgrowth of her earlier use of the *Village Voice* ads and marks a continued interest in the artistic manipulating of the means by which ideas and belief systems spread through the public: the media. However, the choice of newspaper as a canvas is significant for other reasons. Newspaper as a surface presents particular challenges to an artist, especially one using a charcoal pencil. The surface of the material is given to smudging and can be difficult to overlay with color because of the print and the paper's propensity for tearing. In addition, charcoal as a material tends to smear and dust-off in the process of drawing so that it is difficult to maintain the integrity of the image being drawn. Charcoal drawings are often finished with a fixative to preempt damaging smearing. (As a matter of course, charcoal is more often used in preliminary drawing and sketching than as the method for a final piece.) This choice of process suggests instability and even mutability, concepts that the drawings carry with them.

Throughout the series of twenty drawings that make up *Vanilla Nightmares*, Piper attempts to unearth the racial and sexual subliminal content that circulates along with the news from influential and (allegedly) objective media such as the *New York Times*. Piper creates from the standpoint that this piece of mainstream media she incorporates into her art is not simply a vehicle for the nation,[27] but also a vehicle for a racialized rhetoric of innocence. Her goal is to destabilize the racial logics that buttress the U.S. nation-state, and the

instability of the process itself indicates a move toward destabilizing controlling images. In her work, denial and erasure become elemental features of the rhetoric of innocence, and this rhetoric takes on a performative value, which develops out of the of notion projection.

Linking together issues of consumerism and identity, *Vanilla Nightmares #3* is illustrated on a Bloomingdale's advertisement for a women's clothing line called "Street Safari."[28] The ad consists of images of White women wearing elements of clothing that might be suitable to extremes of temperature and accessories such as a water canister and a whip. The line itself is designed around the fantasy of transporting the mystique and adventure of a presumably early-twentieth-century African safari into the metropolitan, urban space of contemporary New York City. More importantly, one can infer that simply by wearing these clothes, one will be able to partake in this sense of adventure; it is an experience that the consumer hopes to buy. Piper's page choice reflects her recognition of a particular fantasizing at work in the construction of the public sphere world of advertising.

That which is implicit in the Bloomingdale's ad, that which greatly contributes to the exotic and extraordinary nature of the safari experience, is the Black body itself. Guides, trackers, translators, and personal assistants were and continue to be Black people in many African countries. Seeking to bring out this reality, Piper draws in the bust of a menacing-looking blackened figure behind the printed images of White women appareled in their "Street Safari" gear. The figure represents an abstracted, negated image, and her choice makes plain the racialized construction of the exotic. The presentation of thick dark knuckles—which seem to jump out at the viewer—around the White model's neck is an explicit move to conjure images of the cinematic creature King Kong. This figure has been a symbol of exoticism and monstrosity since he first appeared on screen in 1933.[29] This visual allusion analogizes the figure that Piper draws in to a beast and also suggests its menacing nature. The advertisement becomes a presentation of the familiar trope of "beauty and the beast." This highly recognizable fairy tale construction can appear as innocuous as an advertisement, but it is drenched in social conventions in regard to understandings of race. It is this lurking body that exists under the (black) ink on the page and latently in the minds of the viewers of the ladies' clothes that Piper seeks to bring out with her charcoal pencil. The figure's body lies literally underneath the images of the White women. Piper is also careful to contour the outline of his face around the text of the ad so that it appears to be written upon him;

Figure 1. Adrian Piper, *Vanilla Nightmares #3*, 1986. Charcoal, oil crayon on newspaper, 25 3/8 × 13 7/8 inches. Collection of the Walker Art Center, Minneapolis. T. B. Walker Acquisition Fund, 2004. © Adrian Piper Research Archive Foundation Berlin.

accordingly, he also lies beneath the words on the page. Yet, his body takes over the page dominating the ad. In conversation with the images from the original ad, the drawing recognizes a desire for the mystique and exoticism of a safari without a commensurate acknowledgment of the racial and class dynamics that such an experience would entail. Piper's drawing unveils a process of erasure at the same time that she makes visual racist conceptions of Blackness in order to unsettle that erasure. Further demonstrating the significance of her technique, Piper's charcoal pencil process itself suggests the ironic erasability of the figure—the same figure through which she is able to undermine acts of social erasure of the Black body that take place in advertisements. In Bullins's play, Al Goode creates a fantasy that masks his own action in his first confession; he erases his own culpability through this fantasy. Throughout her series, Piper documents comparable acts of erasure that circumvent culpability or involvement in racist frameworks. The rhetoric of innocence emerges through these acts of erasure.

Part of what Piper accomplishes in drawing in the dark figure is an expression of the idea of Black abstraction, which Thomas Ross theorizes alongside the notion of the rhetoric of innocence. Ross explains that such racialized abstraction "is a rhetorical deprivation of the black person in an abstract context, outside of any real and rich social context" (6). This conceptual method of removal and simplification allows for the remaking of the context in which one's choices play out and makes it possible for one's choices to be less troubling and without negative ramifications. The effect is that the Black subject becomes a phantasmatic device for the construction of White identity. In the process, this subject is forced to "occupy the shadows, the periphery" of the realm of personhood (38). The connection that Ross makes between enigmatic darkness and periphery is relevant to Piper's work. The dark coloring of the figure is not only a sign of melanin-rich skin, but it is also a visual indication of this spatial location of marginalization. The eruption of the dark figure on the page of the advertisement functions as an acknowledgment of Black abstraction itself and how it is at work in the marketing of these clothes. Piper attempts to make visible the process of Black abstraction here and throughout the series. This abstraction is intimately connected to the articulation of White innocence.

Piper's investigation of the racialized fantasy of travel that emerges in #3 is made even more explicit in #6. This piece is made from an advertisement of American Airlines' fares to the Caribbean, and it features a White couple sunbathing on an empty beach. Situated above this idyllic setting and taking up a majority of the 14 × 22–inch page is a poster of information about the airline's flights to Caribbean island nations all for between $299 and $369,

including hotel, roundtrip airfare, and a rental car for twenty-four hours. The phrase "get carried away" is italicized at the bottom of the listing. This phrasing is meant to encourage people to travel, but it also intimates that there will be exciting and unusual diversions to be experienced. The islands that are listed as being on the possible itinerary include: Puerto Rico, Haiti, Aruba, Trinidad and Tobago, Guadeloupe, Dominican Republic, Martinique, Barbados, St. Thomas, Antigua, St. Croix, Curacao, St. Maarten, and Jamaica. Heading this information is the title "AAmerican's Caribbean," as two *A*s are the common abbreviation for the airline. This title is meant to indicate the islands to which the airline flies; however, the construction of the phrase is evocative, and Piper chooses this particular page for this reason. The heading suggests both U.S. ownership and economic imperialism: America's Caribbean. Metaphorically, the ad itself situates a White, heterosexual couple as the benefactors of this imperialism.

To accompany the White vacationing pair, Piper draws in the outline of two naked men, both with erect penises. Each aroused man is caressing one member of the White couple. Neither of the charcoal figures looks at his "intended." Instead, like the menacing figure from #3, each one shifts his gaze outward to the viewer, bringing her into the scene and making the viewer the object of this gaze and of the desire. The cliché "get carried away," which is intended to encourage the reader of the ad to patronize the airline, takes on additional loaded levels of meanings through its location directly above the center couple in Piper's drawing. It is the image of the naked male figure straddling the White man (who looks to be deeply satisfied) that could be deemed the most "deviant." Here the viewer is confronted with not only the threat of (possibly unwanted) sexual aggression and interracial intimacy, but also the danger of homosexuality—from a heteronormative standpoint. That which the original ad absents are the actual bodies of the local men and women who live on these islands throughout the year and, importantly, will be serving, cleaning up behind, and possibly gratifying the White bodies that choose to "get carried away" to the Caribbean on American Airlines.

It is important to note that unlike in #3, these figures are charcoal outlines; they are shaded, but not colored in fully. The fact that these figures are not filled in with the charcoal but are outlined and then carefully blended is relevant here. Piper avoids drawing the full bodies of the figures, choosing instead to give each a haunting presence as they lurk above and beside the couple. The outlines here suggest a completely different visualization from the shadow-perimeter connection that informed the crafting of #3, but this alteration still contributes to the piece's involvement in Black abstraction. As Ross explains it, abstraction has to do both with the transformation of

Figure 2. Adrian Piper, *Vanilla Nightmares #6*, 1986. Charcoal drawing on *New York Times* page from Sunday, June 22, 1986. 22 × 13 7/8 inches (55.8 cm × 35.2 cm). Collection of the Adrian Piper Research Archive Foundation Berlin. © APRA Foundation Berlin. Photo Credit Andrej Glusgold.

a material subject into an idea and with the removal of complexity. It is this second meaning that informs the representation in *#6*. The phantom or ghostly presence achieved through the purposeful refusal to "color" in the bodies functions as a reflection of the figures' being absented or abstracted from the social rhetoric of travel. They signify an alternative representation of the notion of Black abstraction. Piper's artistic move mimics the operational function of Whiteness as Ross details it.

In reading *#3* and *#6* together, one can recognize how outlets of the (White) media create fantasies through simultaneously erasing and suggesting Black bodies. Piper's drawings suggest the idea that there is a spectral Black body that lurks within and helps to constitute the communal fantasies that the advertising companies are tapping into to market their products. In this sense, racist constructions exist within the inner-workings of public media and the social imaginary. In a commentary on *Vanilla Nightmares*, Piper explains that racism "expresses fear of conquest; it is an admission of and an overreaction to feelings of powerlessness. It thereby expresses a fear of the violation of boundaries, of invasion, of penetration—of geographical or political boundaries in the limiting case; of physical and psychological boundaries more fundamentally" (253). The fear of violation is evident, but *Vanilla Nightmares* illustrates that this same fear, or subliminal concern, can be used to erect boundaries of identity as well. The reason that advertising pages are chosen by Piper is because consumer advertising depends on constructions of race and sexuality that are rhetorically denied through absenting.

The later drawing *#18* goes further to involve the viewer and invoke constructions of agency that are crucial to the willing of innocence. Instead of the viewer being subject to one set of eyes, there are dozens. In this drawing, it is difficult to make out the newspaper page itself because Piper has drawn in a sea of dark faces looking out in desperation at the viewer. The faces could be read as male, but they are relatively androgynous with no hair. In the foreground, the viewer sees full faces, but the faces become hidden by the multitude of other heads until all that is visible are ridges of foreheads by the time one's eyes reach the background. Flattened hands face out and the knuckles compress against the borders of the bottom of the panel making these faces appear to be trapped or locked behind an invisible screen out of which we the viewers look. Instead of using the pages of the newspaper or an advertisement itself to create the meaning of the piece, the viewer is forced to concentrate on these enclosed faces.[30]

In terms of its composition, *#18* is eerily reminiscent of a 1963 abstract acrylic painting by Reginald Gammon called *Freedom Now*. In this painting, Gammon copies and transforms photographic journalist Moneta Sleet's

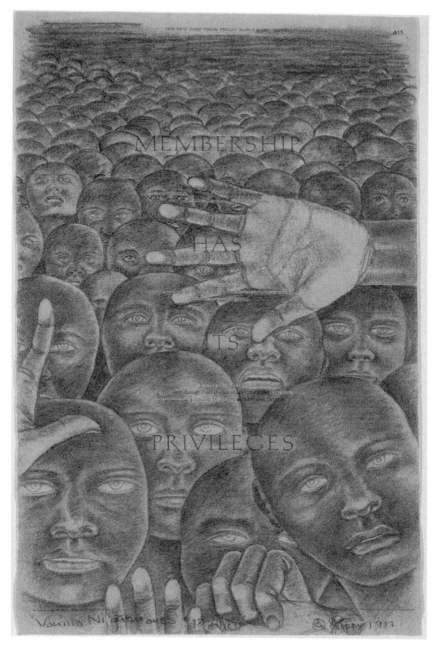

Figure 3. Adrian Piper, *Vanilla Nightmares #18*, 1987. Charcoal on newspaper, 22 3/16 × 13 11/16 inches (56.3 × 34.8 cm). Williams College Museum of Art, Williamstown, Massachusetts, Gift of the American Academy and Institute of Arts and Letters, New York; Hassam, Speicher, Betts and Symons Funds (91.5). © APRA Foundation.

black-and-white photo of the March on Washington. Exemplifying the idea of aesthetic translation of political matter, Gammon takes a photographic image of political action and converts this visual documentation into a painting. *Freedom Now* was a part of the critically acclaimed Spiral *Black and White* show at the Christopher Street Gallery in New York, which featured African American artists exhibiting work on the Civil Rights Movement, all of which was done in shades of black and white. Linking together artistic and political questions, the show offered artists the opportunity to employ similar artistic strategies as they reflected on the multifarious dynamics of radical activism and U.S. racial constructs. The visual plane of Gammon's painting has two main sectors roughly divided by an ostensible horizontal: a lower half or foreground made up of protesting faces and an upper half or background made up of the legs of marchers. The top half offers a more literal rendition of Sleet's photograph, while the lower half presents expressionistic and depersonalized faces of anger, frustration, and despondency. This visual presentation illustrates that Gammon is less interested in a realistic rendering of the marchers than in a re-creation of the sentiments being expressed that may or may not have been captured by the work of the photojournalist. The complexity of meaning apparent in the faces indicates (1) a lack of homogeneity in this group of figures and (2) Gammon's foregrounding of the differing affective responses that constitute the mass in the painting and the faces in the original photograph.

The faces, which are crowded into Gammon's frame, prefigure Piper's contorted faces in *Vanilla Nightmares #18*. Both Gammon and Piper revise or restructure imagery to comment on the U.S. sociopolitical situation through a monochromatic palette. Arguably, there is no more dominant, albeit oversimplifying, metaphor for race relations in the United States than "black and white." Piper's decision to rely on a black charcoal pencil is a playful manipulation of the black ink of the newspaper that is analogous to Gammon's treatment of the black and white appearance of Sleet's photograph. Moreover, her method also taps into popular conceptions of racial rhetoric just as Gammon's does. By situating Piper's work in relation to Gammon's, the viewer is able to appreciate how both use their artwork to manipulate the affective meanings that get contained within or muted by media forms associated with allegedly objective documentation (photography and newspapers). Both artists question how meaning and form get inscribed into archival objects, and both do so through imaging the abstracted Black body and calling on the connotative meanings of black and white.

In considering that which gets documented in *#18*, it is vital to recognize that four words emerge from beneath the faces in this drawing: "Member-

ship Has Its Privileges." Piper creates the drawing so that the viewer sees the faces before she sees the print; once the viewer sees the faces—the obscuring blackness and distorted figures—she then realizes the meaning of the words that emerge from beneath the anonymity and distress. The expressions on the faces on this page do not reflect any sense of privilege or advantage. The privilege or benefit expressed by the emergent words is not having to belong to or not being imagined as among the contorted, suffocated faces drawn on this page of the *New York Times*. It is Whiteness that is not depicted on this page; in fact, not even the actual pallid color of the newspaper page is apparent in the drawing. The vanilla nightmare, then, is not simply the idea of having to face a Black sexual beast, but rather to find oneself located *within* this blackened page instead of having the luxury of being a viewer. This ability to will oneself as being outside of the boundaries of this blackened "nightmare" and uninvolved with the forces that created it helps constitute White innocence.

To some, Piper's decision to draw in these ominous, beast-like Black figures might appear to be less than radical because of the potential for the series to perpetuate stereotypes or negative racial images. This conclusion might be reached especially when *Vanilla Nightmares* is compared to the earlier *Mythic Being* performances, which sought to confront White people with the constructed stereotype. However, this idea obscures the complexity of her method of disruptive inhabiting. Piper's goal in the later series is to shed light on the ongoing investment in racial constructs throughout the social world. Only by exposing these stereotypes and the hold that they still have over the social imaginary can they be exorcised and their power diminished. She, like the other artists discussed here, chooses to inhabit social concepts to offer critiques of them. The possibility of having her work read as reactionary is the risk of her critical strategy—just as Bullins's work verged on objectification and stereotype. The situation is a result of the inhabiting critical practice. The aim in this strategy is not to perpetuate limiting conceptions of Black identity but to expose their ubiquity. Piper's menacing figures can also be read as an attempt to create a Black gaze that returns and disrupts the structuring White gaze of the viewing public. It is precisely for this reason that so many figures stare out at the viewer. In this sense, Blackness occupies the position of the subject of the gaze instead of the object created by a racializing gaze that undergirds White innocence. Piper visually attempts to reroute the creation of social meaning through these seemingly threatening figures.

If one regards this series in relation to Piper's earlier public enactments and artistic performances, it becomes evident that her point in the *Vanilla Nightmares* series is that the imagining that goes on in the presentation of

the conceptual matter of newspapers is in part a performance. The imaginative, willful leaps that help to form Whiteness are also performatives in that they seek to create that which they describe. John Bowles argues that Piper's early 1970s staged tableaux and performance projects theatricalize racism and seek to put the audience and their beliefs on display (8–11), and this understanding is also present in the *Vanilla Nightmares* series of the 1980s. This later series enacts a performance on the page that mimics how the *New York Times* audience both creates White identity and employs Black identity. Her drawings attempt to capture an act of creation that is also an act of erasure. In documenting this performance, Piper seeks to initiate a transformation in the audience whose actions the work imitates. In a 1970 short essay "Art as Catalysis," Piper insists, "[one] reason for making and exhibiting a work is to induce a reaction or change in the viewer"; she continues, "[the] work is a catalytic agent, in that it promotes a change in the entity (viewer)" (32). Thus, it is the viewer that is Piper's concern in her early commentaries on her art. She is focused on how to change the audience here, but her later work also demonstrates an interest in investigating how the audience or viewer constructs meaning through racial matter. The artistic drive to transform the viewer develops into a concern with the viewer's thought process. The 1980s series of drawings that I discuss expands Piper's earlier conceptualization of art as a catalytic agent and in doing so contributes to an ongoing conversation about the social operation of Whiteness within the Black imaginary. The series demonstrates that the rhetoric of innocence is not simply to be understood as a claim of innocence as is the case in *JoAnne!!!*. Instead this rhetoric encompasses a performative process that seeks to create White subjectivity through the denials and erasures of action and knowledge. By unveiling the erasures and denials that exist within the logic of the news media, *Vanilla Nightmares* exposes an implicit rhetoric of innocence.

Throughout *Vanilla Nightmares*, Piper visualizes how racist logics are embedded in the public sphere and make possible the individual articulation of identity. Her artistic work resonates with and anticipates John L. Jackson's later theoretical work on understandings of race in contemporary U.S. culture. Jackson explains:

> In the decades following the civil rights movement, a new paradigm of race relations has arisen from the smoldering ashes of de jure and de facto racisms. Not only have legislative and economic discrimination—segregation and physical coercion or violence—predicated on race been explicitly outlawed, but statements betraying any personally held racial biases are altogether un-

acceptable in most of the public sphere. As a result, explicit racism has gone underground, at least partially, relegated to people's hearts and inner thoughts. To define oneself publicly as a racist, to claim that identity and commitment to older forms of blatant racism, is to embrace one's place on the fringes of society. . . . The era of *de cardio* racism of a racism banned from the public sphere and reimagined as snug within the inaccessible hearts of other people, requires new methods of analytical engagements, methods far from anything we've ever used to make sense of the racial ties that bind us together.[31]

He develops the idea of *de cardio* racism to describe a social setting in which racist actions have been mostly eschewed and repudiated publicly while racism still operates as a dominate means of navigating the public arena. The language of *de cardio* (of heart) metaphorically suggests the realm of feelings, but the internalization at the core of the concept also has much to do with thinking. His point is that racism serves as a force that structures how people think and interpret the world around them even in an ostensibly antiracist social political climate. The concept of *de cardio* racism aids and abets a different kind of claim of innocence. If racism has been delegitimated legally and made socially unacceptable, one might conclude that racism as such has ceased to operate. This conclusion obscures how racist ways of thinking subtend the mechanisms of the social world or the actions of individuals. Jackson concludes by insisting that this new form of racism that secures social innocence vis-à-vis discrimination and inequality necessitates "new methods" for navigating this Post–Civil Rights predicament. Piper's series, which unearths ongoing investments in racist thinking, stands as a creative approach to supplying such a method.

The work of creative artists is crucial for coming to terms with the changing mechanisms of race thinking that Jackson describes.[32] More importantly, Jackson's analysis reveals the extent to which the claim of innocence still undergirds the conceptual framework of U.S. White identity in the twenty-first century. By employing newspapers as the source and substance of her creation, Piper's art illustrates how this idea works in a general way. She identifies an extensive recurring pattern of thinking that involves the body politic as a whole.

Willing the Self into Being

To close this chapter, I turn to poet Cornelius Eady, who moves from the general to the particular in identifying a historically specific instance of the claim

of White innocence that relies upon the kind of Black abstraction that Piper teases out in her art. The focus in his work is on the individual as opposed to state institutions or the public sphere showing the extensive saturation of this imagery in U.S. culture. In the poetry collection *Brutal Imagination* (2001), Eady converts a racialized national news story into art just as Bullins had done decades before. He elaborates the complex social dynamics that undergird conceptions of Black and White identity within public media that Piper scrutinizes and the significance of performativity to this matrix. The movement from visual art to poetry is significant. Considering Piper's work helps to reveal the process of visualization that is crucial to Eady's poetic sequence, and the poems make clear the implicit rhetorical strategies that underpin *Vanilla Nightmares*. One better appreciates the particular generic achievements of each artist when each respective work is put in conversation with that of an artist addressing similar questions but working in a different genre. More importantly, Eady combines Bullins's and Piper's respective strategies to unsettle the rhetoric of White innocence, and he translates these strategies into his poetic sequence *Brutal Imagination*. Similar to Bullins, Eady focuses on the social implications of the events that led to a specific trial and the legal claims of innocence used to buttress and protect White characters. In the process, Eady's project mirrors Piper's by illustrating how fantasy is fundamental to the social logic of racism, but he shifts emphasis to the singular rather than the collective imagination.

Published in 2001, *Brutal Imagination* explores the events that led to the trial and conviction of Susan Smith. On Thursday, October 25, 1994, Susan Smith of Union County, South Carolina, alleged that she was carjacked by a Black man in a knit cap and that this carjacker took with him her two sons Michael and Alex who were sitting in the back seat of the car. This allegation launched a nine-day search for the missing boys, the car, and the assailant and a media blitz around Susan Smith. On November 3, Smith confessed that she had driven her car into a lake, killing her two young sons.[33] Smith invented a Black man to cover up her own crime, and Eady translates this invention, this act of racialized creation, into a cycle of poems. What Eady actually presents in his work is his own imagining of this White figure imagining a Black figure; he inhabits this White persona that is involved in the veritable creation of Black identity. The poetic cycle is as much about conceptions of Whiteness as it is about conceptions of Blackness. Eady's decision to work in the form of a cycle, a series of poems that reflect on the same subject, is worth noting. A poetic cycle allows for a continual rumination on a topic, while also emphasizing the concepts of perspective and angles of vision. This

cycle keeps returning to and repositioning tropes of visibility and invisibility as well as the notion of mediation as it investigates the rhetoric of White innocence.³⁴ Eady explores how Smith's claim of innocence relied upon willing Blackness into being.

Eady posits a fused, composite identity of the speaker from the opening poem "How I Got Born."³⁵ There is an intrinsic connection between the speaker of the poem—who is later referred to as Mr. Zero—and the Susan Smith who summons him. Eady's decision to refer to the imaginary Black assailant as "Mr. Zero" is especially relevant. It connects this portion of the discussion to Gerald's description of Black subjectivity as having a "zero image" in the public sphere. The name *Zero* suggests the lack of identity and a reduced, abstracted existence. In "How I Got Born," the first-person singular that is used in the title and in the first three stanzas becomes plural by the last stanza: "When called, I come. / My job is to get things done. / I am piecemeal. / . . . / *We* arrive, bereaved" (5; emphasis added). This movement in number recurs throughout the cycle, so it is difficult ever to separate fully the persona Susan from the imagined Mr. Zero. In calling himself "piecemeal," Zero is reminding the reader that he is invoked for particular circumstances—he does piecemeal work (incident by incident), while also alerting the reader to the fact that he is fragmented. In addition, he has no visual existence outside of a composite drawing that was made of him, which was made feature by feature, piece by piece.

The next poem "My Heart" works to explain who this speaker is that is so closely connected to the figure Susan Smith. "My Heart" holds a significant place in the collection because of the loaded image it calls to mind. Eady's choice of title is useful in his project because in her actual written confession, Smith drew in images of hearts instead of writing the word *heart*.³⁶ Therefore, the image of a heart itself conjures up Smith's complicity by alluding to the idiosyncrasies of her confession, while simultaneously reinforcing the importance of image making to this persona (and the actual person):³⁷

> Susan Smith has invented me because
> Nobody else in town will do what
> She needs me to do.
> I mean: jump in an idling car
> And drive off with two sad and
> Frightened kids in the back. (6)

The colon after "I mean" in the fourth line is used to show that the actions that follow are instances of what Susan "needs [him] to do." The colon in this

line also suggests an equation between the two elements of that line such that what the speaker, Zero, means or signifies himself is action. He is not a being but mere action. Susan effectively claims the right to create another identity for herself or for these actions that she does not want to acknowledge publicly; his actions create the possibility for her innocence. She is able to make herself and her actions unseen and in doing so ensure her own existence. This process describes how Whiteness functions in Eady's mind: it makes itself invisible to ensure its presence. In enabling Susan's innocence, the phantasmatic Zero represents the conceptual manifestation of *both* the rhetoric of innocence and Black abstraction.

The poems ends with the line "Everything she says about me is true," and this sentiment reflects the idea that the racialized act of creation of Zero is an act of catachresis. In falsely attributing her actions to Zero, Susan does misname her actions and herself for self-preservation. Such misnaming is also apparent in All Goode's description of the Black stud as JoAnne's sex partner. This instance of catachrestic misnaming illustrates how Whiteness performs itself as Blackness here. Historian Lerone Bennett Jr. emphasizes this exact technique in characterizing Whiteness in his 1965 essay "The White Problem in America." Bennett argues, "There is no Negro problem in America. The problem of race in America, insofar as that problem is related to packets of melanin in men's skin, is a white problem. . . . It was a stroke of genius really for white Americans to give Negro Americans the name of their problem, thereby focusing attention on symptoms (the Negro and the Negro community) instead of causes (the white man and the white community)."[38] Bennett's comments reveal how catachrestic misnaming encapsulates the historical operation of Whiteness and suggest the appeal that Whiteness as a construct can have to a literary artist. This process of false attribution that Bennett elaborates functions as the key rhetorical and poetic device throughout Eady's cycle.

This rhetorical device can be understood as one that is rooted in agency or willfulness. To misname oneself is a willful act not only because of the move to redefine independently one's subjective space, but also because of the forceful assumption of the structural mechanisms for naming. Therefore, catachresis is the ideal apparatus for illustrating and exposing the operation of Whiteness, with which both Bennett and Eady concern themselves. As Bennett indicates, misnaming is also an act of projection, and such characteristic acts of projection also lend to Whiteness a performative quality. Therefore, catachresis itself as a rhetorical device has performative potential.[39] Because the problem of misnaming lies at the crux of the *Mythic Being* enactments, Piper's work similarly illustrates how catachresis can move easily into the

realm of performance. In addition, Bullins's work is itself a performance, and his theatrical techniques allow him to emphasize the performative nature of the false projection of White innocence. Thus, the rhetorical device of catachresis is one that is elemental to the framework of innocence as Bullins, Piper, and Eady each examines it. Bennett's thinking demonstrates how social and political thought of the Black Arts era advanced critical assessments that creative artists would transform into a rhetorical device.

Recognizing the poetic functioning of catachresis helps to unveil an invisibility here that makes itself present through a process of imaging. The poem "Susan Smith's Police Report" develops out of this irony. The purpose of such a report, particularly one that is to be used in legal proceedings, is to recount verbatim what one sensed (saw, heard, smelled, etc.) in a given situation to recreate the scene for someone who was not present. Here it serves as an account of what the Susan figure experienced during the crime. In the poem, the reader finds that the imagery indicates that the man that Susan described cannot be effectively detected by any modality. The poem uses synesthetic descriptions and images to make this point. In this poem that attempts to recreate the police report, Zero's fingers are described as having "Barked the unlocked door open" and the "sight of an indifferent moon" becomes the sound of his voice. The confusion of the senses that the poem presents—fingers making dog sounds and the sound of a voice being heard as an image—indicates that nothing was directly sensed at all. How can one make sense (or sensible) that which was never sensed in the first place? As the poem indicates, this is the purview of metaphorical figures of speech. The metaphorical and catachrestic descriptions betray the fact that the man that Susan's report describes is an imagining. He only exists in the terms of something (or someone) else. The poetic police report here inadvertently acknowledges the reality of Zero's nonexistence.

The cycle also insists that this nonexistence can only be a male or masculine nonexistence. The poem "Why I Am Not a Woman" questions: "How far do you think we'd have gotten / If I'd jumped in her car, a car I wanted / For who knows what, / A woman, / And not noticed the paraphernalia?" (18). The argument here is that Zero could not have been a woman because a woman would have noticed that children must have been in the car from the "paraphernalia"—here "child" is connected to this word instead of the more recognizable "drug." The ironic undercurrent of the poem is the fact that Zero, as was already explained, is a woman: Susan Smith. The two are inseparable though not identical. In Eady's mind, the fact that Smith does not and cannot claim Zero to be a woman derives from an intrinsic understanding of Black female gender identity. Following popular welfare-mother

conception of Black womanhood, Black women are only criminals in their motherhood and are less readily imagined as violent criminals.[40] Racialized gender ideologies enter into the poetic cycle here in a different way. Susan is not only creating Zero, but this poem shows how she is indirectly perpetuating particular public notions of Black womanhood through her creation as well. This poem that sets itself out to be an explanation (answering the question "Why I Am Not a Woman?") is actually more of a long rhetorical question in that it is always relying on widely held (White) conceptions of Black male and female identity and capability.

The complicated levels of public and private signification of Zero in the cycle as a whole are fully expressed in the poem "The Law." Structurally the poem parallels the thematic confusion of identity. "The Law" illustrates that the speaker is real and imagined, Black and White, man and woman. Eady establishes a structure for the poem in which the first four stanzas switch from asserting Zero's Black maleness to his implicit White maternity. The opening of stanzas 1 and 4 concern the speaker's racial identity ("I'm a black man," "I'm black"). The first lines of stanzas 2 and 3 change to declarations of motherhood ("I'm a mother"). This switching of perspective is not an alternation but an inversion. The arrangement does not go Black man–mother–Black man– mother; it goes Black man–mother–mother–Black man. Eady pivots after the second stanza and provides a mirror inversion of the assertions in the first two stanzas. This structural reversal of the ordering is important for two reasons. First, it suggests the confusion in person between Zero and Susan: she appears in the poem where he should and vice versa. Second, this inverted parallelism undermines the coherence that seems to be established by the stanzaic division between Black maleness and White maternity. This chiasmatic structure moves the reader to the penultimate stanza, which concludes: "I float in forces / I can't always control." There is a loss of stanzaic integrity by the seventh stanza, which manifests the idea of the loss of control. The shifting and alternation in the opening of the seven stanzas mirrors the movement suggested in this statement about floating. Moreover, the fact that the fifth stanza breaks the pattern further by talking about racial identity and motherhood together demonstrates that the control that is seemingly established in the structural repetition is lost; the stanzaic movement also cannot always be controlled. One underlying component of the conception of Blackness offered in the "interrupting" stanza is that there is no agency imagined in Blackness or those who are Black. Zero himself summons agency for Smith, but as a surrogate, he has none since he is only words as the final line of the poem suggests: "I'm only as good as my word" (17).

It is significant that these considerations of being and agency arise in a poem that Eady titles "The Law." The poem is not about law or legality per se, but rather about social conceptions that shape beliefs and behaviors— conceptions present in Smith's imaginings of Zero. As the line about floating suggests, the notion of will (Black and White) is fundamental to the poem and the cycle as a whole. In discussing the interactions of race and legal discourse, Patricia Williams insists, "[there] is a great power in being able to see the world as one will and then to have that vision enacted."[41] That which Williams describes is precisely what Eady catalogs in his poetic series about Susan Smith. Whiteness and White characters are imagined as being endowed with this power of willfulness in Eady's poetic work and in Williams's critical analysis. This connection comes out most effectively in one of Williams's vignettes about polar bears, which recur in the text:

> My mother's cousin Marjorie was a storyteller. From time to time I would press her to tell me the details of her youth, and she would tell me instead about a child who wandered into a world of polar bears, who was prayed over by polar bears, and was in the end eaten. The child's life was not in vain because the polar bears had been made holy in its suffering. The child had been a test, a message from god for polar bears. In the polar-bear universe, she would tell me, the primary object of creation was polar bears, and the rest of the living world was fashioned to serve polar bears. The clouds took their shapes from polar bears, trees were designed to give shelter to polar bears, and humans were ideally designed to provide polar bears with meat. (228)

Cousin Marjorie uses the technique of storytelling to discuss her impressions of her life as a Black woman in a highly racialized world without having to talk about specific details or events. The bears in this story see every element and being in the world around them as existing for their benefit. If indeed this world is the one that she has known, it is a world in which meanings have often been imposed on Cousin Marjorie's person. The bears have done no wrong in eating the child because they imagine her as designed for their consumption. They reckon away any culpability.

The polar bears are embodiments of Whiteness literally and figuratively, and these embodiments are constructed around notions of will in the fabular thinking of the quotation. Discussions of will and will-lessness or antiwill form the actual context for this fable in Williams's text: "I realized that one of the things passed on from slavery, which continues in the oppression of people of color, is a belief structure rooted in a concept of black (or brown or red) anti-will, the antithetical embodiment of pure will" (219). The connection that this

legal scholar makes between Whiteness and willfulness (or Whiteness as the desire for agency) characterizes the works that I have discussed as well. These artists conjure and inhabit White innocence in different genres over time to formulate a discourse on will in relation to Black subjectivity, a discourse that would be elaborated on and advanced by Critical Race theorists. Their shared use of fantasizing Whiteness functions as a strategy for commenting on the possibilities for and boundaries of agency for raced subjects. As opposed to simply claiming an oppositional "willfulness" for Black subjects, these artists inhabit different expressions of White innocence to open a discursive space that allows for considering the terms on which agency is defined.

Each artist in this chapter makes clear how aesthetic radicalism turned its attention explicitly to undermining modes of racialized reasoning—here the rhetoric of White innocence—that restrain and distort Black identity. One does not find merely a critique of anti-Black racism in these works. Instead, the artists take up a specific expression of the social symbolism of Whiteness to expose how ideas about race circulate in the public sphere because only by first understanding this process of circulation and then derailing it can one create possibilities for radical articulations of identity. The impulse to close ranks yields a rich method that exceeds Black separatist thinking.

In the work of Bullins, Piper, and Eady, the artistic process of deconstructing White innocence relies upon manipulating and evoking performative strategies. In their hands, the performance of innocence displaces the rhetoric itself. By emphasizing performance, these artists aim to show that the rhetoric of White innocence is a *performative speech act*, meaning that this rhetoric seeks to create through enactment that which it describes. Bullins, Piper, and Eady all inhabit the speech act in order to enervate it. The experimental nature of their texts derives from this method of engaged critique. In producing such work, they demonstrate a common strategy although working in different media. In addition to bringing to the surface their shared approach, this underlying emphasis on performance also signals an abiding interest in embodiment. Challenging the social operation of White innocence necessitates investigating corporeality; thus performative inhabiting becomes a central component of their respective artistic projects. It is the body and the controlling meanings forcefully attached to it that the emphases on performance hope to highlight. Their strategies lay stress on a process of fashioning and repurposing Black bodies upon which the claim of White innocence depends.

2

The Suspicion of Kinship
Critiquing the Construct of Black Unity

The first two chapters of this study demonstrate the complexity of the artistic exploration of the closing ranks imperative within Modern Black Nationalism, but the focus here is on how Black collectivity gets imagined in nationalist reckoning. Closing ranks presumes that there are recognizable or agreed upon boundaries of identity, that these boundaries make possible political organizing, and that collectivity is mutually beneficial. In their influential social analysis *Black Power: The Politics of Liberation* (1967), Stokely Carmichael (later Kwame Ture) and Charles V. Hamilton present the argument that the act of coming together functions as the first step toward social change, and it is posited as elemental to undoing the destructive realities of racism and White supremacy. Unity and collective self-determination are imagined as being crucial to the organizing that could alter the social terrain:

> Black people must redefine themselves, and only they can do that. Throughout this country, vast segments of the black communities are beginning to recognize the need to assert their own definitions, to reclaim their history, their culture; to create their own sense of community and togetherness. . . . There is a terminology and ethos peculiar to the black community of which black people are beginning to be no longer ashamed. Black communities are the only large segments of this society where people refer to each other as brother—soul-brother, soul-sister. Some people may look upon this as ersatz, as make-believe, but it is not that. It is a growing realization that black Americans have a common bond not only among themselves, but with their African brothers.[1]

In the process of explaining the value of unity, Carmichael and Hamilton also reveal that the logic of kinship is the foundation for forming a radical collectivity. This logic makes possible the envisioning of a Black collective, one that can even transcend national boundaries. Such articulations of kinship-based unity were the building blocks for nationalist ideology as well as the philosophical basis for solidarity for different organizations and activists during the Black Arts era. To understand the social impact of Black nationalist thought, it is vital to consider the pervasive allegiance to kinship during the era.

I turn attention to the artistic scrutiny of the framework of kinship-based unity because it uncovers the creative interest in the nationalist closing ranks impulse. As a site of nationalist concern, unity is constituted by calls for collectivity through a framework of kinship.[2] Even in the face of substantive impediments to it, this aspirational unity remains a crucial element of nationalist thought and attracts a significant amount of popular attention. As opposed to flatly rejecting Black unity because of its clear limitations or because in practice the unity often fails to materialize, I contend that Black Arts era artists inhabit the nationalist pressure point to expose its limits. These artists investigate the implications of the insistence on kinship-based unity in the cause of political change and social revolution. Their projects reflect a consistent dialectical movement between investments in unity and anxieties about the demand of unity. Artists recognize the attraction of this nationalist device for galvanizing the public to action, while also communicating the limiting boundaries on identity that it sets in place.

This dialectical movement results from the disruptive inhabiting of the conception of Black kinship-as-unity producing a discourse of suspicion. A desire to be connected to a community appears alongside and is infiltrated by feelings of distrust about such affiliations. This discourse emerges prominently within works from this historical moment and comes to provide a basis for aesthetic radicalism, the artistic inhabiting of nationalist ideology. Phillip Brian Harper describes Black Arts artistic production in terms of its "divisional logic," and this understanding provides the foundation for the following consideration of suspicion.[3] In his argument, this logic derives from constant acts of comparison in which one establishes one's own identity and authenticity by negating someone else's (e.g., being "Blacker" than, more masculine than). The divisional logic is comparative and competitive in Harper's assessment. I am more interested in understanding this division as an outcome of a skeptical embrace of nationalist rhetoric.

The discourse of suspicion encapsulates the anxieties about the possibilities of community within and after the Black Arts historical moment. Instead of expressing a negative affective condition of postmodernity in relation to state power,[4] I use the term *suspicion* to describe questions of trust about interpersonal relationships that weaken bonds of real or imagined kinship. In the literary texts I examine, suspicion is directed toward Black characters and is used to fashion relationships because Black characters are imagined as untrustworthy to their colleagues and families. Although the context is often interracial strife, the real threat is inside, not out and is embodied as Black. Because these artworks direct suspicion inward, suspicion becomes an intraracial as opposed to interracial formation. With this move, I challenge the presumption that a blind fidelity to community and unity characterizes the work of this time period. In addition, artists manifest this suspicion formally through manipulating narrative structure and perspective in such a way that undermines the unity and coherence of their chosen genres. The approach to the narrative structure parallels the one to kinship. In relying on fragmented and destabilized narratives, these artists illustrate formal manifestations of disruptive inhabiting. I begin by considering the Black Arts era works of John A. Williams and Alice Walker; these authors use the historical novel to foreground and critique kinship as a conceptual lens. From here, I move on to consider how post–Black Arts writer Gloria Naylor maintains a critical interest in suspicion, but she uses it to articulate a new form of connection through the framework of social position in place of kinship. Collectively, these writers demonstrate an important strategy of inhabiting the rhetoric of Black nationalism to subvert it. In the process, they experiment with the structure of their narratives, producing fractured texts that mirror the fractured ideology.

The Cost of Kinship

Paul Gilroy takes issue with Modern Black Nationalist thought because of its overreliance on kinship metaphors. He argues that in the nationalist political imaginary, "blackness has been constructed through the dubious appeal to family as the connective tissue of black experience and history. Family has come to stand for community, for race and for nation. It is a short-cut to solidarity."[5] His point is that the philosophical substrate for Modern Black Nationalism—unlike its classical counterpart—is the reliance on a Blackness-as-kinship paradigm. This defining focus creates ways of thinking that are

conceptually restrictive. The imagined connection to solidarity results in a prioritization of racialized unity to the expense of other desires and imperatives. Specifically, Gilroy points to two problems with this focus on kinship in Black political discourse and cultural productions: the social weight placed on masculinity and the overarching goal of figuring sameness.[6] The idea of patriarchy embedded in traditional notions of kinship gives rise to a focus on articulating masculinity. The desire to figure sameness has to do with erasing or de-emphasizing differences, tensions, and conflicts that could be impediments to unity. These elements plague and ultimately stymie the political ideology as well as the art that engages it in Gilroy's mind.

This critical assessment of nationalism sheds important light on the challenges that this ideology can present to both political and cultural activity. However, there are texts informed by nationalist rhetoric that challenge the reliance on kinship. Novelists John A. Williams and Alice Walker recognize how kinship functions as the foundation for expressing desires for Black solidarity and social justice. Although they appear initially merely to replicate the investment in kinship, these novelists dissolve it. These Black Arts era writers incorporate the logic of kinship into their works to undermine it along with limiting notions of Black identity and sociality. They question what it means to express Black solidarity through the lens of kinship and ultimately find it unsettling. Their texts make use of motifs of suspicion in representing Black relationships to invalidate the nationalist premium on unity. These writers do not simply reproduce the conceptual drawbacks attributed to the terrain of Black nationalism in their artistic explorations. Taking up the logic of kinship functions as a way to disarm it. Williams's and Walker's respective employments of kinship complicate questions of gender identity and familial solidarity, the exact problem areas that Gilroy identifies as emerging through the frame of kinship. In addition, both use the historical novel to accomplish this goal. As Georg Lukács explains, this genre is linked to the development of national consciousness as well as the experience of collective identity.[7] The writers' decision to manipulate this particular form results from their common interest in the paradigm of kinship and the demands of social identity. The historical novel's traditional connection to national consciousness and mass experience makes it an appropriate form for exploring the boundaries of collectivity.

John A. Williams's *The Man Who Cried I Am* (1967) and Alice Walker's *The Third Life of Grange Copeland* (1970) are particularly relevant because in these works the novelists make use of suspicion in their depictions of Black families and community to undercut the construct of Black kinship as unity.[8]

These Black Arts era novels, though strikingly different, both link explorations of trust in Black relationships to examinations of social conceptions of the Black body and gender identity. Williams's novel is governed by the link between Black masculinity and suspicion. His work emphasizes male embodiment in particular and male relationships in the form of lineages in constructing environments of suspicion. Alice Walker picks up this exploration of masculinity and familial lineage while also putting into relief how Black femininity and the female body fit into this project. Each of these novels questions the possibility of Black solidarity in social environments driven by economic concerns. Both demonstrate how the suspicion of racialized collectivity is formulated through an economic framework thereby communicating the imagined cost of reiterated calls for unity and community. This sense of social fracturing gets linked to narrative fracturing in both works.

John A. Williams's historical novel *The Man Who Cried I Am* is a key text for thinking about the translation of Modern Black Nationalist thought into the realm of art. His fiction in general has consistently sought to uncover the complex manifestations of U.S. racism and to showcase how African Americans have had to negotiate the social world over time as the novels *The Angry Ones* (1960) and *Captain Blackman* (1972) both show. *The Man Who Cried*, Williams's most well-known text, has at its base an unveiling of the global realities of anti-Black racism and a demand for solidarity among subaltern peoples for social justice. The narrative chronicles the life of Max Reddick as he tries to establish himself as a writer and to situate himself among a community of other Black male writers. Williams punctuates Max's story with major global events that take place between World War II and the rise of the Black Power Movement, which lead to a radicalizing of the protagonist. This politicized change in the character is made possible initially by his sense of fraternity—or sameness—with and the knowledge he gains from other Black men. However, Williams saturates this process of radicalization with encounters that suggest the protagonist's powerlessness as well as the impossibility of trusting other people, especially other Black writers. Max's tragic story becomes a metaphor for the uncertain possibilities of Black identity and community in a global frame of exploitation of Black individuals. The narrative directs attention toward the problems of the interpersonal and the obstacles to trust through the lens of suspicion.

Williams explores the concept of Black kinship in the novel through the vested interest in Black lineages and the cultivation of connections between and among Black men, and it is through these lineages that he generates internalized suspicion. The novel centers on a community of Black male

writers. The character Harry Ames, who is modeled on Richard Wright, is thought of as the figurative father of Black male writers in the novel, the founder of a line. In fact, in explaining why he is berating Ames in his work, Marion Dawes—a James Baldwin character—insists that it is the "*duty* of a son to destroy his father'" (217). Through this comment, Williams references Baldwin's fractious symbolic father-son relationship that he had with Wright.[9] A similar notion of familial lineage dominates the minds of the writers in Williams's novel, and this understanding sheds light on a dream that Max has. The dream, which ends with Max yelling "I AM," has him maintaining that he is the "end of the line, as far as it's come" (187). In the dream, Max imagines himself as the end of a lineage. The idea of the end of the line represents the loss of connection to Black men as well as the endangering of a space of refuge and security because the group of writers represents a brotherhood. As Dawes's comment suggests, intraracial conflict spoils the relationships between the writers, eventually destroying the lineage. The tensions that emerge in this brotherhood of writers do allow Williams to allude to the earlier Baldwin-Wright moment, but they are also a reference to the infighting that plagued some nationalist organizations throughout the 1960s. LeRoi Jones's Black Arts Repertory Theatre and School, the founding of which helped to inaugurate the Black Arts Movement, only lasted a year because of internal strife, struggles for power, and disagreements between factions about the direction of the organization.[10] The Black Panther Party expelled members from their San Francisco base The Black House along ideological lines one year later in 1966.[11] The fact that intraracial discord could trump the organizational faith in racial kinship puts pressure on the kinship paradigm. Williams links such infighting to an anxiety about lineage, and this connection is vital for understanding the novel's course of events and why Max distrusts his Black peers.

Max's relationship with fellow writer and mentor Harry Ames epitomizes this idea of a lineage of distrust between Black men: threatening kinship. Max dies at the end of the novel because he has found out about the Alliance Blanc, an international conspiracy against Black people, in which the United States is deeply involved. It is through Harry that he gets the information about the Alliance. This information in the form of bundled-up letters and documents is a veritable inheritance from Harry to Max. Ames passes this information on to a man, another writer, he assumes he could trust with it after he dies: "I am sorry [the letter went on] to get you into this mess, but in your hands right now is the biggest story you'll ever have" (213). What Harry appears to give Max with these documents is a mistrust of White power and

nation-states through the awareness of the King Alfred Plan, "the contingency plan to detain and ultimately rid America of its Negroes" by evacuating and interning them in camps (367).[12] However, the "gift" of the Alliance Blanc documents also seals Max's death. In the letter that prefaces the documents Harry admits that "knowing may kill you, just as knowing killed me and a few other people you will meet in this letter" (363).[13] It is a "killing knowledge" that is passed down from father to son in this metaphoric lineage. Max later realizes that Harry wanted him to "inherit" this gift as a form of revenge because Max had had an affair with Harry's wife and had financial success at moments when Harry did not (379). The information that Max initially sees as a secret knowledge that united the two Black writers in a new way becomes evidence of their fragmented relationship, the impossibility of any real connection. This knowledge constructs and destroys the line.

Because this imagined Black family is destructive, the novel intimates that it is Harry, and not just the American government and its White officials, whom Max has not been able to trust. It is the already-murdered Harry who kills Max. Black people, particularly Black men, pose the greatest threat to the protagonist. The fact that those who physically kill him at the end of the novel are Black men working for the CIA substantiates this idea (395–402). The novel ends with Black bodies in conflict encouraging a suspicion of Black people, those whom the central character had begun to think of as kin. These struggles suggest a rejection of the notion of racial sameness and solidarity. The fear of Whites is actually secondary to this unarticulated but very present fear of what one Black man can do to another. This realization about Black communality is destructively disillusioning. For members of this lineage, threatened Black masculinity is at the center of the narrative of suspicion.

The dangers of Black kinship structures also come to light through Max's relationship with his girlfriend Lillian. His desire to be a supportive partner and father challenges his sense of agency and free will. Both the figurative and the literal family are threatening in the text. Max sorely wants to be able to provide for Lillian through his career as a writer, and this desire is brought to a head when she becomes pregnant. The pregnancy, the literal enlarging of family, introduces narrative conflict and trauma. He is unable to find a position that would allow him to support a family, and Lillian does not want to get married or have a child unless she and Max can afford to do so. Consequently, in a pre–*Roe v. Wade* social context, Lillian has a substandard abortion that causes her to bleed to death. Through Lillian's death, Williams is able to comment on the limits of Black reproductive freedom—chapter 3 explores how anxieties about reproduction stimulate nationalist activism.

Her death makes Max acutely aware of the precarious place he occupies in the socioeconomic realm. His stress of finding a job transforms into frustration over his lack of opportunities and anger at those who denied him: "Goddamn them! They could not be accused or convicted of murder or even being near the scene of the crime. What did they have to do with Lillian's death? Everything, and yet, they believed, would continue to believe, nothing" (116). He blames the newspapermen who would not employ him (the "they") for Lillian's death; however, there is no way to hold them or anyone in particular accountable. He goes on to say: "But *damn them!* They refused to understand why he wanted them dead. This was why: They gave Lillian the photograph, the image of the American Family Group, but when she looked very, very closely, she wasn't in it" (116–17). Here, Max expands this destructive "they." It is not simply media employers, but an indefinable, ambiguous everyone who is invested in a specific White, middle-class image of the American family.[14] It is this public, shared image and the image-makers behind it that kill Lillian in Max's mind. Although he eventually becomes successful, he is haunted throughout the narrative by the loss of Lillian and his inability to find a job, later concluding that Whites have a profound and destabilizing power over Black people's lives (316). The familial connection renders him vulnerable to manipulation and leaves him with a sense of unrelenting helplessness.

Williams presents Max's familial obligations as negatively impacting the protagonist's sense of self; the investment in family introduces anxiety about his identity and his body. Max's feeling of powerlessness over the situation with Lillian gets translated into a frantic declaration of masculinity and an assertion of having a damaged body. Max complains: "Can't you see I'm hurting, *hurting*, and my girl, my woman is hurting. My whole mutherfucking life is a gaping, stinking hurt! *Give me my share! I am a man*" (114). This declaration resonates with the later sentiment of the famous and well-documented 1968 Memphis sanitation workers' strike. Television recordings and photographs of the event illustrate that the strikers carried and wore white placards that read "I *AM* A MAN" in black lettering. Williams taps into a claim for masculinity expressed through the framework of employment and discrimination that is integral to the logics of political and social redistribution during this time period; this claim finds a visual expression in the workers' signs.[15] Williams employs similar language to that of this political event, but he provides a contrasting setting and makes possible different implications. During the strike, the statement as it is represented is a reflection not only of manhood, but also of collectivity; crowds of men carry the sign and make the assertion.

Max, on the other hand, asserts his right to manhood alone. The statement is not framed by collective action or intraracial collaboration. Rather, isolation and the feeling of not being helped by anyone—White or Black—characterize this statement. Williams imagines a moment of isolation and fragmentation instead of one of collectivity and solidarity. In the sociopolitical realm, this articulation may have a collective value, but in the artistic imaginary it is reflective of a lack of social connection.

Max's feeling that his life is a violation or injury provides the backdrop for this isolated masculine utterance. His life and body are imaged as a wound. Given what he says, his continued unemployment becomes an act of emasculation or a forestalling of his entrée into full Black masculinity. This wound that is his life gets realized on Lillian's body. She is the actual casualty. Her death introduces a disillusionment that Max never gets beyond because he was powerless to save her, and the loss of Lillian, his access to the familial, stands as a testament of how Max was incapable of realizing his sense of self. His attachment to her means that losing her also signifies a loss of self.[16] The presentation of the relationship to Lillian in Williams's narrative connects conceding to the demands of kinship with endangering the integrity of one's personhood. Imagined and real kinship emerge as threatening.

Williams translates this self-loss occasioned by the investment in family into corporeal anxieties in the text. The unreliability and endangering nature of family gets reimagined as an unreliable and threatening body for Max. When Max first appears in the text, the reader finds that the cancer ravaging his body has caused him to suffer paralyzing pain and to have a constantly leaking anus. He must regularly change the dressings in his underwear because blood and pus continually fill them. Max's leaking, dying body frames and interrupts the text's narrative flashbacks, which are concerned with the menacing nature of racial discrimination in the twentieth century. This uncontrollable body is the lens for interpreting the narrative's exploration of suspicion and discrimination. The loss of personal autonomy that Max experiences gets converted into an inability to exercise control over his body. The reader is presented with a Black body that cannot be depended on or trusted; there is an implicit suspicion of the body itself. The narrative focuses on the male body, but it is a body that is compromised and weak.

Black Arts social critic Calvin Hernton offers a context for making sense of such corporeal anxieties: ontological ambiguity.[17] In an autobiographical essay, Hernton describes what he calls "ontological ambiguity," or the loss of autonomy over the body, as being an element and result of his own experiences of suspicion and paranoia.[18] Hernton explains, "I remember

being afraid of the police. We all were. I do not know exactly when I got that way. The fear, through the process of social contagion, must have been socialized in me by merely living on Slayton Street" (147). The idea of "social contagion" indicates how individual space and personal identity can become contaminated by social perceptions. In explaining the ubiquity of this sentiment, Hernton provides a historical account of the Black hyperawareness of Whites from the colonial period to the present describing it as a legacy for the Black community. In effect, generation after generation of Blacks inherit this feeling because of seemingly unchanging social conditions. The mood of suspicion developed in this work—and others like it—does not limit itself to Whiteness. Hernton references the fact that the paranoia-instilling police officers employed informers in the Black community to enhance their systems of surveillance. Therefore, members of the Black community come under scrutiny within the larger frame of suspicion. Given Hernton's description of his own bodily anxiety, the appearance of such corporeal uncertainties is reasonable. Power embodied as Whiteness can introduce concerns about Blackness and can lead to suspicion of Whiteness. The fact that Black people at the end of the twentieth century might be suspicious of White people given the history of racial relationships in the United States might be seen as a statement so obvious that it could remain unsaid. However, Williams's novel is important because it links an examination of the development of the suspicion of Whiteness to an exploration of intraracial suspicion. The untrustworthy Black male bodies materialize this *internalized* distrust. Ontological ambiguity derives from turning distrust inward. Williams presents the reader with untrustworthy Black bodies in texts filled with untrustworthy Black characters. The narrative reflects a need to internalize and corporealize suspicion. Williams weakens the unity and integrity of the individual body as an analog to putting pressure on the bonds of familial and community affiliation.

In the process of destabilizing conceptions of Black kinship-based unity, Williams also worries the parameters of the generic space of the novel. The narrative structure of the novel participates in the destructive suspicion of kinship. Harry's secret letter to Max contours the trajectory of the second half of the narrative. Rather than merely referencing the existence of this document, Williams inserts the epistolary evidence into the narrative in seven different sections (205, 213, 221, 234, 273, 317–20, and 362–76). The reader keeps returning to this damning document getting a different piece of it each time. Williams slowly unveils the letter providing more clues to its meaning and implication with each part. This segmenting is followed by the

presentation of the letter in its entirety toward the end of the novel along with the accompanying documents that detail the intricacies of the King Alfred Plan—the documents only appear in the narrative in the final, full showing of the letter. After encountering it in parts, the reader must then reread the entire letter. This interrupting letter is the impetus for the narrative itself and provides the scaffolding for its structure. It opens in this way: "You are there, Max? It is you reading this, right? I mean, even dead, which I must be for you to have these papers and be alone in the company of Michelle [Harry's wife], I'd feel like a damned fool if someone else was reading them. I hope these lines find you in good shape and with a full life behind you, because, chances are, now that you've started reading, all that is way, way behind you, baby" (362–64). The action of the novel commences with Max's being followed by Black CIA agents because of what he knows about King Alfred, and the entire story is made up of flashbacks from his past (the "full life behind him") that interrupt the telling of this chase that ends in death. The letter intimates the lack of trust between the two men even as it makes claims at connection. In a sense, Williams sets the course of events of the novel through the opening lines of this letter. The reader sees the effects of the letter before ever getting to read it, but Williams resists giving the reader the letter making her uncertain about its meaning and value. By breaking the letter up, Williams uses the fragments to place the intervening portions of the narrative under a cloud of suspicion. One must read all of the events of the novel through this epistolary lens.

Harry's letter is also important to the experimental nature of the novel's structure because Williams breaks up the third-person omniscient perspective to shift to the first person through the insertion of the pieces of the letter. The perspectival shifts that result from the incorporation of the letter move the reader away from the protagonist and introduce suspicion into the narrative. Structurally, the reader finds the presentation of division through these epistolary fragments. As Max is told in the first line of the letter, knowing about the enclosed information will likely lead to his death. In this sense, the narrative breaks, which switch to the first person away from Max's perspective and to Harry's, prefigure Max's death. Each time the reader has to transition to Harry's first person in the letter fragments, she loses Max. Not only does the presentation of the broken letter symbolize Max's death, but it also indicates the extent to which the protagonist has failed to create or become a part of a community of writers abroad. The interrupted narrative materializes interrupted relationships, failed kinship. That which seems to be a mark of intimacy, the fact that he has been entrusted with the letter, is

actually a sign of betrayal.[19] The letter, then, becomes a means of suggesting kinship connections and unraveling them, and the fractured narrative confirms this idea. This subtle manipulation of the novel's formal presentation becomes an important element of rethinking Black identity and community. Because the historical novel is concerned with collectivity, fragmenting this form functions as a disruption of kinship. The formal experimentation is in line with the conceptual investigation of nationalist concepts.

Williams's novel supports an investment in real and imagined kinship connections so that it can undermine the idea that the logic of kinship can produce a secure or safe collectivity. This narrative about a community of writers is an extended meditation on the challenges that develop from the assumption that kinship frameworks can create a social refuge or a site for collective action. The two areas that Gilroy identifies as founding nationalist thought—masculinity and sameness—emerge prominently in the novel. Nonetheless, the masculinity that is prioritized is a dying one. Moreover, the brotherhood of writers emblematizes sameness, but this sameness is divisive. As the King Alfred Plan shows, Williams recognizes that there are political circumstances that make this kinship reasoning appealing. However, the narrative presents this logic as faulty reasoning, as do actual events in the social world involving nationalist organizations. Williams's reliance on the figurative kinship of brotherhood allows him to link his work to real-world institutional ideologies, but it results in a prioritizing of masculinity—even if it is a damaged and dying masculinity. Other writers moved the consideration of the nationalist logic of kinship away from a firm focus on manhood to undermine patriarchy along with kinship.

Alice Walker's fiction, particularly her first novel *The Third Life of Grange Copeland* (1970), continues the presentation of the risk of kinship-based unity that *The Man Who Cried* establishes, illustrating her engagement of nationalist discourse. Walker's early work emerges during the Black Arts era and registers an interest in the implications of nationalist rhetoric as her poetry collections *Once* (1968) and *Revolutionary Petunias* (1973) and her short story collection *In Love and Trouble: Stories of Black Women* (1973) all evidence. Much of this poetic and fictional work reminds the reader that politicized calls to action and unity have value but also have a material and psychic cost. More importantly, Walker's work is an important addition to this discussion because it illustrates an explicitly feminist engagement of nationalism. In thinking of her work this way, I am guided by Madhu Dubey's scholarship, which uncovers the possibilities that emerged from women writers' investigations of nationalism and the Black Arts Aesthetic specifically.[20]

The novel represents an important expression of feminist critique within the context of nationalist paradigms. As a part of the radical political activity of the 1960s and 1970s, many Black women raised questions about what role women would have in activist organizing and in the hoped-for social revolution. This line of inquiry contributed to the formation of important Black women's consciousness-raising political organizations such as the Black Women's Alliance (later the Third World Women's Alliance) and the National Black Feminist Organization. In her important history of such Black Feminist activist collectives, Kimberly Springer shows how these organizations turned explicit attention to gendered dynamics of racism and sexism within the movements for social change and became important conduits for different articulations of Black Feminist thought.[21] The questioning about women's involvement and the organizational developments did help to stimulate a set of public interrogations into what constituted Black womanhood in the twentieth century that would come to shape the period's understanding of gender. Black women thinkers inside and outside of organizational structures began to ask difficult yet necessary questions: How can we shed light on the specific social, political, and economic pressures that shape Black women's existence without eliding differences? Does changing the social world not first require transforming our communities and intraracial relationships? And how might we reimagine womanhood within the social kinship network and imagined community that the term *Black* describes?

Toni Cade Bambara's acclaimed anthology *The Black Woman* (1970) explores in detail such questions and is a key text for locating the interaction of the critique of sexism and the pondering of Black nationalist thinking. Although the volume is filled with fictional and nonfictional pieces that together lay the groundwork for Black feminist theorizing at the end of the twentieth century, I direct attention specifically to Kay Lindsey's contribution because it takes up an extended exploration of what constitutes Black womanhood and identifies key nodes for rearticulating this space of identity. In the process, she pays especial attention to the family:

> The Black woman has been set apart consistently from her white counterpart. We have instead been considered as a special subgroup within the Black community, which Black men should try to deal with as their own private extensions. This is an illusion perpetrated on the Black man in order to deflect him from the task at hand, which is not to create a domestic niche for his woman, but to re-create a society at large, a task which involves direct conflict with the white agency, which at the very least would overturn all its institutions, including the family. . . . If the family as an institution were destroyed, the state

would be destroyed. If Black people were destroyed, but the family left intact, the basic structure of the state would allow for rebuilding. . . . To be a Black woman, therefore, is not just to be a Black who happens to be a woman, for one discovers one's sex sometime before one discovers one's racial classification. For it is immediately within the bosom of one's family that one learns to be a female and all that the term implies. Although our families may have taken a somewhat different form from that of whites, the socialization that was necessary to maintain the state was carried out.[22]

In Lindsey's mind, to redefine the meaning and social valuation of Black womanhood also necessitates deconstructing traditional conceptions of kinship because kinship structures play a pivotal role in gender conditioning and stratification. Moreover, she links the upsetting of the family to the overturning of the state because of the family's role as an ideological state apparatus.[23] Therefore, disputing the collective investment in kinship is a revolutionary act with dual valences: this act helps to expand the boundaries of the social world as well as those of subjectivity. Notions of family and kinship are often the bedrock of traditional or conservative ideologies—hence the connection to the state with its investment in social stasis, but Lindsey's point implies that the family can become a device for radicalism by first understanding its processes of constituting subjects and then disrupting them. This understanding runs through Alice Walker's fiction writing. Her questioning of kinship, which appears in all of her fiction, is a purposeful assessment of the social instrument of racialized gender conditioning and a meditation on the limits of solidarity and community building from a feminist standpoint. She, like Lindsey and others, seeks to upset recognizable conceptions of family to challenge the common terms of defining both the self and community.[24]

Walker's novel *Third Life* examines Black kinship as a paradigm for unity through the frame of suspicion and emphasizes the importance of gender identity to such an exploration. She also manipulates the structure of her narrative to express the unreliability and instability of kinship connections. There are significant contact points between this novel and *The Man Who Cried*. However, Walker troubles the thinking apparent in Williams's text by questioning the gendered nature of imagined Black relationality. Along with the investigation of Black men's bodies apparent in other narratives concerned with suspicion, Walker inserts rural life into the discussion as well as a sustained consideration of Black female embodiment. The feminist orientation of *Third Life* takes up a more sustained critique of patriarchy and misogyny, yet the shared move of relying on Black kinship connections to challenge the value of kinship and

solidarity indicates how both novels are involved in a project of inhabiting circulating nationalist rhetoric to disrupt it.

The destructive nature of kinship relations constitutes the narrative focus of the family saga *Third Life*. The goal of the title character Grange is to unite his family through a race-based conception of unity rooted in deep suspicion of and enmity toward White people, an ostensible closing ranks lesson. The story traces the Copeland family for three generations zeroing in on Grange, his son Brownfield, and Brownfield's daughter Ruth. Grange's disdain for White people structures many of the decisions that he makes in the narrative. He deserts his wife and son because he cannot handle being shackled by the sharecropping system. He returns from his sojourn in the north because he finds that Whites are in control in Harlem as much as they are in Georgia. Because of these analogous experiences that occur in different geographical locations, he saves money and purchases property to guarantee that his granddaughter will never be dependent on the racist Southern labor system. Grange has a desire to inculcate a distrust of Whites into his family as his conversations with his granddaughter Ruth indicate: "They are evil. They are blue-eyed devils. They are your natural enemy. Stay away from them hypocrites or they will destroy you" (138). This particular characterization of White people as "blue-eyed devils" is a reflection of the racist encounters that Grange has had, but it also has a particular currency in the late 1960s when this book was written.[25] Invoking her contemporary moment, Walker connects Grange to the rhetoric of some Black nationalist-influenced strains of social thought and literary expression. The language used here resonates with statements deployed to encourage the creation of Black spaces and the cultivation of collective autonomy.

Grange's attempt to root a kinship structure in suspicion of Whites fails and proves to be an untenable bond of connection. Although Grange abandons his son as a child, Brownfield does symbolically inherit the mixture of fear and hatred of White people from his father that is resonant with certain elements of the 1960s Black thought. Walker works throughout the narrative to illustrate how this characteristic creates a connection between father and son, yet the two are portrayed as having a broken relationship. The reader discovers that Brownfield, too, often sees Whites not just as the perpetrators of injustice, but also as the direct cause of his own miserable life (219–20). In this conclusion, he finds that his existence is nothing more than a repetition of the life of the man he resents the most, his father Grange (54). Brownfield does not trust White people, but his father's desertion means that there is no sense of family. He has learned his father's lesson, but he refuses to acknowledge him as

kin. Ruth, on the other hand, refuses an unquestioned suspicion of Whites. She questions both her father's and grandfather's criticism of White people (142–43, 219). In these circumstances, it takes a young, female character to provide this perspective. Having lived in a heavily segregated environment and being outside of the world of work as a child, Ruth has only witnessed injustice and violence perpetrated by Black people, especially by her family members. As she insists, "'The White folks didn't kill my mother'" (143)—her father Brownfield did. Through these characters, the novel provides an internal debate about the possibilities of Black relationships and alliances with White people. This discussion of Whites taps into contentious considerations about White involvement in Black political activism, as the debates between the Student Nonviolent Coordinating Committee and the Black Panther Party in the late 1960s make clear.[26] Walker's narrative does present White characters that are manipulative and empowered, yet it also introduces a perspective (in Ruth) that is critical of such flat characterizations of Whites, registering the character's lack of connection to her lineage. The tension around White people becomes a wedge that divides the collectivity of family.

For the Copeland father and son, the aversion to White people is rooted primarily in their respective relationships to land and labor uniting the two men experientially while also commenting on the realities of Black rural life throughout much of the twentieth century. Both men work for a time as sharecroppers in Georgia out of necessity and get deeper in debt every year making it difficult to be independent providers.[27] Like Williams's protagonist Max, Grange and Brownfield find themselves caught in the quicksand of a White-controlled labor economy that ultimately poses a threat to their psychological well-being. Both novels ask the reader to consider what the economics of trust are or what the connection is between economics and trust given the fact that intimate relationships are often informed by economic realities. Brownfield's sense of his situation epitomizes the post-Emancipation economic enslavement both men experience: "His indebtedness depressed him. Year after year the amount he owed continued to climb. He thought of suicide and never forgot it, even in Mem's arms. He prayed for help, for a caring President, for a listening Jesus" (54). Brownfield's reaction to his unending servitude that is the result of his familial obligations is a depression that, for him, has no social, political, or spiritual remedy.

This sense of vulnerability apparent in the quotation manifests as corporeal symptoms visible in both Grange's and Brownfield's encounters with their employers (power-wielding White men). As a child Brownfield notices that Mr. Shipley's "presence alone [turned] his father into something that might

as well have been a pebble or a post or a piece of dirt, except for the sharp bitter odor of something whose source was forcibly contained in flesh" (9). From Brownfield's perspective, proximity to this White man's body distorts and disfigures Grange's body. Later, Brownfield finds himself to be tongue-tied when Shipley offers him the "opportunity" to work for him after Grange leaves (24). The reader finds Brownfield in a comparable state when Captain Davis confronts the young man about working for him: Brownfield wants to cry out that he is not a slave, but he finds himself unable to speak or even move, revealing another instance of ontological anxiety (88–89). These White employers do not simply embody power or evoke labor, but they also signify a life that will be stifling and constraining, as the Copelands' own bodily reactions symbolize.

That being said, anxieties about intraracial connection displace these inter-racial power dynamics as Walker's novel sketches out a racial lineage of abuse and subsequent cycles of intrafamilial violence. Although Grange believes that distrust of Whites should unite Black people (154), it does not unite his family. Both Grange and Brownfield mistreat their families as a reaction to this restrictive labor situation and the way of living that it promotes. Grange completely ignores his son's existence, cheats on his wife, and ultimately leaves them both. Although he never forgives his father or forgets about how his father's actions result in his suffering and his mother's death, Brownfield physically and emotionally abuses his family as well, ultimately killing his wife in front of his daughters. Because of Brownfield's abuse, Grange never trusts his son enough to allow him to have access to Ruth again. This lack of trust leads to his killing Brownfield to prevent him from getting to Ruth (70). There is no pity and little love between these two men, these genera-tions of Copelands. Because Ruth finds herself unable to trust her father, the reader becomes aware of how a deep distrust moves down this kinship line. Walker creates a lineage in this narrative that all but destroys itself through the undermining of trust. The dead bodies of Grange and Brownfield an-nounce the end of the narrative. Grange murders his son to protect his grand-daughter from Brownfield's antipathy, anger, and desire for retribution for a life of subjugation and solitude. In turn, he is shot by the police in the forest behind the home he built to provide economic security for his granddaugh-ter. In Walker's text, family (and the unity that it symbolizes) is not only not trustworthy, it is also life threatening.

Although Walker places the reader in rural environs in this narrative as opposed to the urban landscapes that structure the development in *The Man Who Cried*, circumstances or conditions that circumvent the creation of

intimate bonds emerge as prominent. It is the precise nature of the labor economy characterizing this rural space that fractures such bonds. This life of subjugation and recurring violence is rooted in a connection between labor and land, but the male characters imagine that women and their bodies forge the connection between these men and the labor economy of sharecropping. From this perspective, family and home are not spaces secure from the influence of the oppressive labor culture: "[Brownfield] prayed for a decent job in Mem's arms. But like all prayers sent up from there, it turned into another mouth to feed, another body to enslave to pay his debts. He felt himself destined to become no more than overseer, on the white man's plantation, of his own children" (54). The comfort he sought from the strain of providing exacts more pressure. His marital bed becomes a site of enslavement, and heterosexual intimacy appears as a means of subjugation. Here, the Black female body is an important symbol that interrupts intimate bonds. The perceived obligation to women creates the male characters' need to work. For example, Brownfield had been freed from the system of sharecropping after his father left and his mother died, but he voluntarily returns to it because he feels as if he must to win Mem from the (employed) schoolteacher that she is dating. Families constrain these male characters within systems of oppression instead of serving as race-based refuges from them.

Along with illustrating the psychological effects of sharecropping, Brownfield's feelings about his wife's pregnancies reveal how, from the men's perspectives, it is women's bodies (and the children that they produce) that tie them to the debilitating labor economy. The next chapter offers a sustained consideration of the contested terrain of Black reproduction, but it is important here to take into consideration how Black reproduction is imagined as constraining and as a force that limits the social possibilities of Black men and women. Walker's narrative connects Brownfield and Mem's lovemaking to the space of his labor in the field: "As the water [that Mem had brought to him as he worked in the field] ran down his chin and neck, so did her love run down, bathing him in cool fire and oblivion, bathing him in forgetfulness, as another link in the chain that held him to the land and to responsibility for her and her children, was forged" (50). The more children that Mem gives birth to, the more Brownfield accuses her of having slept with White men (54). This accusation has nothing to do with questions of paternity, but rather with a feeling that Black women are complicit with White men in the destruction of Black men because of a complicated visualized connection of reproduction with indentured servitude. Black women cannot be trusted along with White people from Brownfield's perspective. No possibility of trust or a sustained connection between men and women exists here.

By focusing on and destabilizing family as a figure of unity, Walker establishes a narrative framework in which Black women cannot trust Black men; intraracial solidarity is nearly unachievable in the world of the novel. This idea resonates with the critiques of Black women activists during the 1960s and 1970s about Black male sexism and organizational discrimination, which contributed to the creation of the National Black Feminist Organization in 1973 and the Combahee River Collective in 1974.[28] Although the Black male body may be presented as stifled or constrained in Walker's novel, these threatened Black men pose psychological and physical threats to Black women. As is clear from Mem's experiences, pregnancy does not simply tie a man to a woman, but it can also place a woman under male domination. Brownfield plots to get Mem pregnant so that he will be able to rule over her in her "weakened" condition.[29] Moreover, Ruth never trusts her father because of how he treats her mother and because of his cruelty and intimidation of his daughters. She is unsure about whether she can trust White people, but she is confident in her distrust of her father or even, at times, her grandfather. The narrative itself makes it difficult for the reader to have faith in Grange or Brownfield because both constantly take advantage of women who love and depend on them. Although Grange has grown compassionate by the end of the novel in providing his granddaughter with security and a home, this domestic stability was made possible through Grange's manipulation of his naïve lover Josie's faith in him (140).

Third Life presents a complication of heterosexual desires and the obligations attributed to the members of such couplings. From this vantage point, it becomes discernible how Walker's work is in conversation with Williams's novel. Still present is an artistic desire to interrogate the idea of unified Black community or safe and affirming Black kinship structures. Nevertheless, Walker takes the consideration out of the primarily homosocial setting to think about Black heterosocial and heterosexual interactions. The Black male body and the Black female body face threats and are imagined as being threatening to each other. Accordingly, the idea of competing gender ideologies becomes basic to the formulation of Black gender identity. In her discussion of Black gender roles and gender identity, Toni Cade Bambara explains, "it doesn't take any particular expertise to observe that one of the most characteristic features of our community is the antagonism between our men and women."[30] The sense of this multifaceted enmity between Black men and women recurs in artistic production of this period, as Carlene Hatcher Polite's rarely discussed Black Arts era novel *The Flagellants* also makes evident—a Black couple are the titular flagellants, who emotionally and physically punish each other.[31] The antagonism Bambara points to is one

structured by feelings of suspicion and betrayal and reflects the idea that Black masculinity and Black femininity are theorized in terms of conflict, an idea that forms the basis for Michele Wallace's argument in *Black Macho and the Myth of the Superwoman* (1978).[32] Walker's work suggests the idea that the Black family is imagined as a site of destructive conflict. Given this social understanding of the Black family, the use of Black kinship as a paradigm for political action is fraught and divisive.

Walker's novel, concerned with domestic violence, filicide, and depression, ends with Black bodies encountering the state and the police. After getting out of jail for the horrific murder of Mem, Brownfield decides to sue his father for custody of his youngest daughter because he is determined to have "what belongs to him." Not love but revenge and "oppression-based insecurity" drives Brownfield's actions.[33] The judge in the court proceedings decides to award Brownfield his daughter not because he is a suitable guardian, but rather as a gift to one of the judge's pet "nigras" (Brownfield). This trial scene ultimately lays bare the power this White man wields over another person's life and death. In this moment, Ruth's Black female body becomes an object of economic and affective exchange in a scene of White-controlled and state-sanctioned Black helplessness and ultimate destruction. It is here that Grange kills Brownfield to prevent him from getting Ruth. The violence done in this room ends with Grange's being shot by the police outside of the home (the site that materializes both economic trust and kinship) that he has attempted to secure for her future. The narrative reflects a desire to keep in perspective the role that Whiteness plays in Black intraracial conflicts. I explore the presence and significance of notions of Whiteness in the considerations of Black social identity in chapter 1, but here I show how this is the backdrop for undermining Black kinship structures.

The choices Walker makes in presenting the dynamics between Black unity and conflict exhibit how the manipulation of the narrative runs parallel to the critical assessment of kinship. *Third Life* is also a third-person omniscient story, but Walker does not concentrate primarily on one character as Williams does with Max; she makes more purposeful use of the narrative mode by shifting the perspective actively. In doing so, she creates a disjointed narrative. The disjointedness that appears in this novel prefigures the segmentation of narrative form that will characterize her next two novels: *Meridian*, with its short story–like sections, and *The Color Purple*, an epistolary novel. That being said, Walker's earlier poetic production informs the formal structure of the novel. The 1968 poetry collection *Once* directly precedes *Third Life*. The collection details the challenges to kinship and unity among Black people

in the context of political activism. Importantly, *Once* is primarily made up of sequence poems: "African Images," "Love," "Karamojans," and "Once," "South," "Compulsory Chapel," "Mornings," and "Exercises on Themes from Life." Each of these sequence poems is composed of a series or chain of enumerated or unmarked shorter poems or poem fragments. This technique allows Walker to shift perspective constantly, to provide multiple insights on the same subject, and to have the structure of the poem register this movement. Perspective and fragmentation become the recurring motifs because of the poetic technique itself. Walker would return to this structural strategy in her 1973 collection *Revolutionary Petunias & Other Poems*.[34] More to the point of this discussion, the shifting poem sequence form becomes the basis for the shifting perspective of her first novel. In creating a narrative using a poetic sensibility, she transcends the boundary between the poetic and the narrative. Walker relies on a cross-generic strategy in crafting this historical novel. The cross-generic technique is important to the larger argument of *Radical Aesthetics* because it is not just that aesthetic radicalism involved multiple genres; rather, this concept unveils how artists attempt to transgress the boundaries between genres as Walker's novel shows.

The first half of *Third Life* is closely aligned with Brownfield, while the second half of the novel shuttles among Grange, Brownfield, and Ruth, with particular attention to the family patriarch. This shifting strategy produces a number of noteworthy effects. The alignment with Brownfield at the beginning of the novel encourages the reader to sympathize with him by viewing Grange's abuse and violence through his young eyes. The later positioning along Grange's perspective as he tries to protect his granddaughter situates the reader to see a character who had been an object of contempt as now arguably worthy of respect and sympathy. Walker's shifting perspective allows her to manipulate the reader's sympathies as well as undermine the expectations that the reader has of the central characters. Although neither character is completely trustworthy, as Ruth's perspective shows, both function as the site of ethics and responsibility at different times for the reader. It is hard to know whom to trust. Walker produces an unstable narrative for a story about conflict and the limits of familial trust. The shifting and unreliable alliances imagined in the text are the source of the shifting and manipulative narrative presentation. The idea of narrative uncertainty emerges from Walker's disjointed, poetry-derived structure and becomes an elaboration of the suspicion of kinship. Her family saga tracks the destruction of a family through a fragmented and untrustworthy narrative. Like Williams, Walker fragments the form of the historical novel structurally (through her poetic

composition and perspectival shifts) as a way to impede the narrative construction of collectivity, a central concern of the historical novel as a genre. She inhabits the genre to disturb the path toward collectivity.

From different perspectives, *The Third Life of Grange Copeland* and *The Man Who Cried I Am* put on display the Black Arts era treatment of the Blackness-as-kinship construct that Carmichael and Hamilton advance and Gilroy condemns. However, the novelists showcase both the weaknesses of the radical rhetoric of unity and its applicability. They take up kinship for the reasons that Carmichael and Hamilton explain. They also anticipate Gilroy's critique of kinship-based nationalism, but they do so from within the framework. In the novels, there is a definite recognition of the realities of anti-Black racism that encourage the formation of group consciousness and desires for self-protection and collectivity. That being said, Williams and Walker are mindful of the dangers of losing the self under the impress of the collective—whether that is a brotherhood or a family. These anxieties are put in the foreground and are expressed in terms of suspicion: a distrust of intimates as well as a distrust of the body itself. This suspicious sentiment is a critical strategy of engaging the discourse of kinship so that it can be unsettled. At best, there is an uncertainty about the viability of the emphasis on kinship framework in these literary texts. Walker and Williams acknowledge the conditions that create the desire for unity but register a persistent reluctance about it. The movement of this politicized imperative into the world of art entails transforming it from a demand into a question. The remainder of the chapter will consider how later writers take up this question of Black kinship-based unity and offer a solution that continues to move away from the framework of kinship, building on Black Arts era cultural productions.

Embracing Suspicion, Reimagining Collectivity

Creative writers producing after the Black Arts era continue to be interested in the cultural weight placed on the idea of Black unity, and they rely upon the discourse of suspicion in addressing the concept. If artists such as Williams and Walker present unity figured as kinship structures (real and imagined) to destabilize it, later writers use this exact destabilized unity to imagine new forms of connection through civic standing or social position as opposed to kinship. Political scientist Tommie Shelby's discussion of Black nationalism and solidarity is instructive in making sense of this turn toward positionality.[35] His work suggests that nationalism—with its reliance on kinship structures and concomitant gender ideologies—may have aided in making Black

relationships suspicious, but this mode of thinking can, ironically, become the ground on which secure bonds can be formed.

Shelby argues that shared racial identity and kinship do not provide a sound foundation for Black political solidarity, but he maintains that this solidarity still has significant social and political relevancy. He believes that it is possible to have a basis for unity among Black people that does not undermine individual or group differentiation and that allows for intragroup disagreement, while also upholding Black solidarity. By embracing the notion of social justice, Shelby insists that Black Americans can form cohesive groups. In countering a kinship model of nationalism, he contends: "My alternative suggestion is that we conceptualize black interests in terms of the unfair social disadvantages that some individuals or groups face because they are (or their ancestors were) socially defined as members of the "black race."... In this way, black political solidarity should be understood as black collective action in the interest of racial justice, not on behalf of an ideal of blackness" (150–51). In focusing on social justice and enduring Black social and political disadvantage, Shelby's work puts forward a conception of collectivity formed through social position instead of an all-encompassing and shared cultural or ethnic identity. Rather than thinking that Black Americans should be united because they constitute a figurative family, the notion of positionality indicates that a path to solidarity can be created by attending to how individuals occupy similar locations in the social world and have comparable interests and needs to be addressed. Instead of a racialized logic, there is a focus on sociopolitical circumstances. This emphasis resonates with the prioritizing of positionality that characterizes much of the scholarship that makes up Queer of Color Critique, which I discuss in the introduction. Therefore, one can recognize how Shelby's understanding of solidarity shares a foundation with the expressions of queer theory that inform my approach to the artistic engagement of nationalist ideology.

The theoretical movement from kinship and toward positionality that Shelby traces in his critical work serves as the foundation of more contemporary creative texts that explore the social and political viability of Black unity. Gloria Naylor models the shift away from kinship to positionality in her experimental novel *1996* (2005).[36] Naylor is an important inclusion in this analysis because her work is rarely considered in relation to nationalist paradigms.[37] She began writing after the peak of the Black Arts Movement, but her work as a whole continues the exploration of the construction of Black kinship that helped to define Black Arts projects. Her novels *Women of Brewster Place* (1982), *Linden Hills* (1985), *Mama Day* (1988), *Bailey's Café*

(1992), and *Men of Brewster Place* (1999) together signal a sustained interest in exploring the internal and external challenges to Black collectivity during the twentieth century and often present kinship connections as vexing. Building on the endeavors of its predecessors, the later novel *1996* invokes and then undermines the unifying Black kinship-as-unity paradigm. However, Naylor concludes this work by envisioning unity through the frame of a subject's social position. In the novel, suspicion functions as elemental to this rethinking of Black communality. Naylor uses suspicion to illustrate the limits of communal identification and to imagine innovative means of group affiliation. This foregrounding of suspicion as an ironic tool for connection shows how this discourse continues to circulate around theories of Black unity in literary culture. In addition, this novelist relies on a fragmented narrative structure to mount her argument about the need for fracturing and reforming the political construct of unity. John A. Williams's and Alice Walker's respective treatments of the historical novel lay the groundwork for the experimental narrative form that defines this twenty-first-century work.

The plotline of *1996* pivots around the question of the place of Black nationalism in the twenty-first century, and Naylor crafts the novel as an artistic outgrowth of nationalist thought and anxieties. It is important to note that Naylor published the book through Third World Press, an independent and Black-owned publisher started by Haki Madhubuti, Carolyn Rodgers, and Johari Amini in 1967.[38] The publication of this book carries with it an endorsement of a historically Black nationalist literary network. Nonetheless, *1996* has not generally been read as a work of literature and has been all but ignored by the world of literary criticism. In his discussion of the changing nature of racism in Post–Civil Rights U.S. culture, anthropologist John L. Jackson describes Naylor's novel as a text of racial paranoia because it unveils a Black distrust of White people and state power structures in the twenty-first century.[39] However, Naylor also details the fracturing of Black intraracial connections grounded in kinship. This novel critiques institutionalized racism as well as government intrusion on rights of privacy while also finding fault with the Blackness-as-kinship formulation key to Modern Black Nationalism. In its place, Naylor makes a case for solidarity around questions of the state's infringement on civil rights. She produces a fictionalized form of the argument that Shelby offers in his critical prose. Her novel is a text deeply rooted in nationalism, but it is one that deconstructs one of the ideology's dominant paradigms.

The question of social justice surfaces in the narrative because the protagonist becomes the subject of a secret investigation since she is deemed

to be criminal in her thoughts. In this novel, a government surveillance operation—the National Security Association (NSA)—victimizes a character named Gloria Naylor, and this constant monitoring causes her to question continually whom she is able to trust in her life.[40] It is not so much a particular act, but rather how people believe that she *thinks* that makes her guilty. Two issues rise to the surface in making Gloria a veritable criminal. First, the narrative suggests that (mis)perceived anti-Semitism leads to her being targeted (29, 32). Although the reader finds out from Dick Simon, the NSA director, that "[every] black, Latino, and Asian writer who has had any press coverage is on the NSA's Watch List," the fact that Gloria is believed to be a sympathizer with the Black nationalist Louis Farrakhan provides the second and definitive rationale for the technological eavesdropping. The narrative positions the protagonists' sympathy and affinity for Black nationalist thought as the characteristic that ultimately makes her vulnerable. This connection also positions the ideology itself under threat by state forces. Because her transgression ultimately involves what are deemed to be problematic ways of thinking in the world of the novel (anti-Semitism and Black nationalism) as opposed to a specific action, which would have a definite beginning and end, Gloria can never be free from suspicion. It is for this reason that the NSA surveillance does not cease even when Gloria is found not to be a threat to anyone. The persistent monitoring of her life functions as Naylor's extended critique of unchecked breaches of personal liberties.

Gloria's experience of constant surveillance fragments her sense of interiority, undermines her sense of agency, and establishes an antagonistic relationship between individual citizens and the government. The intrusive observation begins in a small town on the island of St. Helena off the coast of South Carolina. The NSA places listening devices in Gloria's home after she has a contentious misunderstanding with a Jewish neighbor who happens to be the sister of the director of the NSA. She is routinely followed whenever she goes out, and a base camp is set up in a house near her own on the island. The character insists that the most challenging part of the entire experience is the loss of control of her life (90). Any sense of self-determination that she might have had is interrupted by the constant monitoring of her activities. She goes to St. Helena for two reasons: to work on her next book and to cultivate a garden. This garden becomes a target for destruction as the surveillance becomes more intrusive into her life and personal space. The team of young men who are watching her from the house across the street decide to destroy the garden precisely because it has value to her (63). This team moves beyond simple information gathering by seeking to disrupt Gloria's

life and her sense of personal agency. Such microaggressions make plain the potential for governmental abuse to extend to the most quotidian and minor elements of life, thereby indicating the limitless nature of state power.

In response to this state-sanctioned physical and psychological accosting, Gloria makes an ostensible kinship move by turning to her Black male friend C. J. Hudson, whom she thinks of as a brother, for emotional support and guidance. She symbolically turns "inward," meaning toward another Black person for connection and protection. Unfortunately, she does not yet know that CJ has been enlisted to participate in her harassment. He is an academic and covert government operative and has been contacted to help in the investigation of Gloria. This Black friend cannot be trusted. Although he initially refuses to take part in the surveillance because of his friendship with Gloria, NSA Director Simon uses CJ's homosexuality as leverage against him: if he does not assist, he will be "outed," putting his career at risk. Connecting sexuality to suspicion, his sexual orientation makes him susceptible to this manipulation and ultimately a tool for Gloria's demoralizing. When Gloria discovers CJ running back from the house where the NSA team is holed up, she is emotionally devastated: "for the first time since this whole ordeal began, I cried" (76). Up to that point, all of the surveillance, no matter how invasive, seemed impersonal, but this Black male friend's involvement demonstrated to Gloria that there was no one, no matter how intimately linked, on whom she could depend or with whom she could share her concerns safely. This realization undermines any sense of racialized camaraderie that she had expected and makes everyone, Black and White, untrustworthy. This Black man's alliance with state-sanctioned White power unsettles her sense of security and threatens her sanity. What Gloria realizes is that she has no community nor can she ever have one. It is for this reason that she is described as "a woman alone" throughout the novel.[41] This descriptor is an indication of the instability and unreliability of kinship bonds.

The challenge to kinship connections is continued when Gloria returns to New York. Gloria is on the point of losing control of her mind because of the surveillance tools used on her when she retreats to New York, but her life there reinforces her experience of betrayal in St. Helena. The surveillance team uses high-tech mind control weapons to read Gloria's thoughts and put negative, self-destructive ideas in her mind: "I remember watching Mel Gibson's 'Braveheart' for the fifteenth time when the first thought came to me: *I am a bitch.* It seemed to have just floated up from the bottom of my mind. . . . *I am the worst bitch in the world. I want to kill myself.* Where

was this stuff coming from?" (99). This new psychological invasion is made possible through the complicity of another Black man, Gloria's neighbor Monty Swiss. Once again, Gloria has been betrayed, and a Black man is at the helm. Monty's jealousy and resentment of Gloria's financial and material success lead to his allowing the NSA to use his home to spy on her. Gloria refers to this mind control that Black men have aided and abetted as the "ultimate rape" (121). She uses a metaphor of bodily violence to talk about a feeling that is not confined to her physical body. The trope of mind control that structures the narratives is not unfamiliar in Black literary culture. The control of the mind was central to Black nationalist thinking during the Black Arts era.[42] The articulated desire to create and encourage new Black aesthetic practices itself is an attempt to reclaim the Black mind from Eurocentric hegemony. The concerns with gaining control of the mind and Black autonomy represent central elements of the nationalist priority of "closing ranks"; these ideas emerge here but do so in a way that makes the intraracial threatening.

Writing is another way that kinship is invoked in the narrative, but it comes to do a different kind of work from that done by the disappointing connections to Black men. Writing is closely connected to Gloria's gardening. In fact, gardening is a symbol for writing in the novel, and this connection explains why Naylor makes so much of the destruction of the garden. The disturbance to gardening is really an interruption of writing, which represents an endangering of her livelihood and a severing of a means of symbolic connection. More to the point, the association between these two activities also indicates a connection to conceptualizations of Black feminism. Within the African American literary imaginary, the motif of gardening functions as a pivotal expression of Black female creativity, especially at moments when Black women had little time or few opportunities to write. As Alice Walker's essay "In Search of Our Mother's Gardens" makes clear, gardening provides a space for stifled Black female creativity and identity.[43] Emphasizing the importance of gardening to Gloria allows Naylor to make the intertextual connection to Walker's work and to locate her writing in a Black Feminist artist lineage. In terms of the narrative, Naylor helps the reader to see that loss of agency and privacy—in the monitoring and the destruction of her garden—jeopardizes her sense of gender and professional identity as well. It is for this reason that Gloria feels as if she is losing part of herself. The writing-gardening linkage forges a connection to other Black female artists and extends earlier understandings of Black feminism.

However, the emphasis on writing in the text does not rest at establishing this racialized and gendered connection. Naylor chooses to have her protagonist decide that the only way to challenge her debilitating state of suspicion is through the act of writing:

> Writing, even under the best circumstances is not an easy task, and I was asking myself to write under an impossible condition. I asked my mind to dig in just a little bit more and pull up the strength to tell my story. I asked myself to look beyond the scars. The yellow pad was on the table before me and so was the pen. I only had to pick it up and start, one sentence a day. *If I could manage just one sentence a day, then I wasn't alone and I wasn't worthless.* It didn't matter how many were against me or how strong. If they couldn't keep me from that one sentence, I had won. (128–29; emphasis added)

Through writing, Gloria begins to negotiate the stifling location of suspicion and to feel valuable and connected once again. The discursive space of her writing liberates her from a state of isolation. The novel, a work consumed with illuminating many components of suspicion, also represents an attempt to end the paralyzing state of suspicion. In a 2006 interview with journalist Ed Gordon, Naylor calls the novel cathartic;[44] this adjective denotes the kind of release toward which Gloria writes. An implicit component of this catharsis is gaining the ability to feel a sense of connection with other people. Her writing is about connection and collectivity, ideas that are not necessarily limited by particular racial or gender boundaries.

In a sense, Naylor's novel is the most experimental work discussed in this chapter, and the nature of her experimentation participates in the conceptual impulse of finding alternative means of connection, a desire that contours her story. The narrative exists somewhere in the murky terrain between fact and fiction. Because Naylor gives the protagonist her own name and makes the character a well-known writer, the work has a clear autobiographical connection. Nonetheless, Naylor writes *1996* using a third-person omniscient perspective and not first person. This move allows the narrative to occupy the psychic space of not only Gloria but also Dick Simon. These are the two characters of focus of the novel, and much of the narrative vacillates between a concentration on Gloria and one on Simon. A significant portion of this memoiristic novel deals with Simon's personal frustrations and growing antipathy toward this woman he has never met: "What Dick Simon wants is for Gloria Naylor to just go burn in hell. He's feeling a growing hatred for this woman who has now invaded his dreams. Hating her is easier than hating himself for letting her matter" (78). The shifts in perspective, the vacillation

between Simon the investigator and Gloria the suspect, inside and outside the space of suspicion results in Naylor's presenting to the reader a narrative in conflict with itself. As with *The Man Who Cried I Am* and *The Third Life of Grange Copeland*, manipulating the story's perspective is crucial to the creation of narrative fragmentation. Moreover, *1996* represents both an intensification of the concept of the historical novel and a movement away from that genre. The fact that the novel roots itself in reality and appears to recapitulate actual events (i.e., the main character being modeled after the novelist) functions as an explicit exploration of the *historical* novel. However, the heavy reliance on speculation and knowing the unknowable (the access the reader has to the NSA director's thoughts) pushes away from the realm of fact and situates the text as a memoiristic work of fiction; it is a hybrid text.

Naylor's decision to include a factual addendum at the end of the novel is an outgrowth of this narrative construction. After the novel draws to its close with Gloria's insisting that she is in a battle for her mind, Naylor attaches three factual documents: John St. Clair's litigation against the U.S. National Security Agency, which details the National Security Agency's possibly illegal use of technology to monitor private citizens; Cheryl Welsh's "Survey of Evidence Regarding Mind Control Experiments," which discusses the development of mind control weapons by world governments and major institutions; and a short list of relevant websites concerning mind control. This addendum serves to corroborate the possibility of the novel's imaginative speculations and to transform the form of the text. This additional material unsettles the generic boundaries of the work that precedes it. This inclusion pushes the work back into the realm of the probable. It is a fictional text that roots itself in reality; it makes truth claims without asserting itself as fact. The novel bursts at the seams through these factual documents so that the narrative exceeds its own ostensible generic limits. The addendum establishes a textual intimacy between the author's experiences and those of other people, but this unity exists outside of the realm of racial identity; it is neither a kinship structure nor is it defined by race. An environment of social threat exists for multiple groups of people, across traditional identity boundaries, and such threats create an urgent need for coming together in some fashion.

The fictionalized Gloria situates writing as the means by which she can regain a sense of control over her life and mind, yet this act is also a channel for creating community outside of a framework of kinship. The narrative and its addendum serve as a source of information for the reading public. Naylor (and her protagonist) reaches out to the reader of *1996* through this

companion to the narrative. In actively connecting Gloria's story to the experiences of others through the addendum at the end of her novel, Naylor forges a connection to St. Clair, Welsh, and anyone else who is sensitive to the abuses of civil liberties and government intrusions (whether sanctioned or not) into the private life of its citizens. This move allows the novel to proffer a conception of civic solidarity rooted in positionality that reflects a shared stance of social critique. Naylor's writing functions as the foundation for connection for this imagined community of activists. The protagonist's conclusions about writing and the novelist's manipulation of her work's structure make evident that unity is possible and important, but kinship is presented as being an unsustainable avenue for it.

Naylor's *1996* displays how the key rhetoric of Modern Black Nationalism can be taken up and transformed in the contemporary moment. This hybrid text is interested in a specific series of injustices and makes direct connections to real-life cases and controversies. In doing so, it illustrates the pressing need for nationalist principles while reconfiguring the terms of possible solidarity. The intense questioning of kinship and narrative unity does not mean that the possibility of unity is completely repudiated in the pages of Naylor's novel. Although the kinship connection is found to be ineffective, the author envisions alternative means of forging connection and community. The work is a critical meditation on community that casts aspersions on the reliance on kinship-based unity for imagining sociopolitical spaces, and in the process, it offers a new basis for articulating identity and social change through unity.

From this perspective, one can recognize how Naylor anticipates Tommie Shelby's critical contention that collectivity can be productively formed through recognizing shared interest in equal social rights and opportunities in the civic realm. A conception of social justice is elemental to Gloria's writing on the NSA and mind control devices. The novel imagines a non-kinship-based solidarity, which is consonant with nationalist thought. In doing so, *1996* exemplifies the value of embracing a suspicious position, one that is resistant to notions of kinship and to abuses, while yielding a tenable form of unity. One can find traces of fragmenting suspicion in contemporary African American literary texts, but this phenomenon has also moved toward what theorist Eve Kosofsky Sedgwick would call a more *reparative* approach in that it attempts to re-create bonds and relationships while at the same time calling such connections into question.[45] The suspicion does not merely fracture bonds. It offers unexpected means of relation. In fact, *1996* ends on a note of hope that is basically absent from either *The Man Who*

Cried or *Third Life*. The formulation of a non-kinship-based solidarity makes this shift to the reparative hopeful and possible. The novel grows out of a particularly distressing dilemma: exhaustion with the paradigm of kinship exists alongside a recognized need for collective action. Such collectivity is at the heart of social revolution and the reimagining of the social world from the nationalist point of view. Closing ranks is still an imperative, but the idea that it needs to be rooted in racialized kinship is found to be undesirable and a cause for profound suspicion. In the social imaginary, suspicion of kinship structures does not necessarily incapacitate or isolate a subject. Naylor informs her readers that there is a constructive power to suspicion that can be harnessed for community formation. This tumultuous terrain is the ground on which Black solidarity and community are imagined in the twenty-first century, but this imagining has roots in the recent past. Within artistic culture, intraracial anxieties and feelings of distrust about such intimacies interrupt and reconceptualize the circuits of affiliation that function as the foundation of Black unity. The point is not that in the twenty-first century, no one relies on racial kinship or that there is an absolute rejection of it as a political framework. Rather, artists and political thinkers undermine the overdependence on this logic because of the limits it can put on the exact radicalism that it sets in motion.

The Bodily Logic of "Revolutionizing the Mind"

3

The Demands on Reproduction

* *Worrying the Limits of Gender Identity*

This chapter marks not only a turn to a different site of nationalist concern, but also a shift of attention in terms of the central argument from the nationalist framework of "closing ranks" to that of "revolutionizing the mind." In the world of expressive culture, the principle of *revolutionizing the mind* often means adopting new ways of imagining Black corporeality. *Negro Digest* editor Hoyt Fuller insisted that the political "rebellion in the streets" that resulted from the radicalized Black consciousness of the 1960s chiefly generated new means of assessing the Black body.[1] This chapter highlights how reproduction functioned as a conduit for the bodily consciousness for which the emphasis on revolutionizing the mind calls. The question of reproduction was a controversial source of debate and activism during the Black Arts era. In emphasizing the significance of Black reproduction to the realm of radical social protest, nationalist activists and thinkers not only employ the familiar body-state metonym, but they also situate reproduction as the primary analytical site for the production of social meanings of Black subjectivity. However, cultural producers such as Faith Ringgold, Toni Morrison, and Spike Lee inhabit this site of nationalism to show that reproduction as a rhetorical framework has exhausted its value. They make this point by exploring the conceptual limits of reproduction and condemning the logic it advances, while also providing new insights on the ways of thinking reproduction advocates.

During the Black Arts era, there were significant public disagreements about how Black communities should understand birth control and its place in the public sphere, and these debates became the focus of discussions of reproduction and helped to shape the larger theoretical terrain of Modern

Black Nationalism. As historian Jennifer Nelson explains, birth control became an explicit component of state policy in the United States during the 1960s.[2] The U.S. Department of Health, Education, and Welfare funded birth control clinics in many states.[3] Unfortunately, many women, particularly women of color, suffered medical abuse at these public clinics and state-funded hospitals, bringing to the surface the historical connections between eugenics and birth control as the works of Angela Davis, Dorothy Roberts, and Harriett Washington elucidate.[4] In this context, reproduction stands as a politicized site for analyzing the relationship between African Americans and the state as well as the possibilities for Black self-determination.

The discussions about birth control specifically and Black reproduction generally vary widely. Black activist groups such as the Student Nonviolent Coordinating Committee (SNCC) and the Black Panthers (pre-1973) campaigned actively against birth control, and key Black public figures such as Whitney Young and Roy Innis saw birth control as suspicious at best and genocidal at worst. To advocate for or use willingly birth control meant participating in racialized murder/suicide for these critics. Many of the public complaints emphasized that any local or state policies that encouraged birth control centers without also supplying total health care programs were shortsighted and discriminatory. There was often less a flat rejection of the pill than a critique of how and where it was being introduced and disseminated. Vocal supporters of birth control such as the Combahee River Collective, the Third World Women's Workshop, the Black Panthers (after Elaine Brown's rise to power in 1973), and figures such as Martin Luther King Jr. likened forced reproduction to enslavement and believed that Black women should have access to it if they wish.[5] The prohibition of birth control suggested that the Black body could become a site of modern-day enslavement. On either side of the issue, Black reproduction becomes overly invested with conflicting social values in public discourse and overlaid with contradictory race-sensitive ethical imperatives.[6] Because it is discussed as a site of agency and a site of manipulation, Black reproduction in general is imagined to be threatened *and* threatening at this historical moment.

Although these public disputes are significant to understanding the discourse around reproduction, birth control is not the focus of the discussion that follows. There were cultural producers who sought to explore the cultural significance of the pill. Black Arts dramatist Ben Caldwell's 1968 one-act play *Top Secret, or a Few Million after B.C.* stands as a prime example.[7] Reflecting expressed concerns about genocide, the play situates the birth control pill—the B.C. in the play's title—as a government conspiracy thought up to stifle the Black American population, which the White government officials

fear takes up too much geographical and civic space. Caldwell uses Black reproduction as an instrument for unveiling the racist structures that are an integral part of state administration. Creative consideration of birth control enables a piercing social critique and reveals the ambivalence toward reproduction, because it is vulnerable to social manipulation and because it can become the source of limiting representations of Black personhood. Rather than tracking artistic attention to the thorny dilemmas birth control introduces, this chapter explores how the discourse around Black reproduction in the context of the anxieties about birth control leads to increased attention to the means of and possibilities for gender expression. Demonstrating this idea, Toni Cade Bambara argues for the value of the birth control pill because of the control it affords women *and* men in the 1970 essay "The Pill: Genocide"; however, this consideration leads her to meditate on the social expectations of women and men that derive from reproductive obligations.[8] Examining the bodily freedom that the pill proposes results in a reimagining of gender roles. Talking about reproductive capabilities means talking about possibilities of gender identity. Modern Black Nationalism's ideological concern with reproduction (e.g., the birth control pill, population control, sterilization) produces opportunities to consider the modes of gender expression reproduction establishes.

Although reproduction's familiar function as the principal figure for expressing community stability and perpetuation makes it a staple in social and political theory of all kinds, my concern is with how reproduction functions as a site for formulating gender expression in the world of art. Black Arts era cultural producers often recognize the connection between reproductive obligations and gender conventions for both men and women, as the discussion of John A. Williams and Alice Walker in chapter 2 shows. Despite this definite link between reproduction and gender identity that emerges in such works, the three texts that I take up contest the employment of reproductive imagery as the necessary rhetorical channel for perpetuating gender identity. I discuss at length artists that seek to unsettle the gender categories that the nationalist axis of reproduction sets into place *through* the logic of reproduction. In different media, Faith Ringgold, Toni Morrison, and Spike Lee each shows the limits of the premium placed on Black reproduction by using it as the primary lens of their investigation, and in the process, each makes a demand for a new grammar of Black identity. The revolutionizing the mind principle finds expression here as a desire for a new framework for identity outside of the realm of reproduction. This understanding does not result in a flat rejection of reproduction; instead, it yields complex critiques of the social conventions reproduction engenders.

Regardless of whether reproduction is posited as a site of liberation or one of confinement, the logic depends on a deep investment in its analytical potential. There is an overvaluation of the reproductive Black body and what it signifies in Black nationalist cultural reasoning. Consequently, artists question the overriding investment in reproduction that makes both understandings (liberation and confinement) flourish. Ringgold, Morrison, and Lee survey the contradictory discourse surrounding reproduction to prove that it is not a sustainable means for social critique or for articulating modern Black identity. These cultural producers show that reproduction as a critical method inevitably undermines itself because of the contradictory social meanings ascribed to it. To make this point, each inhabits the divisive debates around reproduction circulating throughout nationalist thought. Significant to the consideration in this book, these artists demonstrate the key elements of aesthetic radicalism, the artistic engagement of nationalist rhetoric, by relying on formal manipulations as they translate the political anxieties around Black reproduction into art.

Recasting the Pregnant Body

Visual artist Faith Ringgold produced work during the Black Arts era that examines the rhetoric around Black reproduction. She is an important inclusion in this chapter because attending to her work creates the opportunity to make clear the significance of visual artists to the aesthetic radicalism of the time period. Growing out of her desire to address pressing social and political issues in the 1960s, Ringgold created a series of oil-on-canvas paintings called the *American People Series*. In her memoir *We Flew Over the Bridge*, she explains, "James Baldwin had just published *The Fire Next Time*, Malcolm X was talking about 'us loving our black selves,' and Martin Luther King Jr. was leading marches and spreading the word. All over this country and the world people were listening to these black men. I felt called upon to create my own vision of the black experience we were witnessing."[9] Ringgold sought to find expression for revolutionary fervor and social analysis in the realm of visual art; she saw herself as a "political reporter in terms of art."[10] For the *American People Series*, Ringgold developed a style that she called "super realism." The artist explains that her idea "was to make a statement in [her] art about the Civil Rights Movement and what was happening to black people in America at the time, and to make it super-real" (*We Flew* 144). She achieves this goal by enhancing "the political and psychological content through the use of stark imagery and a vivid palette."[11] The term *super realism* is also a play on the term *surrealism*.[12] Following the surrealist style, Ringgold attends to the

workings of the subconscious and the tests limits of the realist representation in her art. The "super" phrasing has to do with the employment of the fantastical to some extent, but it also registers the intensification of the degree as in a "truer" realism. Through the concept of super realism, Ringgold blurs the line between the unconscious and conscious worlds, the private and the public realms, thoughts and actions. As Lisa Farrington suggests, the paintings made in this manner reflect the "cloisonniste" style, which describes a form of post-Impressionism that makes use of bold forms and contrasting colors.[13] Ringgold's super realism embraced the Impressionist interest in real-life subject matter and the use of vivid colors, but she also relies on distortion and the manipulation of her figures for dramatic effect. The emphasis on color contrast allows the paintings to accentuate discontinuity.

Such discontinuity is the actual subject of the super-realist series. Ringgold portrays the acute disconnect between the ideals of U.S. democracy and the realities of the vexed interactions between different groups of American people. For example, #18 in *The American People Series: The Flag is Bleeding* consists of the U.S. flag with bright red blood dripping from the flag's red stripes. Integrated with the flag, three larger-than-life figures stand: a White woman, a White man, and a Black man. The three figures are linked at the elbows. The Black man is holding his hand on his chest as if pledging to the flag, but he is bleeding from a stab wound in the heart. This figure holds a knife but has the same satisfied look on his face as his two White peers. For Ringgold, the price of the equality and fraternity that the intimate positioning of the figures suggests is the Black man's blood—perhaps even self-drawn. Here and throughout the series, the promise of democracy is juxtaposed with the realities of discrimination, racism, and seemingly unchanging social conditions. Ringgold's decision to develop an abstracted, hyperrealist style of painting has to do with her sense of the immediate need for change that social conditions demanded but for which there were few definite solutions. The artistic method that informs the creation of the series concerns the translation of sociopolitical needs into radical aesthetic practices.

Although the *American People Series* explores pressing political questions through art, I examine the later *Slave Rape Series* because it relies explicitly on imagery of reproduction to intervene in nationalist-influenced conceptions of Black subjectivity and because this later series develops further the super-realist style. Ringgold's collection *The Slave Rape Series* (1972–1973) is a sequence of narrative paintings on quilted fabric that features depictions of ostensibly African women, some of whom are armed with weapons, in front of lush landscapes. The title is meant to suggest that the temporal coordinates of the setting are during the period of enslavement in the Americas. Ring-

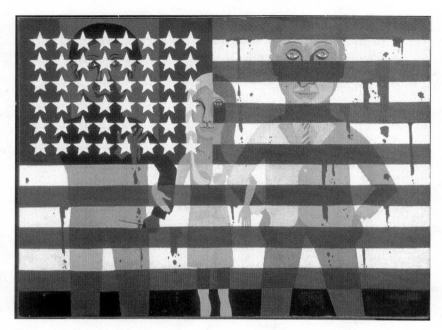

Figure 4. Faith Ringgold, *American People Series #18: The Flag Is Bleeding*. Oil on canvas. 72 × 96 inches. ACA Galleries. © Faith Ringgold 1967.

gold explains that for her the series constituted "a narrative in which [she] placed [herself] in the time of [her] female ancestors" (197). The visual cues in the painting do not indicate clearly the geographical setting; the viewer is at a loss to contextualize the figures. Ringgold does little to give the paintings a sense of depth, opting instead to have the nude figures appear flattened against a plane of trees and plants. Because there is no discernible depiction of the ground, several of the figures appear to be falling through the air help-lessly with arms flung up and mouths open in anguish and shock (e.g., *#13* and *#15*). In a few of the paintings (e.g., *#15* and *#16*) there are booted, white-appareled legs on the left side of the canvas that suggest someone is fleeing the scene. Significantly, many of the female figures are pregnant. Ringgold's decision to foreground pregnant nudes in the paintings is not merely about depicting the sexual dynamics that underscore the history of enslavement; she is commenting on contemporaneous attitudes of Black female identity through reproductive imagery. It is important to note that the *Slave Rape Series* is not only an outgrowth of the *American People Series*, but also of her 1972 *Feminist Series* of cloth-framed paintings made up of colorful landscapes with accompanying texts in which Ringgold attempts to grapple with the

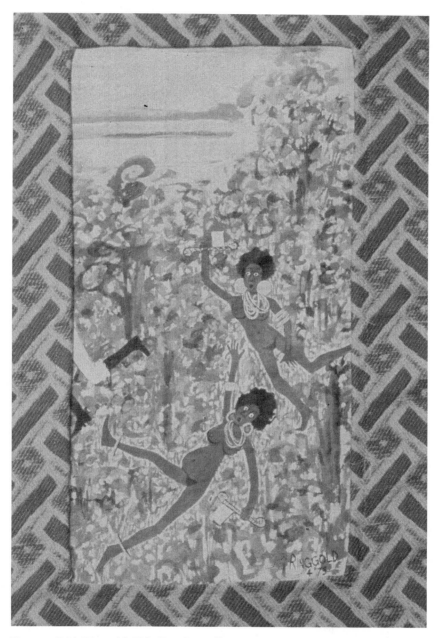

Figure 5. Faith Ringgold, *Help Your Sister: Slave Rape Series #15*. Acrylic on canvas. 53 × 22 inches. Artist's private collection. © Faith Ringgold 1973.

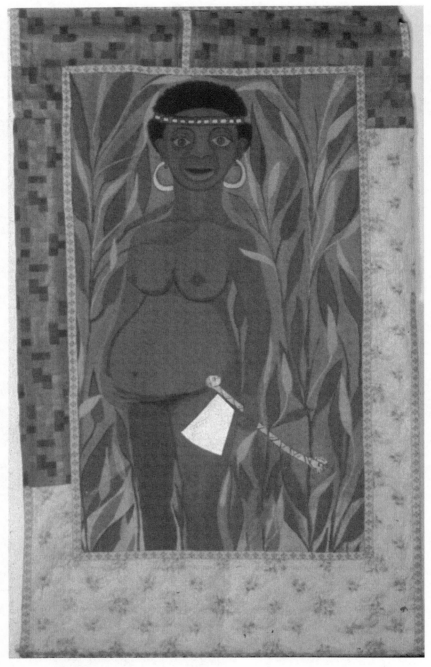

Figure 6. Faith Ringgold, *Fight To Save Your Life: Slave Rape Series 3 of 3*. Oil on canvas. 87 × 48 inches. ACA Galleries. © Faith Ringgold 1992.

possibilities of feminist thought and interpersonal connection. The exploration of the historical constitution of Black female identity and the meaning of Black reproduction that emerges in the 1972–1973 series is an outgrowth of this preceding investigation of feminism.

The title *Slave Rape Series* signals her feminist intervention into the public discussions on rape during the period. The language of rape pervades nationalist commentaries during the Black Arts era, but not always as a way to talk about sexual violence against Black women specifically.[14] "Rape" is deployed as a metaphor for the Black condition in America and especially the state of masculinity; it functions as code for emasculation. Eldridge Cleaver's discussion of how he became a rapist in *Soul on Ice* (1968) situates this regrettable sequence of events as, in part, a result of White patriarchal deforming of the Black masculine psyche.[15] The framework of rape is employed to theorize Black masculinity. LeRoi Jones provides an extended discussion of rape in his 1965 essay "American Sexual Reference: Black Male."[16] In the essay, he equates rape to robbery; in doing so, he presents it as an illicit transaction between Black and White men, which results in perversely stimulating pleasure for White women.[17] Black women's experiences of sexual violence are marginalized—when considered at all—in such analyses. This marginalization is reflective of a focus on manhood that can be so pervasive that even a discussion of rape has little to do with the female body. In her essay "To Whom Will She Cry Rape," Abbey Lincoln uses the language of rape to talk about sexual violence and to highlight the social silencing of women in the context of social activism.[18] Ringgold's move to employ rape as a framing device for her work represents a similar attempt to dislodge the concept from problematic deployments and recenter Black women in the conversation. The absenting of male figures from the series serves as the visual indicator of this strategy. The reference to "slave rape" appears to draw our attention to historical injustice primarily, but Ringgold also points to a prominent focus on rape in nationalist critique, which positions it as a device for articulating masculinity.

Ringgold's depiction of the pregnant figures in the *Slave Rape Series* stands in contrast to other circulating visual uses of the reproductive body. For example, this body functions as the basic means of analysis in the 1964 SNCC report "Genocide in Mississippi." The report forms part of the historical backdrop for the thinking in Caldwell's play *Top Secret* and the public debates about birth control and Black reproduction.[19] The SNCC document discusses Mississippi House Bill 180, which passed that legislative body on March 11, 1964, with a vote of 72 to 37. This bill sought to penalize the birth of illegitimate children by punishing the parents with a choice of either imprisonment for

one to three years or sterilization. Though the language was broad enough to apply to individuals of any race, the writers of the report demonstrate how the preceding debate itself was "anti-Negro": the report makes clear how the discussion on the floor of the house and the media coverage of the bill reflected an abiding interest in decreasing the number of Mississippi Black people on the "welfare rolls," and it shows that there was an expressed goal that this legislation would encourage Blacks to leave the state. Even if the bill was written in such a way to indicate no particular group explicitly, during the course of the discussion, the legislators turned the state's attention to Black reproduction. The seven-page typewritten report is filled with information about the specific social and legal abuses in Mississippi and the hypocrisy of the U.S. legislative system in general. Reproduction serves as the means for these macrocritiques.

In addition to this significant content, the title page of the report signals an anxiety about reproduction. This opening page features the grayscale outline of a woman whose face is in profile and whose body is in three-quarter profile. Her gaze is lowered, and her arms are crossed beneath her breasts at mid-torso. She is positioned in the left side of the visual plane. To the right of her are the words *Genocide*, *in*, and *Mississippi*, all of which contour her face. The downward positioning of her face suggests contemplation or perhaps shame. The location of her arms creates a stance that is determined and protective. Taken together, these gestures yield a framing figure that is apprehensive and fearful. The writers use the visual presentation of this figure and the content of the report to indicate that this framing figure is pregnant. This image provides a meaningful preface for the damning report. As much as the tone of "Genocide" is often one that is defiant and resilient, the report grows out of an absolute panic about what are perceived to be death-dealing actions on the part of the state that would weaken and ultimately deracinate Black communities. The initial image admits and archives this fear. This visual depiction situates Black reproduction as vulnerable and the female body as in need of protection.

These ideas are also present in the *Slave Rape Series*; however, Ringgold modifies such readings of the reproductive body and Black female gender possibilities. The fact that the nudes appear to be ungrounded or falling through the air suggests powerlessness and vulnerability. The frame of rape ostensibly works to enhance this understanding. Nonetheless, Ringgold's decision to illustrate several of the nudes with weapons (axes) in hand undercuts an uncomplicated reading of weakness. On first blush, the legs on the side of the canvas that seem to be in motion might be thought of as a violator fleeing the scene of the crime (the titular rape), but the presence

Figure 7. Student Nonviolence Coordinating Committee, "Genocide in Mississippi" cover page, 1964. Ellin Freedom Summer Collection. McCain Library and Archives, The University of Southern Mississippi. Courtesy of the Ellin Family and the SNCC Legacy Project.

of the axes introduces other levels of meaning. These legs in motion could also be fleeing from the idea of female-derived power and strength that the axe-wielding figure is meant to stage. Ringgold suspends her figures between the state of being agential and the state of being powerless, and the lack of perspectival depth creates this effect visually. Ringgold recalls the politicized conceptualization of the pregnant body as vulnerable that is elemental to the SNCC report, but she also recasts this vulnerability by scoring it with resistance and willful force.

This move to alter the presentation and understanding of the female reproductive body within the space of enslavement is also a move to deconstruct familiar gender categories that were available during the historical moment in which Ringgold created the painting sequence. The concepts of motherhood and warrior (or social actor) that are made present are often diametrically opposed within social discourse, as Lisa Farrington points out in her consideration of the series.[20] The realities of enslavement, which the paintings engage, meant that enslaved individuals who became parents did not necessarily have a right to their children and might not have had the opportunity to raise them. The emphasis on reproduction in the Black nationalist context resulted in an abiding concern with motherhood—not

necessarily parenthood. This exclusive connection between reproduction and motherhood evinces a conflation of the state of pregnancy with the work of childrearing in such a way that the father can be absented from the latter activity in favor of other forms of community building, resulting in a gender-specific, diametrically opposed division of nationalist activity: mothers and male activists.[21] This mutually exclusive state of affairs produces limited possibilities for women and constrictive gender categories for women and men. Ringgold's *Slave Rape Series* takes on this gendered division of political labor and unsettles it, as well as the historical understandings of women that aid and abet it. By seeking to undermine the binary itself, the series also implicitly questions the construction of the Black male as actor although he is absented from the visual plane of the paintings. Even though the viewer only sees the women, the depictions demand that the viewer reconsider the possibilities of Black masculinity outside of the framework of political agent divorced from the domestic realm by challenging its theoretical partner.

A deconstruction of Black gender constructs goes on throughout this series of paintings. With its visual explorations of kinship, motherhood, enslavement, and the body, Ringgold's art prefigures many of the critical moves Hortense Spillers would make in her seminal 1987 essay "Mama's Baby, Papa's Maybe." One of Spillers's most salient points is that the captive Black body in the context of the Middle Passage is an *ungendered* body:

> I would suggest that "gendering" takes place within the confines of the domestic, an essential metaphor that then spreads its tentacles for male and female subjects over a wider ground of human and social purposes. Domesticity appears to gain its power by way of a common name, more exactly, a patronymic, which in turn, situates those subjects it covers in a particular place. Contrarily, the cargo of a ship might not be regarded as elements of the domestic, even though the vessel that carries the cargo is sometimes romantically personified as "she." The human cargo of a slave vessel—in the effacement and remission of African family and proper names—contravenes notions of the domestic. . . . Because, on any given day, we might imagine, the captive personality did not know where s/he was, we could say that they were culturally "unmade," thrown in the midst of a figurative darkness that exposed their destinies to an unknown course. . . . Under these conditions, one is neither female, nor male, as both subjects are taken into account as *quantities*." (214–15; emphasis in original)

Spillers reads the experience of the Middle Passage journey as necessarily a degendering process because of the violent dismantling of domestic space and kinship ties as well as the preempting of the right to forge intimate con-

nections and express identity independently. The captives are caught in a spatiotemporal suspension of being ungendered while they exist as cargo or itemized objects. Although the equation of Black flesh with quantifiable consumer products was to continue after the Middle Passage, the gender suspension does not. The degendering that characterizes the journey is replaced by an act of gender misnaming, which constitutes the extended operation of enslavement. Spillers describes this misnaming as the process by which distortive naming practices are used to render the Black body into an object. The litany of stereotypical appellations such as "Mammy" (suggesting the ever-maternal and domestic-focused woman) and "Sapphire" (indicating the emasculating and unfeminine woman) used for Black women stand as examples of this fallacious naming that are rooted in a distorted and destructive understanding of Black femininity. These designations reflect a discursive grammar of false description. The gender misnaming apparent here comes to characterize modern Black life in Spillers's mind, and it develops out of and is a complement to the captive state of gender suspension.

Ringgold takes the fundamental ideas behind these two theoretical concepts—suspended gender and gender misnaming, which Spillers would develop in her essay years later—and makes them the subject of her radical paintings. The suspension of the figures in the paintings can be read as the liminality of their existence, the fact that they can be located between and among multiple planes of existence and identification. They cannot be pinned down by one simple reading. It is through Ringgold's suspended presentation that the gender misnaming comes under critical scrutiny. As my discussion has illustrated, the move to detail warrior-mothers is a purposeful attempt to disturb seemingly inflexible conceptions (or misnamings) of Black gender identity. Ringgold does not merely situate the category of mother as a problem, nor does she only claim a female right to the warrior construct. Instead she inhabits both, thereby suspending the viewer between the two categories throughout the course of the series. This choice does not call either single category into question; rather, it contests the means by which gender is both devised and expressed, the veritable machinery of gender identity off of which Black nationalist discourses fed. In describing the larger goals of her essay, Spillers insists, "we are less interested in joining the ranks of gendered femaleness than gaining the *insurgent* ground as female social subject" (228–29). The materialization of such gender-redefining female insurgency is iterated throughout the *Slave Rape Series*.

Although I emphasize the significance of the imagery of the collection, Ringgold's innovative method also contributes to her investigation of Black gender identity. She created the series using a Tibetan silk painting with an

embroidery technique called *thangka*, which she first employed for the *Feminist Series*. It is a mixed media form of art that entailed Ringgold's painting on quilted fabric. She also added geometrical African designs around the borders of the paintings. Her decision to use *thangka*-inspired quilt painting was, in part, pragmatic. Farrington describes how "[Ringgold] had been compelled to carry her large-scale paintings up and down the fourteen flights of stairs that led to her Harlem apartment" (128–29) for years; thus, the method of using portable quilts allowed Ringgold to transport her work more easily. The technique also allowed for a more immediate and intimate interaction between artist and artwork.[22] Ringgold's interest in the *thangka* technique suggests that the work of art in her mind is not exalted, but rather made a part of everyday life. This understanding places an emphasis on the materiality and tactility of her chosen medium. Evidence of Ringgold's labor (even her sweat) marks these painted canvases. Ringgold's stated attraction to the material means that she gains a different level of personal power through her chosen medium. She expands her artistic agency in a work that is about reimagining the expressive modes of Black women's agency.

The fact that this process involves using a quilt is of especial importance. Ringgold's mother, Wili Posey, crafted many of the quilts, so one must think of the series as a Black female collaborative endeavor.[23] The process suggests collective Black womanhood, and this idea is exhibited in the paintings through the repeated presentation of the nude figures in pairs.[24] The use of the quilts as primary material is also significant because it establishes a connection between Ringgold's work and that of Alice Walker. Walker's 1973 short story "Everyday Use," which revolves around a quilt, was written and published at the same time that Ringgold was producing her series.[25] In the story, the quilt stands for the contested terrain of Black female identity and creativity, central ideas in Ringgold's quilt-paintings. Like Walker, Ringgold does not employ the quilt only to elevate what one might consider to be traditionally woman's work; instead, the quilt becomes a symbol for the social significations of female labor of any kind and the designations that get ascribed to this work and ultimately to the women's bodies. The quilted fabric, this embodiment of domestic labor, functions as the medium for expressing female insurgency, and reproduction serves as the primary integer for this insurgency. Through these quilts of nudes marked by their reproductive capacity, the viewer witnesses a hermeneutical attack on common means for reading Black bodies. Ringgold uses reproduction to establish a visual interrogation of Black gender identity. She does not discard completely the framework of reproduction. She, like other Black Arts era artists, questions the understandings it encourages.

Engendering Community

The specific employment of reproductive imagery to dismantle gender ide-ologies in the context of Black nationalist impulses continues later into the twentieth century. Many African American artists remain interested in the impact Black nationalism has on social thought even after the Black Arts period. Novelist Toni Morrison and filmmaker Spike Lee exemplify this in-terest and produce works that question the nationalist premium placed on Black reproduction. I turn first to Morrison. In considering the engagement of nationalist thought in Morrison's novels, one might expect a discussion of *The Bluest Eye* (1970) or *Song of Solomon* (1977). In *The Bluest Eye*, her first novel, Morrison explores the viability of the popular nationalist expression "Black is Beautiful!" through the tragic desires of the impressionable child protagonist Pecola. In *Song of Solomon*, she investigates the group pressures for solidarity and community building as well as the politicized demand for social restitution in having Milkman Dead go on an epic search for identity. Morrison carefully crafts the narratives of both of these early novels around key elements of nationalist ideological concerns.

Notwithstanding these connections, the later novel *Paradise* (1997) is a useful text to include in this chapter because in it Morrison links an explicit engagement of Black nationalist thought with reproduction to dispute the construction of Black gender identity.[26] She offers a narrative treatment of the gender dynamics Ringgold considers in her visual text, but the novel probes the parameters of individual and collective identity by tracing anxiet-ies about reproductive lineage primarily. Explorations of the value and impact of nationalism suffuse the text. Morrison shuttles between Classical Black Nationalist concerns and Modern Black Nationalist concerns: she attends to the abiding concern with self-regulated Black geographical homeplace,[27] while also dealing with deep anxieties about the possibilities of communal-ity and the shifting meaning of Black embodiment in the modern world. This shift in focus emerges because the novel has a wide historical gaze: it moves from the end of the nineteenth century to the middle of the twentieth. Reproduction is the lens through which nationalist thought is expressed in Morrison's investigation. The narrative interest in the establishment of all-Black towns results in the triangulation of nationalist impulses, anxieties about reproduction, and the politics of gender expression. Although the Black families that found the towns of Ruby, Oklahoma, and (earlier) Haven, Oklahoma, in Morrison's final novel of her "love trilogy" desire to protect their communities from prejudice and violence,[28] the reader finds that this desire for security through these racialized enclaves is self-destructive.

Morrison links gender identity and reproduction through a geographical matrix. First, the investment in reproduction appears as a desire to found an all-Black town. The narrative describes the geographically ubiquitous "Out There" that surrounds the autonomous Black towns: "Out there where your children were sport, your women quarry, and where your very person could be annulled; where congregations carried arms to church and ropes coiled every saddle. Out there where every cluster of white men looked like a posse, being alone was being dead."[29] More than simply detailing attempts to protect Blacks from different kinds of social threats as expressed here, in *Paradise,* Morrison explores an anxious concern with the perpetuation of Black lineages and the lengths to which individuals will go to protect them. The establishment of the Black towns in the novel links an awareness of the past with a consciousness that emphasizes the regulation of reproductive practices. The ancestral leaders of these families responded to the travails of the post-Reconstruction period in U.S. history by looking for a Black town only to be "disallowed" from an existing Black settlement made up of light-complexioned Blacks (194–95). Their shared dark skin caused this "disallowing." A general fear of "scattering" held by the leader of the troupe Coffee (later Zachariah) Morgan intensifies the sense of collectivity that this rebuffing enhances:

> The scattering would have frightened him. The breakup of the group or tribe or consortium of families, or in Coffee's case, the splitting up of a contingent of families who had lived with or near each other since before Bunker Hill. He would not have had trouble imagining the scariness of having everybody he knew thrown apart, thrown into different places in a foreign land and becoming alien to each other. He would have been frightened of not knowing a jawline that signified one family, a cast of eye or a walk that identified another. Of not being able to see yourself re-formed in a third- or fourth-generation grandchild. Of not knowing where the generations before him were buried or how to get in touch with them if you didn't know. (192)

The concern apparent here is with the disappearance of the physical manifestations of familiar genetic or familial lines, the same manifestations that were the source of the disallowing. Both Haven and Ruby (where the primary narrative actions take place) symbolize efforts to stave off such loss while also challenging the thinking made present in the "color" refusal the families faced. The founding families' basic goal is to secure a viable future for themselves.[30] In these all-Black towns, there is a strong desire to propagate physical and character traits through the sanctioning of the public space of

the municipality. The community leaders cultivate a racialized interiority that is materialized publicly as a town. A reproductive logic grounds not only the settling of the towns, but also the very fabric of the narrative.

The novel foregrounds Coffee Morgan and his lineage as central among the town's twelve founding families, and through him, Morrison establishes nationalist drives for community building and reimagining identity. Although encouraged to move because of general social pressures, the specific impetus for setting out is Coffee's decision to create a new life after he and his twin brother Tea face racialized humiliation. Upon seeing identical physical attributes reproduced in two faces, a White man asks the two Black brothers to dance for him at gunpoint. Tea complies, but Coffee chooses to take a bullet in the foot instead. The narrative continues, *"From that moment they weren't brothers anymore.* Coffee began to plan a new life elsewhere. He contacted other men, other former legislators who had the same misfortune as his— Juvenal DuPres and Drum Blackhorse. They were the three who formed the nucleus of the Old Fathers" (302; emphasis added). As the quotation intimates, Coffee's decision to create a new life and later to change his name to Zachariah is more than a desire to distance himself from an environment that would degrade his character. This decision marks an aspiration to create a new lineage for himself, one that would not comply with threats of intimidation. Tea's decision to dance becomes a moment of demasculinization in his brother's eyes. He and Tea are no longer kin because they cannot be put in the same patronymic lineage—symbolized by Coffee's name change—nor can they be deemed as having similar perspectives and desires. The new life that Coffee begins to plan without his brother entails securing a stable means of masculinity for himself and the other men with whom he connects. Coffee sets out on a veritable project of gender production. The act of founding the Black towns is prompted by desires for new lineages and an uncompromised space for identity because of the crushing reality that he and Tea could no longer be brothers.

The serious expectations that contribute to the creation of Ruby mean that citizenship has stipulations. Because of the social directives that are part-and-parcel to membership, Ruby functions as what Katrine Dalsgard calls a "covenanted community."[31] Life in Ruby is guided by a code of ethics on which collectivity is defined and membership determined, and the unspoken covenant represents a pledge or vow to live by that code.[32] The forebears of the Ruby citizens had guaranteed that if "they stayed together, worked, prayed and defended together" and continued to increase the size of the community, they would never suffer the fate of other all-Black towns

(113). The mutual pledge to community and propagation creates a belief that the families of Ruby are immortal—according to legend no one had ever died within the town of Ruby. This maroon-like settlement is understood in terms of eternal security and immortality through lineage and firm ethical behavior and strict gender expectations for men and women.

Recognizing the weight given to lineages that constitute formal communities allows Morrison's exploration of nation building to become evident. I follow critic Candice Jenkins's understanding of the narrative as being infused with a Black nationalist outlook. Jenkins explains, "[rather] than interpreting this town, Ruby, as some sort of allegorical version of Euro-American nationalism—a critical move that takes the rather remarkable step of re-centering whiteness while discussing a text from which representations of whiteness have largely been excluded—I intend to read it as precisely what it seems to be: that is, a deeply flawed model of African American community building, driven by what is undeniably a black nationalist impulse" (283). The aspiration for control of autonomous geographical space suggests this nationalist understanding. The inhabitants of Ruby cut themselves off from the world that surrounds them to ensure this autonomy. They have sacrificed amenities such as television, police, and "discos" to obtain the solitude and safety of Ruby (274). It is only within this space—this minination—that these characters feel as if they can preserve the lineage and nurture their culture. The actions taken to protect the town and its inhabitants can be read as nationalist anxieties about both identity and secure communal space.

Although the discussion thus far has emphasized the inhabitants of Ruby, the women who live outside of the town's boundaries in the Convent (Connie, Mavis, Gigi, Seneca, and Pallas) are the primary focus of attention for the inhabitants of Ruby as well as many of the critical respondents to the novel. The building referred to as the "Convent" by the inhabitants of Ruby was once a Catholic school for Indian girls but is now an unofficial boarding house for people in trouble or for those who have nowhere else to go. The misnomer *Convent* can be attributed to the fact that nuns did live there from the time Ruby was founded until a few years before the opening of the narrative. This particular designation also reflects the Ruby community's internal focus on sequestering and self-seclusion, revealing more about the residents of Ruby than about the inhabitants of the outlying former school. It is more the way that some of the Ruby citizens view the Convent women and less who they are that leads to nine men—who represent the leading town families—from Ruby invading the Convent and attacking the women in the well-known

opening of the novel: "They shoot the white girl first. With the rest they can take their time" (3).

The Ruby community's general association of the Convent women with unethical reproductive practices gives way to this violent and disheartening course of events. Critics Magali Cornier Michael and Geta LeSeur among others have explained the supposed threat that the five women pose to citizens of Ruby by the fact that they are women who live without men and who appear not to need men.[33] From this vantage point, a patriarchal, masculinist drive motivates the attack. The significance of such thinking cannot be overstated. However, it is also important to consider the relationship of the attack to the narrative's emphasis on reproduction in its delineation of the feeling the Ruby residents have about the women living in the Convent. A host of events lead to the townsfolks' rising suspicion of Connie and her houseguests, all of which relate to issues of reproduction. The young Arnette Fleetwood goes to the Convent when she wants to hide her pregnancy. It is rumored that Connie assisted Soane Morgan with an abortion. One of the other social catastrophes blamed on the women is that "four damaged infants were born into one family" (7). In an attempt to get a reprieve from taking care of these same "damaged" children, their mother, Sweetie Fleetwood, ends up at the Convent one night, and she (as have others) claims to hear phantom baby cries coming from different parts of the house (130). The men who arrive to rid the town of the women's nearby presence are most alarmed by mysterious "infant booties and shoes ribboned to a cord hanging from a crib" because they find no child on the grounds (7). It is imagined that something improper goes on at the Convent in regard to children, whether born or not.

Suspicions of illicit homosexual practices exacerbate the sense of immorality about reproduction. After forcing Mavis, Gigi, Seneca, and Pallas to leave K.D. and Arnette's wedding reception, town patriarch Steward happens upon the women's Cadillac pulled over on the side of the road. Mavis and Gigi, always on the verge of an argument, had been fighting and end up out of the car "rolling on the ground, dresses torn, secret flesh on display" (169). Seneca is in the car holding Pallas, who is despondent. This exhibition of physical and emotional intimacy is too much for Steward. He later spurs the nine men to violent action by explaining succinctly the "problem" that these women pose to the town in these terms: "No men. Kissing on themselves. Babies hid away" (276). These women are not behaving as women should (meaning as socially acceptable mothers and wives) and are setting a bad example for the women living in Ruby. Therefore, they are imagined as posing a threat to the stability

of the community. A prevalent gender impropriety on the part of the Convent inhabitants becomes the galvanizing impetus for the attack.

The relationship of Arnette Fleetwood to the Convent is perhaps the most telling, because it reflects the Ruby community's perception of the assumed link between the Convent women and questionable reproductive practices while also making clear the community's obsession with lineage. Arnette's pregnancy is one that is socially unacceptable in Ruby. She has fallen in love with K. D. Morgan and has become pregnant by him outside of wedlock. As had many women before her, she goes to the Convent desperately seeking help. Angry at her body for having put her future in jeopardy, she arrives pounding her womb with her fist. The abused child dies soon after Connie delivers it, but Arnette flees before she sees the baby. The issue of legitimacy directs her down the seventeen-mile road between Ruby and the Convent. Arnette cannot have an illegitimate child, because that would mean that she would be an unacceptable mate for K. D. in his uncles' eyes given the severe conventions of respectability that govern male and female behavior in the community. The town historian Pat Best explains that an official marriage is vital to the town's future; it is critical to both families involved and the town's conception of itself (215). Arnette is the last hope for successful progeny for the Fleetwood clan, because all of Jefferson and Sweetie's children are damaged, and K. D. is the last of the Morgan line and the only available male "8-Rock" (the name given to the original founding families) whom she can marry. Both represent the end of a line; their child is the only guarantee that either family will continue to exist in Ruby. The threat of the disappearance of the original eight families signifies the end of the entire community itself, because these families are so closely linked to the collective sense of identity. The fact that immediately after her wedding ceremony, Arnette rushes back to the Convent to get the child that she had left there a year before demonstrates her investment in the need for social legitimation. Her anxiety about the context of her child's conception signals the scrutiny paid to every phase of reproduction. As she arrives, she announces, "'I'm married now. . . . Where is he? Or was it a she?'" (179). Displaying no remorse, she wants the baby back—the child that she had all but beat out of her body—when the child could be legitimized by the marriage ceremony, a ceremony that the town itself needed. Her troubling behavior and improper reproductive actions get projected onto the space of the Convent in the minds of Ruby citizens. Arnette went to the Convent in the first place for help with the "problem" that she was dealing with, because she felt that it was one for which the women there were best suited to provide help.

The social emphasis on lineages and lines means that unethical actions vis-à-vis reproduction cannot be brooked, nor can anything that might put the line in danger. From this perspective, the reader realizes that the most palpable threat posed to the community from the Convent women comes from Consolata ("Connie") because of her relationship with town patriarch and founder Deacon "Deek" Morgan. Connecting the events through narrative proximity, Morrison places the section of the novel ("Lone") that has the Ruby men meeting together to orchestrate the assault immediately after the section ("Consolata") that details Connie's affair with Deek. Deek's romantic liaison with Connie was troubling primarily because he almost left his wife for her, endangering the family line and the future of Ruby. He was not behaving as a good town patriarch, a good husband, or a good brother. Aligned closely with Lone's perspective as she eavesdrops on the plotting against Connie and her friends, the narrator explains,

> Nor could [Lone] have imagined how deep in the meat of his brain stem lay the memory of how close his brother came to breaking up his marriage to Soane. How off the course Deek slid when he was looking in those poison and poisoning eyes. For months the two of them met secretly, for months Deek was distracted, making mistakes and just suppose that hussy had gotten pregnant? Had a mixed-up child? Steward [Deek's brother] seethed at the thought of that barely averted betrayal of all they owed and promised the Old Fathers. But a narrowly escaped treason against the fathers' law, the law of continuance and multiplication, was overwhelmed by the permanent threat to his cherished view of himself and his brother. (279)

Therefore, two understandings make Deek's relationship particularly unbearable. The first is what one might call the "law of the father" or the divine commandment of reproduction that forms the basis of the town covenant. It is the men's responsibility to reproduce as much as possible in an appropriate manner. Connie's racial and ethnic background that might produce a "mixed-up" child renders her completely unacceptable for the 8-Rock community.[34] More importantly, Steward laments the possibility of losing the thicker-than-blood connection that he believes he and his twin brother Deek have because of their shared beliefs: the cherished view that they are more than twins but the same person. The mutual investment in reproducing their community actually functions as a means of enhancing their fraternity. That which is placed in peril because of the relationship with Connie is not only the propagation of the line, but also Steward's conceptions of himself and the world around him that he wants to see engendered in younger generations.

His fear is that he, like his forbear Coffee, will look at his brother and realize that they can no longer be brothers because of the loss of a shared investment. His desire for a new lineage gets linked to his forming new community so that the production of a line comes to lie at the heart of communal identity.

For that reason, the most important shooting is not the oft-mentioned "white girl" of the novel's first line, but rather Steward's shooting of Connie. The shooting of the "white girl" gets most of the critical attention because of its textual location and its evocation of racial identity and interracial relationships in the novel. However, it is this second shooting—which occurs in the narrative nearly three hundred pages after the first—that indicates that the prominent concern of the scene of invasion and violence is one of purity of the bloodline and fidelity to one's familial obligations. As the men are firing out of the Convent window at three of the women who are trying to escape after they have shot the "white girl," Connie walks into the room:

> Consolata enters, bellowing, "No!"
> The men turn.
> Consolata narrows her gaze against the sun, then lifts it as though distracted by something high above the heads of the men. "You're back," she says, and smiles.
> Deacon Morgan needs the sunglasses, but they are nestled in his shirt pocket. He looks at Consolata and sees in her eyes what has been drained from them and from himself as well. There is blood near her lips. It takes his breath away. He lifts his hand to halt his brother's and discovers who, between them, is the stronger man. The bullet enters her forehead. (289)

It is as if history is threatening to repeat itself as Deek and Steward stand in front of Connie with guns in hand, and Deek appears to fall in love with her again. Deek's attempt to halt his brother from shooting anyone else is a move to thwart the plans that they had made together for the protection of the town and become once more "distracted." The moment locks Steward into the past, a past in which the future of the Morgan line and the values of Ruby community was put into question. This symbolic temporal positioning is an unconscionable possibility for Steward. If ensuring the line is about ensuring the future, someone who forces one into a paralyzing past is endangering the line as well. Consequently, Steward shoots Connie between the eyes that once again appear to cast a spell on his brother.

It is important to read Steward's shooting of Connie and the attack on the Convent in general not only as a patriarchal destruction of a woman-centered and -controlled space—though I agree with this assessment—but also as a

desperate attempt to gain security and assurance for the community in an unsure time. It is a violent move to gain stability over Black racial and gender identity and the lineage of their autonomous minination. This assertion is not meant to make light of or de-emphasize the violence visited upon the bodies of Connie and the other women, but rather to help shed light on the manner in which the narrative draws to a close with actions that seek to protect both the present and future of the second attempt at paradise that Ruby's reproductive enclave symbolizes.

The characters' frantic and violent attempt to safeguard the communal identity of Ruby can help the reader to make greater sense of the last chapter of the novel and the actual conclusion. The final chapter is titled "Save-Marie," which evokes the Catholic "Ave Maria" prayer making the Convent and its history present, while also serving as a name of a child in the story who is need of protection. As the section opens, Save-Marie, one of Sweetie's children, dies. This passing is the only presence that Save-Marie has in the narrative. The placement of this child's death in the novel is important, because it appears after the invasion at the Convent. The symbolic power of Save-Marie lies in the fact that she is a child who dies. Children function as symbols of futurity, yet this child is dead. This dead child image frames the final events of the novel by serving as the opening image. Therefore, the denial of futurity or disappointed futurity is the lens through which we must read the conclusion and reflect back on the attack. No one in town agrees on what the actual sequence of events was that early morning at the Convent: some of the attackers try to make themselves seem innocent of any crime, and not one of the witnesses who shows up later is certain who fired at whom or if anyone fired at all (296–98). The stories do not match up.

Fueling the disagreement is the fact that no one can locate the bodies of Connie, Mavis, Gigi, Seneca, or Pallas. The women have seemingly disappeared. The families in Ruby cannot be sure what happens because they cannot account for the bodies. The bodies disappear because the inhabitants of Ruby refuse to account for or take into account the bodies and lives of these women. The disparity in the stories is not simply a desire that no one (or no family) seem particularly culpable. Rather, this inability to describe what happened signifies the limits of narrativizing. The idea that there are thresholds on narration recurs as the trope of the "unspeakable" and as formal breakdowns within several texts in Morrison's corpus.[35] The disagreements about what happened at the Convent reveal that the inhabitants of Ruby can no longer tell a unified story about themselves or about Ruby. It is not that the story is itself beyond narration, but rather that the people

cannot *collectively* form a story. This difference of opinion finds a parallel in the vocal dispute about the meaning of the phrase on the "lip" of the town oven. This oven had originally marked the center of the town of Haven, and when the families decided to move farther west and start over, they took the oven apart brick by brick to ensure its safe relocation. A town motto was inscribed on the lip of the oven, but the first few letters were no longer legible. The older generation insisted that the motto read: "Beware the Furrow"; the younger generations argued that the lip read "Be the Furrow of his Brow." This difference of opinion causes much strife in Ruby. The inability to agree on what happened exacerbates this discord. Thus, Steward's desire to protect the town has ultimately brought internal divisions to the surface. The obligation to reproduce properly introduces social dilemmas and even death. In other words, throughout *Paradise*, Morrison demonstrates how the ethnoracial commitment to perpetuate community can actually unravel communal ties. Through this work of fiction, Morrison advances the contention that the nationalist prioritizing of reproduction can compromise ideals of group identity mainly because of the codification of gender that it entails.

Morrison's novel is especially relevant to this discussion because of her narrative experimentation. Two specific elements of experimentation support the larger investigation of the investment in reproduction. First, Morrison's novel is ambiguous about the racial identities of the Convent women; it is always debatable who the White girl is as well as which of the other characters are Black. Morrison accomplishes this goal through obscure references and by giving textual clues that could be read in multiple ways. She manipulates the reader's expectations of how one writes about race and characterizes different racial groups. She stimulates the reader's desire to know and then disregards this desire. This feature of the novel recalls her short story "Recitatif," which was published in Amiri and Amina Baraka's 1983 anthology *Confirmation: An Anthology of African American Women*.[36] In both the short story and the later novel, the reader is denied a sense of certainty about the primary characters. Although there is an extended narrative focus on them, the reader leaves the texts in a state of doubt; the reader spends hundreds of pages (in the case of the novel) with characters without knowing basic elements of their identities. Morrison refuses an understanding of a novelistic narrative as explanatory or even revelatory. These fictional narratives impart confusing questions instead of knowledge. This narrative treatment functions as a device to offset the focus on reproduction within the plot. By manipulating the purpose of a narrative frame, Morrison provides a structural contrast to the senses of security and certainty that the town leaders believe that reproduction will

provide. The promotion of reproductive logic is about ensuring stability and order for the community-minded leaders of Ruby, but Morrison's narrative treatment introduces structural disorder into the text. *Paradise* reflects a narrative upsetting of the idea of reproduction-produced order and identity and questions the possibility of obtaining these. The text examines the nationalistic concern with reproduction as a foundation for collective identity and stability, but the novel's structure works to undermine such attempts at control and order upsetting the symbolic investment in reproduction.

The second and final element of Morrison's narrative manipulation can be found in the unmarked coda that closes the novel. The symbolism of the lack of a collective voice, as discussed, is the ground on which Morrison composes the last section. *Paradise* ends with a final, unmarked section that portrays the Convent women as ostensibly intact after the attack. Each of the women materializes in seemingly supernatural ways to loved ones from whom they had fled. Shown reestablishing connections to their past, these women are also preparing for battle. Gigi and Pallas are armed with weapons, much like the women in Faith Ringgold's *Slave Rape Series*. This supplement or appendage to the narrative is not a sequential element of it. Its presentation apart from the rest of the novel operates as evidence of disconnection; it exists in the space of a narrative break, suspended from yet related to the preceding course of events. The novel ends by stressing such suspension and disconnection. Anticipation of impending action fills each page of this spectral coda to this text. Although the last moment in the novel has been read as connecting the women not to violence but to loving and nurturing because Connie is being held affectionately,[37] the novel's final line, "Now they will rest before shouldering the endless work they were created to do down here in paradise," implies imminent, arduous actions for these figures. These women characters are on the verge of battle, and it is the town of Ruby that will be the recipient of this warring "endless work." In fact, the novel's original title was *War*. The question of whether or not the women have actually been resurrected and form a genuine threat to Ruby is immaterial. This coda that re-presents the assaulted women is provided to suggest that Ruby's stable sense of itself and its secure future are and will continue to be in jeopardy because of the town leader's own actions and investments. Whether or not the women will return, what they represent—the loss of community—has always been and will continue to be present.

The obligation to propagate and protect Black space is the exact force that threatens to bring about the town's destruction. The investment in reproduction that led to the attack on the Convent is represented as endangering

the community. As with Ringgold's series, the presentation of these warrior women who are also supportive and caring is an attempt to sabotage the codification of gender identity that the race-defined, covenanted community of Ruby endeavored to set into place. The coda, like the narrative ambiguity, reveals Morrison's goal of showing the collective belief in reproduction and perpetuation as defunct and even hazardous in a story of Black nation building. Morrison, like Ringgold, attempts to subvert and recast the codification of gender identity that the nationalist prescription to reproductive logic sets into place with the objective of recalibrating the means of gender expression.

Improbable Reproductive Resolutions

The emphasis on reproduction in Black nationalist thought yields unceasing attention to the parameters of Black gender roles. It is not only within the realms of prose fiction or painting that this project of rethinking Black gender protocols gets developed. Spike Lee's cinematic work takes up this gender disruption. Lee has explored the impact of Black nationalist thought in many of the films that he has written and/or directed such as *School Daze* (1988), *Do the Right Thing* (1989), *Malcolm X* (1992), *Get On the Bus* (1996), *Bamboozled* (2000), and *Red Hook Summer* (2012). His work is a crucial place to turn to in order to locate the artistic translation of nationalist discourse that constitutes the realm of aesthetic radicalism. Lee's work also provides an opportunity to think further about the relationship between the logic of reproduction and masculinity. Although many of his films demonstrate a concern with nationalism, the 2004 feature-length film *She Hate Me* proposes reproduction as a viable mechanism for resolving anxieties about gender identity and for rearticulating Black social agency.[38] The film builds on work done by Ringgold and Morrison.

Although Lee's film is a confusing narrative made up of many subplots that pertain to subjects such as corporate corruption, romantic dejection, parental and filial conflict, personal and social power dynamics, unrequited sexual desire, and imprisonment, the primary thread of the film pivots around the idea of imperiled Black masculinity. Lee relies on reproduction as a means of safeguarding this space of subjectivity. He manifests the precise social conceptions of reproduction that made it a vexed issue within nationalist thought. Lee employs reproduction as a device to resurrect Black masculinity because of its familiar conceptual connection to bodily liberation and empowerment. However, in making use of this paradigm, he ends up demonstrating the dangers that emerge from depending on reproductive logics:

being locked in the body and being vulnerable to exploitation. In *She Hate Me*, reproduction emerges as a site of agency and manipulation in terms of Black gender identity recalling nationalist debates on the subject in the twenty-first-century text. Lee embraces reproduction in an attempt to undermine the social conventions that it makes possible, but he ultimately upholds the exact frameworks he seeks to unhinge.

She Hate Me opens by presenting a Black male protagonist in a professional crisis that threatens to sabotage his sense of personal identity and all of his relationships. The film follows protagonist John Henry "Jack" Armstrong, who works for a pharmaceutical company called Progeia and is their youngest and only Black executive. The company is on the verge of releasing Prexalin, an AIDS vaccine, but the executive leadership is waiting on approval from the Food and Drug Administration. In the first few minutes, Jack finds out from scientist colleague Dr. Schiller that Progeia has falsified some of the clinical trial reports to the Food and Drug Administration to ensure that Prexalin would hit the market before a competitor's vaccine. Jack decides that it is his duty to turn the company in on an ethics violation, and this phone call costs him his job and freedom. Jack is fired, all of his liquid assets are frozen, and Progeia attempts to use him as a scapegoat to punish his disloyalty. He loses his livelihood and becomes a suspect in a national investigation. Finding himself betrayed by his own principled actions and in need of money, Jack agrees to a plan concocted by his ex-girlfriend Fatima to accept money for impregnating eighteen lesbians (including Fatima herself and her partner Alex) who want to have children. Jack seeks financial solvency as well as psychic redemption from the public shame of being fired through these reproductive acts.

It is not just that manhood is in crisis in Lee's film; rather, there is a historically specific expression of masculinity that is impaired and needs to be resuscitated through Jack's procreative acts. This understanding is conveyed most effectively through the presentation of Jack's father. His father is wheelchair bound because of diabetes-related illnesses. Lee provides close-up shots of the father taking insulin injections. Unable to walk on his own, this father figure is weak and almost helpless. He must be assisted in and out of chairs. Compounding this visible physical weakness is the fact that Jack's mother angrily yells at and criticizes her husband. In a highly familiar and problematic fashion, this Black female character functions as a vehicle of symbolic emasculation—verbalizing this idea, she even swears to cut his legs off if he will only bring her a knife. Moreover, the interactions between husband and wife occur with her at the top of the stairs and him at the bottom receiving what come across as harsh

reprimands, thereby illustrating a spatialized power hierarchy. Watching his infirmed father experience such treatment inspires the protagonist to include his father in his goal of redemption. The actor playing the father is Jim Brown, a former NFL Cleveland Browns running back, actor, and activist. During the 1960s and 1970s, Brown was an important public figure of Black masculinity, and he has maintained the status of being a cultural icon of Black manhood. In 2002, immediately before beginning *She Hate Me*, Lee produced and directed the documentary *Jim Brown: All American*, demonstrating his respect for Brown as well as the former athlete's social significance. Casting Brown in the film allows Lee to connect contemporary conceptions of masculinity to prominent ones from the recent past. It is not simply that Jack's father is disabled. Lee takes advantage of Brown's recognizability to suggest visually that the public masculine space that he embodied is also in danger.

Lee punctuates these depictions of wounded masculinity with visual imagery of Black male integrity, strength, and sacrifice to serve as imaginative alternatives. Two historical narratives provide the background for the presentation of the protagonist and his father: (1) the story of forgotten Black political player Frank Wills and (2) the story of the Black folk legend John Henry. Frank Wills was the security guard working at the Watergate Hotel who informed the police that questionable activities were going on.[39] Jack's father tells him about Wills when the protagonist is trying to decide what to do about his professional dilemma. Emphasizing his ethical position as a whistle-blower, Jack likens himself to Wills while he is on trial for his alleged involvement in the Progeia scandal. More than simply referencing Wills, Lee suspends the film's narrative structure by splicing in a scene that reimagines Wills's experiences into Jack's dramatic attempt to defend himself while on trial. This full reenactment or story within a story that departs from the course of the events in the film by interrupting the trial allows Wills to be resurrected from oblivion, and it suggests through cinematic juxtaposition that the principles embodied by this figure might live on in Jack's life and actions. Because it is through his humbled father that he learns about Wills, the memory of this figure becomes a component of his reproductive goal of masculine redemption.

Although the references to Wills are about principled masculinity, the allusions to John Henry highlight the body in formulating manhood. This folk hero, who has been the subject of many songs, novels, and poems, over the last century, was a steel-driver working for the railroad. Confident in his own strength and ability, he decides to participate in a contest with the new steam-powered hammer in an attempt to best the machine to save his

job and those of his colleagues who work by hand.[40] John does indeed out-perform the machine, but he collapses and dies after winning. This figure of achievement and self-sacrifice holds a particularly important place within the Black American artistic imaginary throughout the twentieth century.[41] Lee names the protagonist after John Henry and places a painting of this figure above Jack's bed—Jack's surname *Armstrong* strengthens this allusion. In several scenes, the viewer sees the central character sitting directly beneath the painting. Through this placement, John Henry's image gets linked to Jack's sexual activities at home. The equation between John Henry and Jack means that Jack's penis becomes his "hammer," but this connection suggests that there might be a danger to the use of this figurative hammer because John Henry dies in the tale. The viewer is overwhelmed by representations of masculinity: those of the past that are worthy of replicating and those of the present that need to be rejuvenated. Reproduction becomes the means for achieving both of these goals in the protagonist's mind.

From its first scene, the film positions reproduction as a means of self-preservation; Jack embraces it as a way to deal with his anxieties about and perceived threats to his gender identity. Immediately after Schiller tells Jack about the company's machinations, the scientist jumps out of his forty-story office window. Schiller's own silence (he uses the language of cowardice) in relation to Progeia's activities has depressed him to the point of emotional instability. Before committing suicide, he warns Jack not to allow his career to be his life. He dejectedly tells Jack, who is focused wholly on his career to the detriment of his personal life, that "careers are not real" (*She Hate Me*). He then advises him repeatedly to get married and have "lots of kids" within the first ten minutes of the film. *She Hate Me* promotes the same rule of mul-tiplying that drove the Morgans and the other founding families in *Paradise*. Schiller puts a life devoted to the working world in contradistinction to a life devoted to reproduction and creating a family, finding the latter more beneficial to a stable sense of identity and personal happiness. Because he has chosen the less meaningful career-focused life, he decides to kill himself. In Schiller's mind, familial relationships cannot and will not tarnish one's sense of self or endanger personal liberty as has happened with his professional dedication to Progeia. Reproduction is imagined as being able to ground one's identity and prevent life-threatening situations.

The first woman Jack impregnates is Fatima, and from the moment of their physical union, she is endowed in his imagination with the potential to help him remake and redeem himself. When Fatima and Alex approach him with the offer of $10,000 to impregnate them both, Jack is quite wary because of

his romantic history with Fatima. Any interaction with her is difficult for Jack because Fatima cheated on him with a woman while engaged to him. Her presence conjures up feelings of betrayal, humiliation, and emasculation. Unfortunately, his need for money outweighs his feelings of anger and inadequacy. Fatima insists that she wants to conceive the "old-fashioned way," meaning through heterosexual intercourse. Alex, on the other hand, is adamant that she does not "do dick," so she brings a turkey baster to get inseminated. This difference in preference causes relationship tension because Alex is concerned that Fatima still has feelings for John and is using the impregnation as an opportunity to "fuck" an old boyfriend (*She Hate Me*). Her motives aside, having sex with Fatima makes Jack want to right past wrongs against his sense of self that their relationship had caused. The impregnation appears to offer him a second chance to reclaim his sense of manhood.

Jack's sexual encounters with Fatima and the other women he later impregnates are worth considering, because heterosexual intercourse is made absolutely necessary for the women's conceptions. The film is not merely about the power ascribed to reproduction; rather, it explores the transformative capability of heterosexual intercourse because of its potential reproductive capacity. Fatima gets pregnant after having sex with Jack, but Alex, who refused intercourse, does not. The other sixteen women that Fatima brings to Jack to impregnate (for an inflated price of $10,000 a piece) all become pregnant after one sexual encounter with Jack. No matter how unsure any woman was about sex with a man—a stranger at that—they all have sex with him and all become pregnant. After three attempts at an artificial insemination, Alex is still not pregnant, so she resigns herself to the seemingly inevitable and has intercourse with Jack. She becomes pregnant immediately. Dismissing different steps heterosexual and homosexual individuals actually take to reproduce, heterosexual intercourse, which the viewer sees very explicitly, is imagined as categorical to reproduction—its only real condition. Even when Jack is unable to get an erection all of the women still become pregnant. This potency indicates how Lee invests heterosexual sexual intercourse with a fantastical quality. The women's collective attraction to Jack and willingness to sleep with him relay the film's deep investment in a compulsory heterosexuality.[42] Even though the film grew out of Lee's awareness of lesbian reproductive practices, he can only make these practices visually legible through heterosexual sexual encounters. Heterosexuality functions as the key component of gender identity.

The heterosexual sexual contact is essential to Lee as a director, because it allows him to indicate clearly the power of the phallus. Alex's continued inability to become pregnant shows that Jack's sperm is not particularly potent. His penis, however, in the act of heterosexual penetration is. The penis, then, is not only irresistible—no other woman considers not having sex with Jack—but it also has 100 percent accuracy when it comes to procreation. He is more successful procreating than he has been as a business executive. Jack's brother, played by the script's cowriter Michael Genet, jokingly refers to Jack's penis as a "magic stick,"[43] and this descriptor represents the exact understanding that is fundamental to Lee's storyline: Jack's penis is more than a penis. It is a fleshly transfiguration of John Henry's hammer that can do the impossible and the superhuman. It is an overdetermined physical emblem of heterosexual capability and masculine appeal. His reproductive penis promises a new sense of masculinity for him. Lee's decision to represent reproduction only through the images of heterosexual contact reflects the sexist and heterosexist parameters of his conceptualization of this character.[44] When asked in an interview why it was necessary for Jack to have explicit sexual intercourse with each of the women instead of using some form of artificial insemination, Lee responds to his male interviewer, "'What would you rather see?'"[45] Lee's emphasis on the visual significance of the sex scenes suggests a pornographic impulse in the film's direction and pornotropic structures within the film. More to the point, heterosexual penetration functions as the basis for the restoration of masculinity.

The techniques of excess and fantasy materialize in other ways throughout the film. After several bouts of sexual escapades, Lee visualizes Jack's exhaustion by inserting cartoon vignettes of decreasing amounts of sperm cells presented with Jack's face in place of the head of the sperm. These animated sequences signal the film's experimental quality. The curious cartoon additions enhance the trait of fantasy that infuses the film as well as demonstrate how the hypertheatrical is a primary feature of Lee's innovative cinematic strategy.[46] These sequences are added for dramatic effect: his waning strength and masculinity are transformed into diminishing sperm count with sluggish motility. The animation pushes the film from the realm of the realistic to the fantastic in terms of its generic categorization. Lee's plotline is unbelievable—for some it verges into the absurd. The animation signals a consciousness of that fictitiousness. The animated sequences make present literally Jack's state of being, and they do so by presenting sperm with Jack's energetic then exhausted face. The sequences link his identity to his reproductive capacity. He is his sperm.

However, this connection occurs through the frame of ridiculous animation that interrupts the actual events of the film. The cinematic structure suggests that the understanding of reproduction-as-identity is false and fantastical even as the events within the story align themselves with that understanding. This hypertheatrical element shows how the film is at odds with itself in terms of its support for reproductive frameworks.

Similar contradictions and oppositions emerge in the film's presentation of femininity. Lee's rendering of Black masculinity can be considered conservative or even retrograde. However, in the process of using reproduction to provide a bulwark for identity, he also manages to push the conceptual boundaries of common understandings of female gender identity—even though this breakthrough might be short-lived. This point might be a bit unexpected as there are well-known critiques of Lee's limiting conceptions of gender, especially in regard to womanhood. bell hooks makes clear how female characters such as Nola Darling in She's Gotta Have It sexually objectify themselves for the men around them in the name of being liberated.[47] Michele Wallace insists that Lee's films illustrate an overriding mistrust of female sexuality that contours many of the characters and situations that he constructs.[48] Moreover, B. Barton's film review of She Hate Me dismissed the film as little more than "an under the covers masturbatory fantasy for heterosexual men."[49] There is a consistent claim by cultural critics that female characters in Lee's films serve primarily to buttress masculinity and do little cultural work outside of this task.

Notwithstanding these important and influential analyses of his body of work, Lee does attempt a transgressive understanding of Fatima in She Hate Me as he inhabits the gender-forming discourse of reproduction. This assessment grows out of two specific moments in the film. The first occurs when Fatima and Alex visit Jack's house to propose having him impregnate each of them for cash. Frustrated by Fatima's surprise reappearance in his life and confused by the proposition itself, he asks, "You are lesbians, right?" (She Hate Me). Fatima and Alex respond in unison, "We are business women." They refuse to identify themselves using the terms that Jack supplies, and instead they redirect the conversation to their plan of farming out his body for their financial gain. There is a parallel moment that occurs between Fatima and Jack later in the film. In this scene that occurs after she has become pregnant, Fatima has decided that she wants to have an honest discussion with Jack about her sexual orientation. Aggravated, Jack queries whether she is lesbian or bisexual, but Fatima responds by asking why she

has to put herself in a "box" or classify her identity at all. The heated back and forth between the two moves toward the disclosure that provides the climax for the scene. When Jack asks her what she learned from the sexual infidelity with a woman that ended their engagement, Fatima emotionally responds, "I love pussy too" (*She Hate Me*). Sitting expectedly on his bed while Fatima stands, Jack was hoping to get definite confirmation of his ex-girlfriend's, now business partner's, sexual identity. She does not refuse to answer, but she does refuse to give him the *kind* of answer he desires. The theoretical value of her response lies in its ambiguity. Her answer could mean that she is sexually attracted to women *as well as* men (arguably bisexual). It could also mean that she, like Jack, enjoys and prefers sex with women (arguably lesbian), thereby equating their sexual desire and identities. That being said, she is reluctant to use any categorization for her desire. Similar to Jack, the audience members are left unclear and perhaps unsatisfied because of the uncertainty. This ambiguity allows the character to repudiate the terms for defining female desire and identity. This move could be read as a cop-out or a reactionary avoiding of self-definition, but there is a particular power in the refusal here and the one that precedes it in the film. Fatima situates herself outside of the gender and sexual discursive spaces in which Jack and the audience might forcefully locate her. Lee offers to the audience a female character that potentially questions the expected frameworks by which we make sense of female identity and desire.

The visual presentation of actress Kerry Washington in her role as Fatima and her scripted actions and conversation are meant to undermine further expectations one may have of this female character. In every scene that she is in, Washington is heavily stylized to appear effeminate in a socially normalized manner: she wears high heels; she is heavily made up; she has tight-fitting, sexually suggestive clothing, etc. The sartorial presentation is constituted by what are often recognized as visual cues of heterosexual sexualized femininity. This stylization ostensibly produces a reading of Fatima's gender presentation as a femme Black lesbian. By *femme*, I refer to the lesbian butch-femme spectrum. This formation itself describes two interrelated modes of gender expression and embodiment among sexual minorities that reflect identity categories as well as behavioral codes informing interpersonal interaction. The first term of the hyphenated pair describes identity performances of female masculinity and the second female femininity, both of which engage and complicate heteronormative conceptions of gender identity. Kara Keeling's scholarly work provides a lens for evaluating this presentation of a Black

femme character. In assessing the butch-femme formation of lesbian sociality in film, Keeling explains that her interest in the concepts of *butch* and *femme* has less to do with identity categories than with uncovering "an exploration of the constitution of those categories within common sense [that can reveal] the way that cinematic social reality is produced and about the possibilities for alternatives to that reality to emerge from within the processes of its production."[50] Similarly, in my use of the term *femme*, I am interested in the ways in which Black lesbians are rendered visible cinematically. Regardless of how the character might identify in the film, Lee presents her through the frame of a femme. He actively wants the audience to read Fatima's gender expression in terms of conventional femininity.

Spike Lee taps into the prevalence of butch-femme dynamics in lesbian relationships and self-presentations in crafting Fatima. He presents stereotypical masculine behaviors in Fatima's actions throughout the film. She is aggressive with everyone around and always seeks to be in control. She buys and sells Jack for profit, becoming a veritable pimp. Moreover, in talking about her infidelity that ends their engagement, she insists to Jack that she was the active sexual agent. Jack had assumed that Fatima must have been seduced. He maintained that lesbians are "like vultures," "worse than men," and that Fatima likely had little choice or agency in the encounter (*She Hate Me*). Fatima dismisses this account by stating that *she* had pursued the other woman. An aggressive masculinity emerges in all of Fatima's encounters. This characterization pushes against the femme visual cues, which might suggest more clichéd feminine traits such as passivity and vulnerability or being the object of desire rather than the subject. The point here is *not* that being femme forecloses the right to be empowered or that butch-styled individuals cannot be pursued, nor is it that the film tracks a shift or reversal in how this character identifies. Rather, through the crafting of this female character (her self-presentation, actions, and affective dynamics with others), Lee invokes stereotypical means for reading and making visible lesbian identity to manipulate and upset those modes of expression and interpretation. Lee creates a figure with a complex gender expression to question how we read gender. The character he offers to the audience entices us to think of her as femme but also disputes the preconceived notions that attend to this reading of the Black lesbian body. The character at the center of the film's reproductive business is gender-bending.

Unfortunately, the potential gender transgression that the audience gets a glimpse of through Fatima's character collapses under the weight of the

film's investment in reproduction and the gender roles that it creates. Gender conventions that derive from reproductive obligations smother Fatima and extinguish the challenges the character presents in the film. Mark McPhail argues that Lee consistently reinforces patriarchal masculinity even when he seeks to interrogate it because his films "exemplify an ideological and epistemological complicity with the culture he so persistently calls into question" in such a way that he undermines his "oppositional agenda."[51] This predicament destabilizes the challenging subjectivity that I locate in Fatima. Accordingly, the film is in conflict with itself through the development of her character as well. Lee takes seriously the task of questioning the boundaries of identity, but ultimately he is unable to prevent such boundaries from fixing the character development in the cinematic world of She Hate Me.

Connecting his sense of identity to reproduction, Jack believes that he can only regain his moral uprightness by asserting paternity. In one of the final scenes of the film, he tells Fatima and Alex that he wants to be a father to their children and become the patriarch of their home. He goes on to insist that they are his "salvation." Curiously, his other seventeen children that he helped to create do not matter to this righting of the self through paternity. It is the troubled history that Jack has with Fatima that makes her and her children integral to his reimagining of himself. Jack claims his rightful status as the biological father of Fatima's and Alex's sons—rights that he had legally abdicated. He goes on to claim a role as the proverbial master of the house. After explaining their importance to him, he kisses both Fatima and Alex on the lips and all three embrace.[52] Once again, Lee asserts the "power of the phallus" in presenting Alex, who did not "do dick," as having few qualms about allowing John into the women's parental and sexual relationship. More importantly, the audience witnesses the loss of Fatima's characteristic agency and the compromising of her subject status in favor of her apparent paralyzing attraction to Jack. Contrasting with her demeanor throughout the film, she becomes a compliant, dependent persona subject to Jack's will. The film may call into question normative gender roles and identity categories fleetingly, but it ends by establishing the conventions of reproductive heterosexuality.

The final scene of the film assures the reader that the characters of interest have formed a family unit. Alex and Fatima are on a beach with their two sons playing. Jack arrives with his wheelchair-bound father. The (grand)father is left at the top of the steps so that he can look down approvingly on the family scene in this public park. The father's symbolic emasculation depicted earlier in the film has been undone, and the emasculating mother is absented and

no longer a threat. There is no mention of the business world, the trial, or familial conflict in this Edenic setting. This moment in the film is achingly symbolic in that it unites harmoniously the past and the future (older and younger generations) around the male-headed family. Lee uses the camera angle and setting to foreground a family and to elevate patriarchy literally. Lee's desire to have Jack find this personal wholeness through reproductive paternity can be difficult to bear as it means sacrificing or subverting any other identity in the film and failing to undermine consistently the hetero-sexist thinking that informs the narrative structure. Nevertheless, the film embraces reproduction-as-identity only after questioning its gender protocol.

The final moment of the film puts forward a queer configuration of fam-ily, though neither director Lee nor character Jack is prepared to use such a characterization. The fact that the film can be read as an extended het-erosexual male fantasy does not out of hand evacuate the queerness of the Jack-Fatima-Alex relationship. This is not to say that the image of family that closes the film is absolutely radical. It does mean that Lee has to reconfigure the conventional understanding of family and account for the reality of same-sex desire to retain the investment in reproduction. This move questions the ability to maintain such an investment at all because of the length that the director must go to continue upholding reproduction. The attempt to hold on to reproduction as the basis for identity appears absurd. The outlandish-ness is the point in that it signals the impossibility of reproductive thinking and the length one must go to uphold it and the conventions it perpetuates.

By considering the construction of the final scenes of the film, the viewer comes to appreciate Lee's manipulation of photographic techniques to pro-duce a film with experimental qualities. *She Hate Me* is a film that gestures toward the realm of mixed media. While they are in the park, the characters are sitting facing the camera as if they are waiting for a picture to be taken. In essence, the film ends by staging a family portrait. This final moment serves as a parallel to and restructuring of the preceding scene in which Jack appears to pose for a picture with all of the children that he has sired along with their respective mothers on the stoop of a building. Here too, all of the actors smile into the camera as if preparing for a group photograph. The two scenes, which briefly stage photographs in succession, attempt to stop the movement that the camera itself depends on and documents. These near-static arrangements of the characters function as non–still photographs. Lee is trying to make the film do the work of a still photograph. He integrates the history and social meaning of photography through his visual suggestion of a still. Both Susan

Sontag and Laura Wexler link photography—and portraiture in particular—to the construction of kinship networks and domestic space.[53] Sontag explains that early on, photography had an explicit connection to the articulation of family life and relationality: "[through] photographs, each family constructs a portrait-chronicle of itself—a portable kit of images that bears witnesses to its connectedness . . . photography came along to memorialize, to restate symbolically, the imperiled continuity and vanishing extendedness of family life" (8–9). One can read Lee's insertion of cinematic stills as a symbolic attempt to materialize family and kinship-centered identity. As a still suggests, he attempts to stop time in order to secure the fantasy of family. Jack's actions of creating family are reproduced in the form of the film. The scenes of still photographs endeavor to generate stasis, one rooted in reproductive kinship. Lee exposes the thresholds of the cinematic form itself by moving to incorporate another form of camera work into the structure of his film. However, this clever inclusion is unstable at best. The cinematic camera never stops rolling. The portraits are mere stagings that ultimately feel false. This artificiality, which permeates the scenes, undermines the grounding of reproductive identity for which the protagonist grasps. The cinematic stills show Jack's goal of rooting his sense of identity in reproduction as well as the failure of this desire.

Media theorist Victor Burgin links photography, as a mechanism within the "field of representation," to the process of subject formation in general.[54] He explains how the "fixing of images," which describes the work of photographs, lays the foundation for the process of constituting subjects (188). In the context of Lee's film, reproduction functions as the discursive terrain—or field of representation—through which photography can attempt to generate the modern subject. Lee's technical manipulations are a means for suggesting the articulation of identity. The idea of the production of subject status through the appropriation of reproduction (as well as the strategies that convey it) becomes the focus of the innovative film and links Lee's cinematic work to the ideological emphases of Black nationalism and to texts that engage this system of thought.

Ringgold, Morrison, and Lee each contest accepted ways of thinking about Black gender expression, and they achieve this goal by inhabiting and manipulating images of reproduction. To varying levels of success, they interrogate the modes of reading the Black subject through the vehicle of the reproductive Black body with its attendant vexing social connotations. Read together, their different projects all epitomize the artistic engagement of the nationalist

premium on revolutionizing the mind, but they take this premium out of the realm of political rhetoric and work it into artistic strategies. Whether in visual art, fiction, or film, these artists showcase the limits of a social reasoning rooted in reproduction and make clear the inability of this reasoning to account for complex expressions of identity. These artists do not merely reject reproduction. They find fault with the gender role expectations that reproductive reasoning encourages. They dwell within such frameworks to unsettle their margins and begin to create a space for imagining alternatives. These artists continue to respond to the politicized desire to revolutionize the mind through the vehicle of the body.

4

The Space of Sex
Reconfiguring the
Coordinates of Subjectivity

The artistic engagement of Modern Black Nationalist rhetoric resulted in increased attention to the critical value of sex. The cultural weight placed on sex occurred because political liberation was expressed in terms of bodily freedom and because the language of intimacy functioned as the dominant vehicle for communicating social change. Specifically, there is a focus on heterosex acts and patriarchal heterosexuality as having special political value. An emphasis is placed on these sites because within the Black nationalist imagination, racism is thought to have distorted the meaning of the physical act as well as the social arrangements around it for African Americans. For example, statements by men and women at the 1970 Pan-African Congress make evident that revivifying patriarchal heterosexuality functions as a component of nationalist antiracist activism.[1] This idea recurs throughout the political writing and cultural activities associated with the Black Arts historical era: Eldridge Cleaver's collection of social criticism of creative writing *Soul on Ice* (1968), Assata Shakur's lyrical memoir about her 1970s court case and imprisonment *Assata* (1987), and Maulana Karenga's *Kawaida* philosophical system of thought all reflect an investment in patriarchal heterosexuality as a vital element in Black radicalism. The sex act (and its social implications) functions as the substrate for nationalist conceptions of the place of African Americans in the public sphere, and artists bring this embedded idea to the foreground to reconfigure Black social identity. This creative exploration of the sex act becomes an extension of the ideological paradigm of revolutionizing the mind.

The Blaxploitation film genre demonstrates this idea. Although it depends heavily on exploitative images and overwrought tropes of Blackness, the genre as a whole reimagines the possibilities of Black political agency while providing critiques of state power, racialized discrimination, and structural inequality. The genre often foregrounds sex as a primary analytic in its project of reenvisioning the social realm as films such as *Shaft* (1971), *Superfly* (1972), *Foxy Brown* (1974), and *Dolemite* (1975) demonstrate. Melvin Van Peebles's controversial and popular *Sweet Sweetback's Badasss Song* (1971) is often considered to be the predecessor of many of these films, and it illustrates how sex acts function as vehicles for nationalist analysis. This independent film that Van Peebles wrote, produced, directed, and starred in himself was shot in nineteen days using a small, nonunionized staff. Van Peebles describes the goal of the film as getting "the man's foot out of [his] ass" and claims that it features the "black community."[2] These statements suggest a political motivation in the film's design. The central action of the film involves the protagonist Sweetback's running from the police, and this situation allows Van Peebles to establish an antagonistic relationship between law enforcement and the Black protagonist.

Van Peebles's political story is told using a graphic sexual grammar.[3] He does not simply incorporate sexual encounters into the plot; rather, he showcases detailed sexual depictions in the experiences of the protagonist Sweetback and imbues the sex act with transformative powers. The scene in which the protagonist performs in a sex club exemplifies this point. This early scene is a sexual tableau that is directed by a Black man in a fairy outfit with a wand and wings who calls himself a "fairy godmother." The show starts with two women, one of whom is wearing a false beard and a dildo, beginning to have sex in front of a paying audience at this private club. Through the theatrics of this fairy godmother, the woman wearing the dildo turns into a naked Sweetback, and he completes the act to riotous applause. Illustrating the value placed on sex in the world of the film, Sweetback later ensures his evasion from the police through similarly graphic sexual encounters. Paradoxically, working in the sex club exposes the protagonist to the police—as he is arrested immediately after the show, but his sexual performances later provide his means of escape. The scene of sexual intimacy and nonnormative sexual expression enables a transformation of the self and blurs the line between the private and the public, thereby imbuing sex with a power to dislocate and redefine.

Van Peebles's film epitomizes the artistic engagement of sex as a site of Black nationalist discourse and serves as a manifestation of the premium

placed on revolutionizing the mind. Throughout the film, Sweetback is foremost a sexual actor; he is constantly performing sexually for an audience and achieves agency through achieving orgasms. Stephane Dunn reads this behavior as visualizing a rhetoric of "black phallic empowerment" or a masculinist parading of sexuality and phallocentrism.[4] This assessment illuminates much about the film. However, Van Peebles's methodology also reflects the pervasive employment of overt and transgressive sexuality as a means of social and political analysis during the Black Arts era. The transformative power attributed to sex derives from its ability to reorient Black embodiment and subjectivity. In Van Peebles's work and that of other artists responding to nationalist thought, sex attains a rhetorical power within artistic culture because it is understood as the basic element in the formation of publics as well as the notion of sociality. It functions as a boundary between individual identity and collectivity consciousness that has shifting coordinates. For many artists of the time period, sex is a tool for analytical critique in nationalist discourse. In *Dutchman* (1964), LeRoi Jones positions interracial intimacy as a radical and possibly destructive instrument for articulations of Black identity. Ben Caldwell writes the play *Top Secret* (1968) out of the anxious realization that heterosexual intercourse could function simultaneously as the site for the perpetuation and destruction of Black communities. Alice Walker imagines heterosexual intercourse as a means of exacting control over the female body in the distrustful relationship between Brownfield and his wife Mem in *The Third Life of Grange Copeland* (1970). This specific use of sex continues even after the Black Arts era.

Poet and cultural critic Calvin Hernton shows the weight placed on the realm of the sexual during this time period.[5] In *Coming Together: Black Power, White Hatred, and Sexual Hang-Ups*, he explains sexuality's role in the formation of Black identity and provides a framework for analyzing its appearance in artistic texts. Hernton makes the case that the premier way to understand the Black subject as social being and democratic citizen is to determine her condition as a sexual being. From this standpoint, political crises are resolved through the terms of intimacy, and sexual intercourse becomes a metaphor for political engagement. Sexual identity and expression are the conduits for the articulation of social liberation. The interpenetration of the sexual with the sociopolitical realm forms the exact basis for Van Peebles's explicit engagement of the sexual in his film. His presentation of a sexual outlaw argues for the fundamental relationship between sexuality and social liberation. Both filmmaker and writer insist that the political language that demarcates Black identity is ineluctably sexual.

Hernton's writing also marks a larger and ongoing nationalist interest in conceptions of social space and Black sexual identity.[6] The Black Arts era interest in explicit (read public) sex stands as a desire to collapse the distinction between public and private to reconfigure the coordinates of identity. The first section of this chapter shows that this dependence on sexual matter during the Black Arts era surfaces as a persistent inhabiting of popular understandings about Black sexuality that discovers artistic value in that which appears to be limiting: the sexualization of Black identity. As they replicate the nationalist focus on sex, novelist Cecil Brown and poet Jayne Cortez offer a challenge to the doctrine of patriarchal heterosexuality. Following this consideration, the second section tracks how the engagement of sex becomes the ground upon which later artists, particularly Black gay and lesbian writers, unveil the constitutive erotic dimensions of social identity by turning to Darieck Scott's experimental fiction. Artists such as Scott undermine the prioritization of heterosex acts that were integral to nationalist discourses. In invoking the nationalist connection of sex to social critique in order to manipulate its implications, the chapter models the strategy of disruptive inhabiting. These artists also expose the concerns with sex and space that suffuse the book as a whole. Each of the writers discussed relies on formal manipulation or experimentation as a device to transform common understandings of Black sexuality, understandings that nationalist thought encouraged. This connection between the critical engagement of sex and formal innovation reveals how aesthetic radicalism emerges in these texts.

Displacing Sexual Folklore

The reconceptualization of sexual and gender identity is integral to fulfilling the promise of the ongoing Black Freedom Movement. The realm of the sexual functions as an "undiscovered country" that must be mapped—just as political lines are being redrawn. Therefore, representations of the erotic can be read as attempts to identify the sexual folk mythologies haunting Blacks in public and private. Because the Black body has been a politically contested site, the writers I consider find that investigating the sexual folklore and stereotypes about this body enables the movement of political discourses into aesthetic terrain, the basis of aesthetic radicalism. Using the creative writing of Cecil Brown and Jayne Cortez, this section demonstrates that sexual myths and folklore become dominant means for exploring the social realm and the intimate realm simultaneously, collapsing the defining distinction between the two. The disruptive inhabiting of folklore about Black sexuality

is the primary means for effecting this spatial disintegration. These artists achieve this goal by invoking the sexual stereotypes that circulate around Black bodies to deconstruct them, and in the process, they produce innovative works of art.

Cecil Brown employs sex as a technique to examine the overlapping conceptions of the public and the private in the novel *The Life and Loves of Mr. Jiveass Nigger* (1969).[7] This picaresque text follows Black expatriate George Washington around the streets of Denmark. As the title intimates, the narrative details the sexual adventures that George has as he moves from one woman to the next. George presents himself as a seducer of women, and he seeks to make his private bodily acts the substance of his social identity. The form of the novel allows Brown to parallel the character's sexual escapades with his social experiences by narrating the two together. Although George wants to claim agency through his apparent womanizing, women often take advantage of him. Unsettling hypermasculine conceptions of Black masculinity, Brown makes George the object of manipulation, and in doing so, he uses sex to undermine formulations of Black male agency. He purposely situates prominently the patriarchal, oversexed Black man in the text to broadcast the unsound and flawed nature of the myth.

In *Life and Loves*, Brown describes George's sexual encounters with five women in the space of the narrative, but George's intimate encounters with the White woman Ruth Smith are the most significant to the narrative trajectory and to Brown's construction of his protagonist. Smith is the consul at the U.S. embassy in Denmark. George seeks out Consul Smith because he has run out of money and is in danger of being evicted from his boarding house. Beyond being a symbol of access, Smith is the textual nexus of all George's sexual encounters: he meets both the married socialite Mrs. Hamilton and the college student Gloria through Smith and her connections; he encounters Michelle at a bar only after Smith has provided him with an indenturing loan that makes the visit possible; and he seeks Smith's assistance to get money for Pat to have an abortion. George has sex with each of these women at some point in the narrative, and each of these sex acts is connected textually to George's relationship with Smith. This empowered White woman makes possible all of George's seductions. It is only because of and through her that he can claim for himself the title of "cocksman."

More than a fundamental sexual link in the narrative chain, Smith is important because the physical encounters that George has with her reveal the vexed feelings that he has about sex in all of his intimate relationships as well as the confused feelings he has about his body even as he confidently claims

the reputation of a cocksman. Brown describes their first sexual encounter in the private hotel that Smith rents for him in these terms:

> With one hand she tore his pants and grabbed his cock, with a grip so passionate that he screamed, only to have the sound drunk by her voracious mouth. . . . She began to breathe like a bull, and then she stood up and slipped out of her panties; still in her white blouse, she leaped on his cock grabbing it, jabbing herself with it, finally getting it in, and then pulling it up in her as far as it would go, she let out a scream that sounded like an attacking Indian. Then it was obvious to George that the woman was having a tremendous orgasm. She came for what seemed like a full two and a half minutes. She moaned low and lowly like a wolf. . . . He felt a deep joy in thinking that he would like to fuck her forever. Still there was a numbness at the back of his head, just beneath the head, where the neck starts. It was a though he had been lobotomized.[8]

This passage reveals that Smith is less a lover than a consuming, destructive force in this sexual encounter. She is imaged as a wolf, a bull, and an "attacking Indian," and George is little more than a tool to be controlled through his penis by this menacing force. George is barely present in the narrative description of the encounter. This scene offers the reader a symbolic reversal of what she might expect given the image that George seeks to present as the novel opens. When George explains to his fellow expatriates that he would go to the U.S. embassy to ask for money, they insist that the officials will turn him down. Spirited and defiant, he vows that he will use a gun or perhaps even his "cock" to get his way. This early equation of his penis with a gun suggests that he sees himself as a kind of sexual revolutionary similar to Van Peebles's character Sweetback. The conception of the penis as the primary means of masculine social empowerment brings to the fore the phallocentric way of thinking apparent in the Black Arts era imaginary and in the U.S. social imaginary in general. It also recalls the protagonist's phallic empowerment in Spike Lee's *She Hate Me* discussed in chapter 3. Yet, the reader does not find George exacting control or gaining access through his figurative gun in this scene or any of the other sex scenes that constitute Brown's tale. Smith manipulates George's penis as if it is an artificial dildo or sexual toy as opposed to a flesh penis attached to a sentient person. Because George's penis is not his own but an instrument of White agency and fantasy, Brown forces the reader to ponder, "Whose cock is it?"[9]

The recognition of this absenting of George for his penis can help the reader make sense of the feelings of "numbness" and of having been "lobotomized" that George references in his encounter with Smith. As Smith is approaching

climax, George contemplates further these sensations: "[While having sex with Smith, he began] to concentrate on the numbness; there was something in it, some message, something written on a piece of paper and placed in a bottle and sent afloat. Just then the woman tightened her legs around his back, and began to release slowly a long melodic line of AAAHHH's" (104). George begins to realize that there is meaning to the psychic numbness that he senses during the sexual activity—although the narrative quickly returns the reader's attention to Smith's pleasure before George can make sense of this "message." The sexual experience carries with it an inexplicable loss of full consciousness for George. The next morning George describes sex as a "symbolic death" (107). This description (or perhaps realization) clarifies the lobotomizing power of sex for him. He is not simply equating sex with death. He is becoming aware that sexual encounters can entail embracing a sexual *symbolism* that requires the death or loss of individuality. Through this sexual symbolism, the body becomes devoid of the mind—mental intelligence, deductive reasoning, cognitive awareness, etc. This understanding emerges at other points in the narrative as well. After having sex with another woman, George has a dream that he has a "Golden Cock" (79).[10] In the dream, he realizes that to possess this overdetermined emblem means that he must "risk his neck" or lose himself permanently to that image.

The "Golden Cock" dream sequence and George's dalliances show how the cultural symbolism of sex can lock one into the body and render the mind nonexistent.[11] The popular conception of the Black male as "stud" or cocksman is an instance of this exact symbolism that understands Black identity through the lens of the body. The Cartesian mind-body split apparent in Brown's formulation is a reconfiguration of other conceptualizations of Black male gender identity as being primarily about embodiment. One of the most well-known and disseminated examples of the articulation of Black masculinity primarily through a corporeal frame is Eldridge Cleaver's construct of the Black male as the "Supermasculine Menial" in his essay "Primeval Mitosis."[12] He uses this idea to explain the social understanding of the Black male as the ideal manifestation of male embodiment but as alienated or divorced from his mind. This figuration stands as the dialectical inverse of the White man as effeminized or unmanly but as having full access to mental capacity. In his thinking, Black manhood is defined first and foremost through the cultural understandings of Black corporeality. Through George, Brown questions the desire to be embodied as well as the act of being read socially as a body. Later, when George finds that he is facing another bout of lovemaking, he thinks, "*Oh, shit, no, noo, not this again. No more pussy.*

Wanna talk to somebody. Can you understand that, talk, communicate. No more pussy" (161). This rejection of "pussy" has less to do with an inability to perform than a refusal to be understood as a Black stud. This jiveass may have claimed to be a cocksman, but Brown presents a character that is unnerved by the potential of being understood as the bearer of a "golden cock." The text registers an anxiety about a specific conception of Black masculinity, which woman after woman in Denmark projects onto him.

The fact that George is understood through his sexual organ in Denmark forges an important connection to ideas about Black male embodiment in the United States.[13] George's friend Doc insists, "In Copenhagen one found America in its purest, most irreducible form" (53). Denmark is no escape from American racism and prejudice. As expatriates, the men place themselves outside the boundaries of the United States, but they are still embedded within a global matrix of racism. The conflation of these two geographical spaces happens because they share a figurative understanding of the Black body as always already sexualized. The movement of the Black body across geographical space produces no net change in the manner in which that body is understood as occupying social space. Moreover, one must keep in mind that Brown names his protagonist George Washington. This act of naming indicates that this Black character is endowed with the central values and beliefs of the United States, even if those values devalue Blackness. This symbolism that his name carries with it explains why the U.S. consul, an overseer of U.S. affairs in Denmark, directs many of George's actions. Smith rules over George because he embodies the ideals that underlie U.S. social thought. George's character, then, is a mythic cipher. He is a repository of cultural beliefs, both White and Black. Brown crafts this character with mythological attributes and meanings that transcend space and time to undermine them. He summons stereotypes so that he can destabilize their moorings.

The generic construction of the novel participates in this treatment of social ideas about Black masculinity. *Life and Loves* represents a twentieth-century picaresque novel. Stuart Miller describes this genre's defining characteristic as an episodic plot in which events rapidly pile on each other, creating chaos and confusion in the life of the peripatetic protagonist; this chaos leads to drastic shifts in the central character's circumstances and manifests the idea that the character has little to no ability to control his or her life.[14] This understanding clarifies the sequence of events in Brown's novel as well as the continual undermining of the protagonist's agency. Brown's George Washington is not moving from woman to woman as the narrative trajec-

tory seems to indicate; instead, he is being passed around from woman to woman. The remarkable number of sexual dalliances that happen in succession chip away at his sense of control over his life and self-identity. No woman falls in love with him or is given to undue "phallic adulation."[15] These women, Black and White, use him for sex and cast him aside. Both Gloria and Pat leave him for his friend Bob. Although George believes that he is seducing an innocent young virgin when he goes home with Michelle, he finds that she has set her sights on him and has brought him back so that she and then each of her housemates could one-by-one have her way with him. He ends up fleeing the house out of fear. George is running from the recognition that he has made himself into a sexual object. This character is often outwitted instead of living successfully by his wit. The picaresque form of the novel generates this episodic undermining of the character's agency and self-concept. Brown employs the picaresque form to present and then challenge George's conception of himself as a cocksman as well as the stereotype itself. This sequence of events suggests that George's character (and his conception of masculinity) is both the vehicle *and* object of satire in the novel. Frederick Monteser makes clear how satire has often functioned as an element of the picaresque form, so considering the layers of satire in the novel represents coming to terms further with the significance of Brown's choice in constructing the narrative.[16] The form of the novel creates the conditions for the satirical treatment of phallic identity.

The motif of jive that Brown uses to define George and shape the course of events in the narrative illustrates how George's oversexed character becomes the primary object of satire. "Jiving" refers to an African American cultural practice of joking with and manipulating another person.[17] Within *Life and Loves*, jiving also refers to a specific gendered game of one-upmanship that the male characters play. George presents himself as jiving when he fabricates a past hoping to seduce women and when he out-thinks or outperforms one of his male comrades. Illustrating how he sees the entire world in terms of jiving, he tells his friend Reb, "everything is a lie. Life is a lie. But people don't know that, see. Only smart people like me know that" (31). George believes that his jiving perspective—the fact that he has knowledge that others do not and that he actively takes advantage of this imbalance—allows him to see to this truth.

Ironically, the reader finds that George is often jived and tricked by others. He believes that he has manipulated Ruth Smith into helping him by inventing an identity. He says that he is a Princeton alumnus named Paul Winthrop who is down on his luck. Little does he know, Smith finds out that he is lying

and *allows* him to continue believing that he has duped her. Moreover, he is consistently "out-cocked" by his fellow expatriate Bob. He says to a friend, "I think I hate Bob because he is Satan, because he makes me conscious of myself, *conscious of my attempts at finding something solid*. Everything that I have experienced in this city has been tainted by his presence" (203; emphasis added). His relationship with Bob stands as evidence of his inability to jive well. His complex networks of jiving, then, are dissolved in the course of the narrative. The fact that George finds out that Bob, the supreme jiver, is being jived by his White wife completely undermines the ostensibly Black masculine strategy for identity (jiving) that George has used to define his life and actions (193).

Besides being an instrument for a satirical undermining of the protagonist, the jiving motif also functions as a way for Brown to introduce folklore into the narrative. William Wiggins Jr. argues that the novel itself is a "literary extension of Afro-American folklore" (269). Wiggins places the novel in the trickster tradition in general, but he also points out Brown's use of tales about the legendary trickster Efan in particular.[18] Not only are Efan's experiences recounted in the story in bar scenes, but George also calls himself "Efan" in his attempt to seduce Michelle. Through his jiving, he identifies himself as a trickster figure, so his story represents the tale of a modern day trickster although the reader discovers that it is he who is the butt of the joke. The contention that George is a trickster figure also helps to cement the reading of the novel as picaresque text, as the protagonist in such novels becomes a trickster to (re)gain agency in response to a manipulative world. Stuart Miller explains that in becoming a trickster, "the hero makes the only choice other than suicide that the world offers him. . . . Having become a manipulator of appearances, the picaresque character settles into the non-reality of becoming an appearance himself" (56–57). The notion that the protagonist is a trickster figure connects to African American oral and narrative traditions and to expressions of collective identity, but it also helps to frame George as a character that is at a loss for interiority, a situation reflected in the descriptions of his sexual encounters.

Brown uses the formal organization of the novel to contribute to this understanding of this character. He calls the section of the novel that tracks George's sexual encounters a "tale" conjuring conceptions of a mythic hero. He prefaces this tale with a prologue, which is subtitled "A Prismatic Account of Some Important Matters," that introduces the reader to George's history. The prologue itself begins with a meditation on "cussin." A female speaker laments the fact that her husband is "the cussinges' man ever born" (4). In

the process of complaining that she "can't stand no cussin man," she proposes that "a nigger man cuss because he is so poor and ain't nothin' but a nigger" (6). From this realization, she goes on to hypothesize that perhaps "cussing is his way of testifying" (7). These individual obscene expressions (curses) are described as *public* ways of getting to or expressing truth. Although the speaker opens by critiquing vulgarity, she ends by recognizing the value in it as a practice or a method. Therefore, it is through this "prism" of the value of obscenity that the reader should assess the tale of this supposed trickster that follows. The lewd sexual behaviors become elaborations of the "cussin'" that the prologue examines. Brown's structure of the text inserts obscenity into the African American cultural folktale form to show the value of the vulgar to the colloquial expression of Black culture and identity. Two strategic reversals characterize Brown's attempt to reimagine the sexual folklore surrounding Black embodiment: he inhabits hypermasculinity to challenge it, and he embraces vulgarity so that he can offer an unexpected positive appraisal of its value. This treatment becomes the means by which he can suggest the need for new modes of expressing Black identity.

The artistic decision to recast the perverse and the sexually explicit that emerges in Brown's novel provides a hermeneutic to evaluate Jayne Cortez's Black Arts poetic ventures as articulated by her two early books of poetry *Pissstained Stairs and the Monkey Man's Wares* (1969) and *Festivals and Funerals* (1971).[19] Cortez's work confirms how Black Arts poetry participates in the project of investigating sexual folklore surrounding the Black body showing how this move to attend to the sexual in relation to Black identity is not limited to a single genre. Her poetry extends the reach of critiques present in Brown's novel; she provides explicit attention to social conceptions of Black women and sexual minorities. D. H. Melhem describes Cortez's first book in these terms: "*Pissstained Stairs* sets forth the poet's political take on ghetto life, her identification of the working class, her love of music, including the blues as well as jazz, and of its heroes; *and her pervasive use of the body, with all its senses as surreal metaphor.*"[20] Melhem's curious description of Cortez's use of the body is her way of referencing the graphic explorations of sexuality within the volume. The attention to the body that she signals in Cortez's poetry drops out of the remainder of her discussion of Cortez's work and her later interview with the poet. Although critics occasionally mention the importance of the body or sexual imagery in Cortez's corpus, their considerations turn away from these elements quickly.[21] However, even in critical analyses that attempt to emphasize some other element of Cortez's style (e.g., music), one finds that references to the body and sexual metaphors still emerge.[22]

This inevitable return to the body in the critical discussions derives from the fact that Cortez directs her attention to physicality and bodily intimacy in her work. In both *Pissstained Stairs* and *Festivals and Funerals*, Cortez inserts visual drawings done by artist Melvin Edwards—whom she would later marry—that are mostly made up of phallic, vaginal, and uterine imagery. These drawings complement the sexual content of many of the poems. For example, a poem from *Pissstained Stairs* titled "Love" that cries out for such affection—emotional and physical—in desperate, destructive circumstances is juxtaposed with a sketch of an abstract form with what appears to be an erect phallus. The highly representative image can be interpreted as a visualization of the poem's call for "a midnight piece rammed tight in loose warm wetness anointing the spit head" that will provide the "tender strokes of passion caught between lungs breathing out the gate of / moans on those days when sadness cracked & suffocated."[23] The drawing also calls to mind the image of a fertility statuette, which suggests that reproduction might be symbolically paired with sexuality here as a possible solution for the frustration and social suffocation alluded to in the poem. Read together, the poem and image insist on a need for physical intimacy, and this need for and utility of the representation of the physicality of love undergirds the entire collection.

Illustrating the dependence on physicality in her poetic logic, Cortez proffers an expression of racial identity through graphic sexual imagery in the poem "Race." This poem that sets out to be about racial identity and race thinking begins by addressing "Black Man," the "breeder of the great race." The poem is an extended caveat to this figure about his son:

> Your sons tongue hangs low
> with loose diseased pink
> pale dying flesh
> between gums
> suffocating in farts
> & howling like a coyote in the wind
> his bent over dedication to the grunting demons that madly
> ride upon his back
> flying high his ass tonight
> swallowing sperms of fantasy
> in this great Age of Reality
> . . .
> the illegitimate passion of a so-called love affair
> meant only a smack-dab in a greased ass
> from the holders hard-rod (14)

Cortez presents a disturbing scene here in which the sexual acts of "rimming," anal penetration, and fellatio introduce not only death but also fatal and confusing delusions ("sperms of fantasy") that will ultimately destroy this son. These sex acts are presented as being dangerous distractions for this individual that can also endanger the racial community—hence the need for a warning. The speaker in the poem is critical of interracial male homosexuality; the images of a Black man being penetrated by a White man are the primary source of the speaker's grief. These negative sentiments resonate with other late-twentieth-century statements about homosexuality being a definite threat to the Black community.[24] Cortez wrote the poem specifically to think through the question of homosexuality in relationship to revolutionary action.[25]

The poem offers the opportunity for Cortez to examine the stereotypical idea that sexual minorities pose a threat to the larger community; the reader is forced to occupy this belief as well as its attendant anxieties. The speaker goes on to lament, "what good will he be / when the time is here / a non functioning product / Used openly against We" (16). This private act that the reader is witness to through the speaker's descriptions is understood as being an act of public defiance. The subject of the poem is rendered a "non functioning product" because his sexual actions do not fulfill a procreative function. This intimacy with the White body works against the racialized militantism, which the speaker avows, that would purge the "White shit" mentioned in the poem's final line. The speaker makes clear through the homophobic imagery that configurations of Black community (the "We") and Black racial identity are only possible through a heterosexual framework. Nonreproductive intimacy is imagined as destructive and dangerous.[26] Moreover, fraternizing across the color line in any way is equated with subordination to a White social hierarchy in the poem. The speaker's comments indicate that the son's actions constitute a reactionary as opposed to revolutionary way of being. Homophobia is strategically deployed here as the primary device through which heteronormative boundaries of Blackness can be erected.[27] Nevertheless, this employment renders the construction of heterosexuality as unstable and insecure because its definition grows out of the nonnormative. Cortez uses the homophobic imagery to apply pressure to patriarchal heterosexuality that the "Black Man" figure manifests.

However, these are arguments that could be advanced without the images that Cortez relies on in this poem. Why, then, is the reader exposed to these particularly graphic sex acts? Why does the reader need to visualize these acts of intimacy? The answer to these questions lies in the emphasis the speaker places on what I call the "crisis of the visual" throughout the poem. After

describing the subject's seeming perfidious intimacy, the speaker questions, "Is there / a place to cure / this strange illusion / this prancing agony"? (15). The primary component of the problem that the speaker takes up is the fact that young men have become sexually delusional so that their behaviors are determined by undesirable images and ideals. The son figure is driven by a misdirected imagination. The speaker in the poem connects this state of illusion with intimacy with Whiteness. In addition to shedding light on this White-derived misdirection, the quotation also implies that part of the problem is that the speaker (along with other members of the Black community) is forced to bear witness to physical enactments of these destructive fantasies. The speaker can see—and feels as if she is forced to see—homosexual intimacy even in nonsexual acts.[28] It is as if the subject's body carries visually with it evidence of the "smack-dab in a greased ass" at all times so that even the son's walking becomes a sexually suggestive "prancing." The poem as a whole depicts this constant visual expression or public showing as destructive. Ironically, only in representing this public sexual perversion can the speaker of the poem inspire action (by the addressed "Black Man") to scotch the detrimental lewdness. The speaker needs the reader and the addressee to imagine and even inhabit the erotic scene.

The speaker's desire to have the reader dwell within this scene and occupy this space of observed betrayal reveals how the crisis of the visual in the poem quickly becomes a spatial crisis as well. In explicating the distinctions between public and private, Michael Warner explains that in liberal thought, "to be properly public required that one rise above, or set aside, one's private interests and expressive nature."[29] The public marks the space where individual personality and desire are surrendered temporarily for the forging of a disinterested social body. As the notion of being "properly public" indicates, there can be a morality and an ethics connected to occupying public space. The speaker in "Race" develops her lyrical argument from a comparable conceptualization of publicness and public space. She believes that there is a proper way to be publicly Black and for Black bodies to inhabit public space. The "prancing" that she describes is not that way. The speaker would object to the idea of constructing a public identity that would necessitate putting aside racial identity, but she supports one that asks for an erasing of nonheterosexual sexual identity. Race itself becomes a spatialized concept because there is a prescribed way of physically inhabiting or embodying Blackness. Black queer bodies, then, create a spatial crisis. This idea gets taken up in the work of Black gay and lesbian artists later in the century, as I explain in the last section of this chapter.

It is vital to take note of the phrasing used in the speaker's question "Is there a place," because it becomes a refrain in the second half of the poem. This spatial problem results in a call for place. The speaker repeatedly asks for a place that would resolve the dilemma the imagery in the poem presents, but the speaker always suggests that there is only one appropriate and effective solution. Each of the four times that this query appears, it functions as a rhetorical question. The answer the speaker seeks is the title of the poem itself. To put it simply, race is that place. The speaker is not talking about a literal place but rather a figurative space of socially conscious heterosexual Black identity. Following this logic, by occupying this distinct ideological space, one can undermine the damaging "illusions" that threaten the racial identity. The speaker argues that the only way to ensure the perpetuation of Black community is through a particular kind of racialized consciousness. Yet, the speaker presents this idea in terms of race being the only way to save race. Fallacious circular reasoning appears to factor into the speaker's formulations of both Black identity and sexual perversion: (1) Blackness is the only safeguard for Blackness, and (2) continually visualizing the perverse is the only efficacious means for eliminating its visual presentation. This circularity in reasoning keeps the reader returning both to Blackness and to sexual perversion. Such returning reestablishes consistently a relationship between Black identity and sexual perversion within the structure of the poem. Cortez summons this image of Black hypersexual perversion and presents it as deriving from a frame of reference that is itself illogical and nonsensical. The tautological nature of the speaker's logic renders the means of assessment and *not* the son the "non functioning product." Yet it is only by occupying this way of thinking about sexuality and public identity that Cortez can express its unsound nature. The poem finds fault with limiting parameters on racial identity, and this move can be read as a conscious interrogation of nationalist rhetoric around Black identity.

The investigation of sexual imagery and folk thought in *Pissstained Stairs* finds a complement in the imagery of Cortez's next chapbook *Festivals and Funerals*. In this collection, Cortez focuses on issues of history, cultural heritage, and Black solidarity as poems such as "Festivals and Funerals" and "African Night Suite" illustrate. In addition to such social concerns, many of the poems in the collection also reflect a lingering desire to dwell upon representations of the sexual and the genital. The blues-inflected title poem presents questions about the murders of Patrice Lumumba and Malcolm X to indicate that "we have no friends," meaning that support systems for people of African descent are being dismantled and that trust is close

to impossible in the sociopolitical environment in which such political leaders could be assassinated.[30] Social betrayal is inexplicably imaged as a vagina and described as "lesbian."[31] Exhibiting a relation to misogynistic masculinist thinking, the poem uses female genital imagery and woman-centered sexual relations to express the limits of allegiance and social relationships—the female image comes to stand for betrayal itself. Using the sexual to explicate the social, Cortez's poem ends with a definition of the blues as "the erotic improvisation of uprooted / perfection" (9). Blues performances—whether musical or poetic—often have an erotic valence to them.[32] Cortez illustrates how she links the Black cultural history and symbolism that the blues tradition embodies to the realm of the erotic. Contemplations of a Black past can quickly and unexpectedly transmogrify into reflections on the erotic. Accordingly, political assassinations can be framed in terms of genitalia. That which seems to be mere participation in sexist thought emerges as a thoughtful reflection of the different ways in which sexual imagery can express cultural meaning. Cortez's career-long interest in the blues, then, must also be understood as a conscious desire to ruminate on the unavoidable sexual matter of Black social identity.

The poem "African Night Suite" continues the contemplation of the sexual in the midst of the articulation of social identity. As the term *suite* in the title indicates, this poem sets itself up as a blues performance and can be read as a melancholic song of desire for Africa: "Africa / take my hands from the newspapers shacks of / rotten existence . . . keep me in the mud of your belly / fed from the forest of your resistance / far from these mercenaries of illusion" (36). Nonetheless, the poem does not rest at expressing a sentimental desire for Africa; it also seeks to condemn the enduring legacy of enslavement. The speaker in the poem criticizes how enslavement undermined Black agency and control over the body:

> we didn't beg to the suffering of their butts
> like strange horses
> for a coin
> for a crumb
> for god
> for the deceased eyes of a miscarriage
> we didn't present the
> sadness of our knees &
> the callouses upon our lips
> to such wide leg madness as their's [sic]
> against our ovaries (38)

Sexual exploitation and manipulation are the primary elements of the speaker's plaint. The subject of this statement, which keeps unfurling without punctuation for half a page, is the Black body and the possibilities for sexual desire and agency. This historical undermining of sexual agency means that sexual activity for this subjugated group potentially carries with it loss of personal will, as the discussion of Ben Caldwell's play *Top Secret* in chapter 3 also indicated. The speaker and her compatriots did not choose to "beg to the suffering of their [gun] butts" or "present the / sadness of our knees" but were forced to do so.

Because of the link between sexuality and Black embodiment, sexual imagery becomes a barometer of change in the social status of Black Americans. Toward the end of the poem, Cortez inserts a line that does not connect syntactically or structurally to the lines that precede or follow it: "the miracle of erections" (38). It is the only line in the entire poem, which stands out in this way. (Perhaps the line comes to be symbolically improvisational—instantiating a blues aesthetic.) In the midst of reengaged deliberations on the past, this unexpected line presents a sexually stimulated penis as a phenomenal accomplishment. The line, for all of its peculiarity, implies that the possibility of sexual relationships (made present through the metonymic figure of "erections") in the context of a destructive sexual history is itself worthy of artistic and critical attention. The engagement of the sex act and its emblems becomes an index that registers the extent to which Black subjects have been able to unsettle the legacy of the "wide leg madness." Through this line and her work as a whole, Cortez argues for the employment of sex as a way to chronicle liberation from sexual exploitation and social definition.

It is with this idea in mind that one can parse the later poem "Watch Out." This short poem ostensibly takes the form of a warning much the way the poem "Race" does. However, the speaker of "Watch Out" exhibits a concern for the threatening figure that was not readily apparent in "Race." The poem moves from inhabiting a limiting, sexualized way of thinking about Black womanhood to rejecting it:

> Watch out for the woman
> Whose body is bloated with tears
> Watch out for this woman
> Whose brain reacts like foam from
> The inflamed bowels of a whale
> Bitter
> That bitter bitter woman
> Whose eyes have become the guardian

Of men's fly's
Her tongue working out like a machete
Hacking up a taxi driver in Kumasi
His pride blood in her mouth
The fatty tissues of her existence pain
His pain our pain
Watch out for the walrus face pain eater
with flesh under her fingernails
for this woman looking elephantiasis
looking woman is dying of neglect
Watch out for the neglected (25; emphasis added)

Cortez presents the reader with an image of a castrating woman ("pride blood in her mouth"). This image is one that is controversial and carries with it a vexed history within Black American culture. There is a tradition of sexist rhetoric that claims that Black women symbolically castrate their male partners and peers by refusing patriarchy and not acceding to demands of conventional gender hierarchies in general. Michele Wallace explores this recurring language in her 1978 *Black Macho and the Myth of the Superwoman*.[33] This rhetoric circulated widely during the Black Arts era as Nikki Giovanni's 1970 "Woman Poem" shows.[34] Purposely misleading the reader, Cortez appears to be parroting those concerns with her references to a "bitter bitter woman" who takes away a man's "pride" in "Watch Out." However, her description of this figure undermines this assessment. This "bitter woman" is bloated with tears because she cannot cry, and her brain is imaged as foam because of a social understanding that she is devoid of a mind. These descriptions illustrate how this figure is depicted as nothing more than an image. In these lines, the reader is not presented with a being, but rather the product of an imagination. The notion of "neglect" in the final two lines signals a definite tonal shift in the poem and in the presentation of this female figure. There is a movement from a tone of warning to one of concern. This change in tone enhances the implied assessment of irrationality in the earlier poem "Race." The woman figure is seen as a threat, but she is also threatened. Cortez's tonal shift alerts the reader to the fact that this "bitter bitter woman" is actually a social construct that she recasts through her process of poetic documentation. Examining this problematic sexual construct of Black womanhood allows Cortez to establish that the image is one that is *created* and arguably perverse. What appears to be mere perpetuation of the image introduces a consideration of the falseness of sexual mythologies and gender identity itself through engaged critique.

Cortez's innovative poems trace a movement away from restrictive conceptions of Black sexuality. She summons sexuality-based stereotypes to dispute their validity. This strategy parallels Brown's own in the form of the picaresque novel. Both writers demonstrate that pejorative sexual mythologies surround Black bodies. While Brown's narrative focuses on paralyzing notions of masculinity, Cortez turns to the dominant social constructions of Black femininity and sexual minority existence that impede self-definition. Yet they share a common enterprise of subverting damaging mythologies that derive from upholding patriarchal heterosexuality. The work of these two Black Arts era writers exhibit a desire to take up such restrictive mythologies and folk beliefs to do away with them and open up psychic space for radical expressions of Black subjectivity. Brown and Cortez translate the nationalist goal of reimagining the social world into a sustained reconfiguration of the body and the meanings surrounding it.

Queering Space

The use of the erotic as a tool for deconstructing sexual stereotypes and re-thinking identity sets the stage for the artistic projects of many sexual minority cultural producers. In such work, the conceptual space of sex serves as a site through which social change can be imagined. This section tracks how late-twentieth-century Black gay and lesbian writers use queer positionality and erotic desire to restructure the social world. Instead of trying to explode the public sexual stereotypes and mythologies about Black men and women, the writers I discuss embrace the publicness readily attributed to Black sexuality and attempt to redefine the meaning of social space through the erotic. Turning a racist logic on its head, they inhabit a site of possible vulnerability (Blacks as always already sexual and publicly defined) to transform it into a valuable critical technique (using Black sex acts as devices to reconfigure the social realm). In employing this method, these artists align their works with the aims and objectives of Modern Black Nationalist thought and develop the concern with space that undergirds the ideological terrain of nationalism. Moreover, they displace heterosex acts as those most valuable to social critique.

Because of the social impact of the countercultural sexual revolution and second-wave feminism along with the emergence of politically progressive small presses and writing collectives, there is a marked rise in publications by out gay and lesbian Black artists beginning in the 1970s. Important works that appear in this period include, but are not limited to, Ann Allen Shockley's *Loving Her* (1974); Anna Lee's "A Black Separatist" (1988); Audre Lorde's *Zami: A Biomythography* (1982); Alice Walker, *The Color Purple* (1982); Barbara

Smith's *Home Girls: A Black Feminist Anthology* (1983); Joseph Beam's *In The Life: A Black Gay Anthology* (1986); Cary Alan Johnson, Colin Robinson, and Terence Taylor's *Other Countries: Black Gay Voices* (1988); and Marlon Riggs's *Tongues Untied* (1989).[35] For these artists, being out or having a public homosexual identity is an integral part of their articulations of Blackness as well as their understanding of themselves as artists. These thinkers do not just write about their experiences as a person with same-sex sexual desires; rather, each argues that this subject position offers a unique perspective on social problems and the public sphere itself. Barbara Smith explains how Black lesbians and gay men as analytical lenses provide an ideal means for introducing the reality of "simultaneity of oppressions" that affect different groups in society.[36] Their subject positions make possible new hermeneutical modes.

The value placed on the being and perspective of Black sexual minorities points to an important conceptual thread within Black queer theorizing and cultural productions: positionality. Through this idea, I refer to methodologies that use the queer of color intersectional subject position as the basis for social and cultural analysis. This concept is integral to the work of critics such as Kara Keeling, Roderick Ferguson, Sharon Holland, Marlon Ross, Cathy Cohen, E. Patrick Johnson, Phillip Brian Harper, and Robert Reid-Pharr.[37] Collectively their contributions help to constitute the field of Black queer studies. This developing field is less about exploring a specific sexual culture; instead, it represents a set of analytical strategies that decipher racial and sexual systems of social legibility and control from the perspective of a divergent set of lived experiences. Positionality is not only a critical paradigm; it functions as an important component of Black gay men and lesbian art.

The poetry of Cheryl Clarke exemplifies this contention, and this poetry serves as an introduction to the text that I will discuss at length. In the collection *Living as a Lesbian* (1986), Clarke uses the subject position of the Black lesbian as an optic for examining topics as varied as familial relationships and the need for community to revolutionary politics and imaginable possibilities for sexual intercourse. In addition to demonstrating the methodological value of the Black lesbian body, Clarke also offers a sustained investigation of space as she explores what it means to "live as a lesbian." The poem "living as a lesbian underground: a futuristic fantasy" illustrates the prominence of spatial considerations:

> in basements
> attics
> alleyways
> and tents

fugitive slaves
poets and griots
seminoles from Songhay
vodun queens—
all in drag,
stumbling over discarded fetuses
hitching
dodging state troopers behind shades
searching for safe houses[38]

This collection of images opens the poem, and in them the reader finds a catalog of places of hiding and transport as well as dissimilar figures on the run. The diction in the selection ("dodging," "searching") indicates that this movement through space is desperate and that the fleeing figures face an unstoppable, ubiquitous threat. Clarke's poetic syntax suggests an equation of these different figures. She uses no punctuation marks to divide this enjambed series, suggesting a reluctance to inscribe distinctions. Each of the figures referenced—the fugitive slaves, the cultural persona of the griot, native warriors of an ancient West African empire, and chief personas of a West African religion, respectively—occupies a particular geographical location and has a specific sociohistoric significance, yet all of them are connected to Black cultural history and a Black diasporic sensibility. The Black figures in this "futuristic fantasy" face a threatening environment that has them collectively moving from hidden spaces of basements and attics to public, yet transient, spaces of alleyways and tents.

Clarke visualizes what constitutes life "underground" throughout the poem. "Going underground" is a common subversive expression used to describe individuals who must flee from political and/or social persecution. It is also a recurring motif in the work of Black political activist of the 1960s and 1970s such as Angela Davis, Huey Newton, and Assata Shakur.[39] The reference to the underground transports events from the recent past into the poem. The speaker's later warnings to "Travel light" and "don't wait until morning" are in line with this meaning. The real need to move oneself underground indicates an inability to have a public life. The movement through the public in the poem is a movement into impermanent spaces. In this poetic rendering of the world of the underground, movement through space has little to do with freedom or agency. Instead, it conjures images of constriction and danger for these Black bodies in motion.

This vision made available through the critical lens of lesbianism is one that is genocidal and perhaps even cataclysmic as the "children of lesbians

[are] orphaned" and "blacks, browns, and tans / [are] herded into wire fences somewhere" (74). Although Clarke calls the poem a "futuristic fantasy," she links together and builds on past and present realities. The indirect implication of the murdering of lesbians derives from fears about and realities of unpunished violence against sexual minorities. The images of confinement allude to Japanese internment during World War II and bring to mind the high rates of imprisonment of African Americans, Chicanos, and Native Americans in the U.S. penal system. Black lesbianism as a framework leads Clarke to consider the distressing experiences of people of color in general. This futuristic vision in which the injustices of the past and present reemerge lead the speaker to ask, "Where you gon be standin when it come?" (74). Given the images and statements that surround it, the question suggests the near impossibility of a spatial location in terms of identity or geography secure from an omnipresent, injurious influence that would send people of color running.

Whether producing imaginative or critical works, Black gay and lesbian artists often emphasize positionality and the spatial location of the Black queer subject, as titles such as *In the Life, Home Girls,* and *Other Countries* indicate. The critical conception of sex or sexuality as a vehicle for social critique apparent in Black Arts era works is an important element of Queer of Color Critique. The spatial implications of sex (as the language of "positionality" indicates) enable this sexuality-framed scrutiny of the public sphere. Given these connections, the remainder of the chapter will examine how a contemporary Black queer writer explores space to reveal the imagined relationship between sexual identity and social critique. I focus on Darieck Scott's 1995 novel *Traitor to the Race* because it utilizes a spatial methodology to ground the author's approach to sexual identity.[40] More to the point of the larger argument of this book, the novel explores the cultural hold of nationalist rhetoric at the end of the twentieth century, and it does so through queer desire. Deciphering how this writer (and others like him) understands sexual minorities as occupying space is of little interest here. Instead, I determine how Scott uses space as a tool for exploring the erotic underpinning of social identity. He offers up imaginative constructions of *queer space,* a narrative space in which nonnormative desire summons dominant, juridical frameworks in order to unhinge them.[41] This particular strategy in the text serves as a model for the disruptive inhabiting that I argue defines aesthetic radicalism. Linking such critique to experimentation, Scott attempts to cross boundaries between genres by creating a dramatized novel as he questions state power. The formulation of queer space that emerges in this experimen-

tal text is a creative device that produces politicized social critique. This text develops out of the radical work on Black sexuality that appeared during the Black Arts era, but he, like other contemporary queer artists, concentrates on homosex acts as evaluative lenses.

Scott's debut novel *Traitor to the Race* employs queer erotic desire to reconfigure the public realm and to find new ways for articulating private identity. My interest in this novel emerges from Scott's structural and formal techniques that accentuate the thematic exploration of erotics and space alongside his purposeful analysis of nationalist thought. The novel is fixated on storytelling and narration: Scott organizes the major sections of the novel into four groupings, "Prelude: All about Hammett," "Meanwhile . . .," "Later . . .," and "Postscript: More about Hammett," suggesting a self-consciousness about narrating the sequence of events that constitute the narrative and about temporality in general. The reader finds that most of the story revolves around the romantic relationship between a Black man Kenneth and a White man Evan and not directly about the Hammett (Kenneth's cousin) referenced in the organizational headings. The reader no longer has direct access to Hammett after the opening section. In the prelude, the reader finds that Hammett is brutally assaulted in an act of gay bashing in a dark alley. Interrupting Hammett's story, the account of Kenneth and Evan's relationship is told in the textual space between the prelude and the postscript. It is not that the scene of sexual violence against Hammett that ends "Prelude: All about Hammett" serves simply as a *prelude* for the interracial intimacy explored in the rest of the novel. Rather, the nature of the intimacy between Kenneth and Evan becomes the primary conduit through which Scott can comment on the sexual violence and discrimination that result in Hammett's murder.

In *Traitor*, Scott emphasizes fantasy and fantasizing in the investigation of the disruptive power of erotic desire. Most of the novel is made up of chapters that alternate between a perspectival focus on Kenneth and a focus on Evan. However, a number of the chapters are called "Game," and each shows the two lovers role-playing (often in public) in games that end in actual sexual excitement and sometimes sexual intercourse. For example, in one of these early games, Kenneth is a professor and Evan is his disobedient student, and the two get into a feigned argument and a physical altercation on a sidewalk.[42] In another game, Evan is a military "captain" that yells and wrestles with Kenneth, a "whore" (25–26); later on, Evan plays the role of the "sun-god" Apollo, and Kenneth is a "bestial" nymph who attacks and rapes the deity (43–45). The games are ways for the couple to act out their fantasies and avoid some of the actual difficulties that exist in their

tumultuous relationship. Their interactions throughout the narrative are characterized by such public fantasizing. These scenes of role-playing can be read as enactments of social power dynamics, whose format both depends upon and complicates racialized conceptions of identity. They actively enact stereotypes. Scott's decision to inhabit such racialized stereotypes in sexual contexts recalls the earlier work of Brown and Cortez. The primary characters in *Traitor* are actors, but Evan has a flourishing career on a soap opera, while Kenneth is performing at community theaters. Nonetheless, Evan expresses frustration about being typecast as the intriguing "blonde ingénue." Kenneth rejoins this comment by criticizing his White lover for not relishing the social and economic privilege his White maleness affords. Kenneth ends the ensuing argument by exclaiming, "I love you. I envy you. Hate you, adore you. The whole script" (30).

Taking Kenneth's ambivalently charged comment as a cue, *Traitor* can be read as a novel of plays (or dramas), and the elements of plays structure the storyline and the characters. In a different context, Hortense Spillers has held that "sexuality is the locus of great drama—perhaps the fundamental one—and, as we know, wherever there are actors, there are scripts, scenes, gestures, and reenactments, both enunciated and tacit."[43] Spillers's point is that there are preexisting ways of expressing the self and relating to others that shape and perhaps dominate what we consider to be our independent sense of identity. This understanding of sexuality and sexual practices is at the heart of Scott's crafting of his narrative. Scott emphasizes scenes, scripting, and reenactments in these games and the accompanying intimacy that occurs in the privacy of Kenneth and Evan's bedroom and in front of people on streets and in parks. The role playing in their bedroom makes their sexual intimacy, even when alone, a kind of showing, while the role playing in the park demands and attains a kind of intimacy that the municipally controlled spaces suggest is not possible or permissible.[44] Queer sexual encounters are figured as insurgent spatial performances throughout the novel.

For all the weight given to publicness and performance, the novel reflects a deep interest in how secrecy functions as a frame for identity and desire. While sitting in the park trying to think of a new game to play with Kenneth, Evan thinks back to his childhood game playing of "Planet of the Apes" and how these recreational interactions contributed to his gender socialization:

> Guys got called fags ten times a day in my neighborhood. Sissy was much worse. That was for real. My life started to get real secretive about that time. I would be ashamed to think how I acted when we played Apes [crying and

throwing fits because he wanted to be chased and "caught" by the other boys and did not want to do the aggressive chasing that constituted the game], and if anybody teased me about it, I'd get mad and start punching. *What was open for everyone to see when I was nine had to go underground.* . . . it is sad to me, how even when you decide to live a life of play like I have [as a professional actor], you have to kick and scream to play it the way you want to play it, or you have to do it in secret. (178–80; emphasis added)

Through social encounters, Evan learns the necessity of hiding his behaviors and interests early in his life; he comes to understand that there is a certain way to be properly public. Evan realizes that he has two choices in living the life he desires: open defiance or secrecy. Because he must either endlessly expend energy in reactionary conflict or forever conceal himself in the shadows, there is no way to conceive of simply existing. This experience is more than a random memory that returns to Evan or even the defining moment in his psychosexual development. This statement about secrecy is integral to how Scott depicts homosexual identity, Black and White.

Secrets in the novel primarily concern the character that the reader loses access to throughout the narrative space between the prelude and postscript: Hammett. Hammett is gay, and this fact is one that is seemingly unspeakable to some individuals distressed by his brutal death. No one mentions it at Hammett's funeral. Kenneth's family knows about Hammett's sexual preference, but they are unwilling to recognize it publicly. The media and some social organizations refuse to acknowledge that the man who was killed was not only gay, but was also raped. At an impromptu public demonstration to protest the fact that the police have made no progress on locating Hammett's murderers, a Black man from the watching crowd approaches one of Kenneth's friends, Cyrus:

> the man does nothing more frightening than insistently tap on Cyrus's shoulder. "So, so what?" he fires, like a man not quite able to restrain himself. "You saying the man who got killed here was a homosexual?"
>
> "Yes, he was," Cyrus calmly replies after a small recoil. "He was and we think it should be called attention to, that he was a black gay man who was raped."
>
> "Why you wanna say that about the man? Did you know him? You probably don't even know him! How this gon help anything? (141)

This series of inflammatory questions and the interaction itself divulges Hammett's symbolic importance in the narrative and brings Black nationalist exigencies to the foreground. The man's final question "How this gon help

anything?" does not really concern Hammett's case. He is questioning the relevance of this particular protest to the social activism against the ongoing sociopolitical oppression of African Americans. He is asking how this assembling will advance the Black nationalist movement toward civic justice, and he has trouble integrating Hammett's announced queerness into the consideration. Through this confrontation, Scott reveals the possible boundaries of what can be deemed to be radical social activism. The man on the street presumed definite boundaries to the "movement." One does not have to read the novel as necessarily rejecting this nationalist line of thought; instead, *Traitor* exposes the trappings of such thinking to create space for Hammett in the movement the man references. Hammett has a concrete social value that the allegations of homosexuality, which are broadcast by the protest, ostensibly tarnish. However, for Cyrus and his colleagues, Hammett's racialized queerness functions as an important site of political agitation. In death, Hammett embodies a contested terrain. Staged in front of the audience of demonstrators and random spectators, this microscene between Cyrus and the stranger is an effective drama between contending forces that relies on demands of secrecy and public knowledge, questions of intimacy, and assertions of same-sex desire. Through Hammett's absented, queer body, Scott can delineate these contestations of the meaning of political activism as well as the unclear ethical parameters of social identity. Unfortunately, it is only through losing Hammett, by never really knowing him, that the reader can witness this social drama.

This textual recessing of Hammett is staged through the structural foregrounding of the interracial intimacy between Evan and Kenneth, and this narrative focus on this couple enables Scott's presentation of *queer space*. Jean-Ulrick Désert uses this term to describe the complicated nature of actual gay and lesbian communities and neighborhoods. These locations, he contends, simultaneously engage and transgress the social, architectural, and juridical meanings attributed to the areas that they occupy by means of the subversive bodies that collectively inhabit and pass through them. He goes on to characterize this concept in these terms: "queer space is in large part the function of wishful thinking or desires that become solidified: a seduction of the reading space where queerness, at a few brief points and for some fleeting moments, dominates the (heterocentric) norm, the dominant social narrative of the landscape."[45] The nature of such space has little to do with sex necessarily. In Scott's text, it becomes apparent that queer space describes a strategy that disturbs hermeneutical frameworks, which seek to define all relationships and encounters, especially but not only those with an erotic valence.

Interracial desire is figured as a crucial component of this construction of space in *Traitor*. The novel's title is an allusion to negative assessments of intimacy that crosses the color line. The idea that interracial desire would constitute collective betrayal is rooted, in part, in a nationalist conception of community and responsibility to the group or assumed kinship network. It signals an anxiety about the perceived loss of communal ties due to allegiances with an empowered antagonist figured as White people generally. Scott frames his novel with nationalist anxieties about interracial desire. In the essay "Jungle Fever?: Black Gay Identity Politics, White Dick, and the Utopian Bedroom," Scott argues that "[whether] the object of political wrath or the butt of an easy joke, the black/white gay male couple as figure frequently stands on the imaginary border between political consciousness as an African-American gay man and the lack of such a consciousness; it marks the dividing line that defines a politicized, racially conscious identity which is black, male, and gay."[46] In his mind, interracial involvements are understood as reflecting the state of an individual's political awareness. As the diction of the critical passage indicates ("imaginary border," "dividing line"), interracial relationships in this context have a spatial significance that reveals divisions between the psychic/private and the social/public. Scott casts the "black/white gay male couple" not simply as an embodiment of a psychological boundary, but also as an evaluative frame because consideration of this specific coupling enables the analysis of the social world. In describing the couple this way, I direct attention to the power that Scott attributes to interracial intimacy to inform how one evaluates racial, gender, and sexual identity.

Part of the reason that interracial relations are understood as having potential analytical power is because of the social meanings that buttress White male embodiment. Scott goes on to argue that "White dick is socially and historically represented to us as potency; it is power, and power is sexy, just as sex can be the exercise of power—or rather, just as sex can be the interplay of relatively empowered and relatively disempowered roles, roles that can become all the more erotically charged when the markers of different kinds of power, gender/race/sexuality, are acknowledged" ("Jungle Fever?" 310). These indicators of different kinds of power become apparent through interactions with the incarnation of power that we witness in the White male body (particularly in the male sexual organ). Moreover, the concept of "interplay" names succinctly the "erotically charged" role playing that occurs throughout *Traitor to the Race*. Pushing Scott's assessment of the White male body (and its intimate parts) further, fiction writer and cultural critic Thomas

Glave insists that the body of the White male has become a representative of proprietary public space within the U.S. social imaginary.[47] Because of this symbolism, sexual interaction with this racialized phallic emblem means that interracial intimacy always carries with it the potential to shed light on the social realm.

Male interracial desire helps to create queer space in Scott's novel. By transgressing norms about sexual desire, masculinity, racial identification, and public space, interracial desire in the novel sheds light on those conventions and exposes the key assumptions that influence everyday social interactions. Through their employments as jokes, devices of political critique, and social distinction, interracial intimate couples represent a tool for assessing identity as well as political issues. Scott's critical work (and its relationship to his creative work) helps us to recognize how queer space is created through intimate encounters and engagements and *not* through the queer body alone. The physical interaction of these raced bodies creates the possibility for queer space. The novel advances the idea that expressions of sociality and interaction are integral components of imaginings of queer space.

With the notions of engagement and sociality in mind, I return to the game-playing chapters that interrupt the linear progression of *Traitor to the Race*. These games highlight the significance of fantasy to Scott's fictionalized queer space and its potential to make sense of others and the self. They also demonstrate the innovative nature of the novel. In the games, Kenneth and Evan take turns being empowered and disempowered, sadists and masochists, and sexual "tops" and "bottoms" thereby sharing and exchanging the psychic space and public meaning of the roles that each inhabits. The enacted or embodied fantasies the reader finds in the games of desire and exchange signify what Désert describes as "wishful thinking solidified"; thus, Scott intimates the constitutive nature of fantasies to queer space as he understands it. Fantasizing is a pivotal component to this discussion.

The presentation of Scott's games is shaped by what Tim Dean calls the "logic of fantasy" within critical theory.[48] Dean contends, "fantasy offers itself as an indispensable concept for discussing subjectivity and sociality together, without reducing one to the other. And owing to the psychoanalytic insistence on distinguishing the subject of fantasy from the individual who may be characterized as having the fantasy, this concept justifies our speaking of social fantasy or [even] national fantasy, *since fantasy, no matter how private it may seem, is not a strictly individual phenomenon* . . . the concept of fantasy describes how a dimension of sociality—the Other—inhabits the innermost, ostensibly private zone of the subject" (260; emphasis added).

This language of inhabiting and the circular interfacing between the subject and the social resonate with Scott's "game playing." One may assume that the realm of fantasy must necessarily be coextensive with the concepts of "individual" or "private," but Dean makes plain that this realm inevitably gets saturated with the "public" and "social." Fantasy has the potential to destabilize any possible secure boundaries between the private and the public. This fantastical worrying of limits and margins does not conflate the terms under consideration, as Dean is quick to insist. Rather, it highlights the fallacy of their division. The disruptive "logic of fantasy" extends the spatial work that desire accomplishes in this narrative.

The device of fantasy underscores the connection to earlier Black cultural producers. During the Black Arts era, writers relied on sexual folklore and took it to its paradigmatic limits. These folkloric ideas represent common ways of thinking about Black identity that underpin social imaginary and circulate within different media. By destabilizing them, artists also sought to undermine the public spheres that these social conceptions helped to make possible. Later writers translate this examination of sexual folklore into a methodology of queer fantasy, as Scott makes evident. Queer fantasizing in these texts disrupts social space and recalibrates it by concentrating on minoritarian subjectivity. More recent work attempts a fuller realization of the world-making potential of the erotic and in the process offers to private desire a social presence.[49] Currents of desire become the means for imagining alternatives to the social structures that are the object of critique.

In Scott's novel of plays, there is a dramatizing or scripting of desire that pushes it from the bedroom and into the streets. The frustrated man's querying complaints to Cyrus are a response to a skewed nationalist scripting or performance of desire enacted in the protest, which also relies on nationalist gestures. The small protest prefigures the planned "dance-riot," which is much bigger and more passionate, that closes the narrative immediately preceding the postscript. The dance-riot organized in reaction to the poor handling of Hammett's case is a dramatization and performance of transgressive desire:

> A huge crowd—estimates ranged from fifteen hundred to nearly three thousand, depending on the newspaper—appeared in the very center of the financial district. They poured out of vans and cars and subway stations and hotel lobbies—mostly men, but women, too, young and middle-aged, men of color and white boys, some beautiful, others not, many wearing skirts over hairy legs and dangling huge hoop rings from their ears, all bursting onto the streets amid the morning traffic in a horde, on cue. Cars and taxis swerved into sidewalk curbs to avoid them; bleating horns and shouted obscenities

resounded against the glass of the tall building. The crowd charged howling, leaping onto car hoods, grabbing men wearing dour business suits off the sidewalk and twirling them around.... A troop of yodeling white boys, naked in blue paint traced in intricate whorls on their bellies and necks and down the length of their thighs, raced past. Their genitals, the only unpainted flesh on their bodies, bounced around as if trying to get a better look. Then away in the distance, above a vast plain of heads, Evan glimpsed another naked figure, a black man with long sand-colored dreadlocks, straddling something that looked like the stone figure of a horse. The man's slender torso whipped back and forth in rhythmic abandon and his hair writhed about his shoulders as if he were a Gorgon. Like everyone else the man shouted and waved a cat-o-nine-tails in the air. "Mother wants her children to dance again! Mother wants her children to dance again!" (204–6)

This dance-riot is a politicized sexual fantasia that takes place in the conservative and highly regulated financial district; it is destructive, unreal, and erotic. On one level, it represents a creative reimagining of the purposefully disruptive direct action demonstrations of the AIDS Coalition to Unleash Power (or ACT UP) organization during the late 1980s.[50] Scott alludes to actual political action through this scene. Yet, this chaotic event, which never disregards its purpose, is not simply an expression of a desire to assemble and dissent; it is a *dance*-riot. Scott never permits the reader to lose sight of the significance of the human body to the dance-rioters. As onlookers watch the dancers, bouncing genitals actively return the gaze. The dancing and erotic gyrations of the crowd suggest that the human body in all of its variations is important and must be loved, protected, and enjoyed. The dancer-activists' actual presence in the spatial location of Manhattan's financial district is an embodied argument about the right of the queer body to move freely through space. The insurgent performance, which ends with everyone under arrest, attempts to unsettle a regulatory discursive matrix that limits the lives of sexual minorities.[51] In the words of Judith Butler and Athena Athanasiou, the performers attempt "to displace conventional conceptions of the 'public sphere,' or the polis, understood as the particular spatial location of political life" making the financial district a space of appearance for dispossessed subjectivities.[52] Scott uses the dance-riot as a device to effect a queer space within the normalized realm of the market-controlled and government-supported financial district.

As the attire (or lack thereof), props, and actions of the dance-rioters indicate, transgression and the undermining of seemingly traditional values

and social policies are the crowd's primary methods. The dance-riot is held where it is to insist that the dancers have a right to this space; they occupy this location to claim an ownership of it. This idea is in line with Désert's discussion of queer space. He elaborates the concept by explaining that such space "is an activated zone made proprietary by the occupant or *flâneur*, the wanderer" (21). The dance-rioters are the "wanderers" here that trigger subversive meanings and attain an ownership of the street through their physical placement and celebratory movement. The dance-riot acts out an expansive queerness that threatens to alter the nature and meaning of this business-defined space. For that reason, these threatening bodies end up in jail—the regulatory power of the financial district is exercised. As opposed to the dismantling of the regulatory matrix, we seem to find its safeguarding. However, the value of the performance is not lessened by this outcome. Like the games, the performative scene-making and place-making of the dance-riot demonstrate that both desire and the body can resist restraining scriptings and mappings. Read together, the mobile fantasized games and the space-threatening dance-riot reveal that *Traitor to the Race* is a dramatized series of scenes of queer space.

Traitor to the Race is an extended conceit about the constraining nature of state power. For Scott, it would appear that it is erotic desire and not revolutionary or insurrectionist action that can undo this power. Read in a different light, desire is proposed as revolutionary action that transforms the state as well as the space of identity in the narrative. Revolution, then, might require desire—especially queer desire. This formulation indicates how Scott's work expands the parameters of the social and political "movement," alluded to by the character that approaches Cyrus in the street. Throughout this innovative novel, Scott's primary goal is to detail the power of desire to liberate the body from restrictive understandings. It is only from this site of bodily liberation that the social world can be reimagined. Desire becomes a tool for reinterpretation and transformation. Scott's novel can be thought of as an enhancement on the interrogation of the body that emerges in the work of Van Peebles, Brown, and Cortez. However, rather than attempting to unhinge social scripts that appear to pinion Black embodiment, Scott wrestles this racialized corporeal space free from the regulatory domination of juridical powers. His strategy builds on an earlier method of employing nationalist rhetoric.

Scott's novel shows how aesthetic radicalism involves the transgression of boundaries between genres. Again, *Traitor to the Race* can be read as a

novel of plays; its experimental quality lies in part in its *dramatic* structuring. There is a prelude, there are interludes, and the chapters are often written as if they are theatrical scenes. The purposeful employment of the language and techniques of drama in this novel represents a translation or transliteration of the desire to *enact* queer space. The dramatic organization abets the conceptual cultivations of queer spaces highlighted throughout this discussion. Queer desire is conceived as having the power to redefine not only public space as Désert contends, but also the construction of narrative space. Scott mimics the power of the geographically based notion of queer space to alter how we assess the social realm in his textual manipulations of his dramatized novel. In the process, he directs attention to the apertures of both genre and subjectivity made visible by desire and intimacy.

The suggestion of a scene of queer space returns this examination to the sex club scene in Van Peebles's film *Sweetback* with which this chapter began. The Black fairy and her theatrics are elemental to the sexual transformation of the tableau. This gender-bending fairy never appears in the film again, yet Van Peebles cannot imagine the delineation of public Black sexuality or the construction of his sexual outlaw protagonist without this queer figure or her performance. Van Peebles attributes a transformative power to this figure. Although the viewer quickly loses sight of this character, her presence enables the sexual transformation and alters the physical meaning and form of the performing bodies. The point is not that Van Peebles had a radical understanding of Black sexual minorities; rather, his film exhibits, even if momentarily, an investment in the idea that the Black queer body has an inevitable effect on how the space it occupies is interpreted or understood. This body challenges interpretive frames: it can transform a woman into a man, and it can make a site of business and legal transactions explode with celebratory eroticism. It is the Black queer body's tendency toward challenging meanings and redefining space that undergirds the spatial crisis surrounding the "prancing" son in Jayne Cortez's poem "Race."

In this chapter, I have demonstrated how the artistic exploration of the social power attributed to sex is indicative of the transfer of political concerns and anxieties into the realm of cultural production. The politicization of the body and the discourse of liberation developed out of the revolutionary rethinking that made sex and sexuality prominent sites of social critique within aesthetic radicalism. The demand to proffer new significations for the Black body results in alternative understandings of Black sex as well. This steadfast attention to the space of sex is a marker of nationalist rhetoric, and it appears in literary and cinematic culture primarily through the devices

of dislodging negative sexual mythologies and queering space. Both moves divide their attention between the private realm of the body and the public realm of customs and beliefs of the body politic, making clear how sex brings into view the porous boundaries between the two. These writers—like all of the artists discussed in this book—show a triangulation among social critique, innovations in form, and shifting conceptions of Black identity. These complex linkages lie at the heart of aesthetic radicalism and set the course for new directions for assessing the cultural impact of African American political thought and for tracking novel developments within the realm of artistic production.

Conclusion
Queering Representation

Radical Aesthetics and Modern Black Nationalism has explored the cultural terrain of the Black Arts Movement (1965–1975) without limiting itself to that historical moment. In this sense, this book is and is *not* a book about the Black Arts Movement. My interest throughout has been on expanding the critical understanding of artists participating in similarly politically engaged projects during and after the Black Arts era. More often than not, this movement has been thought about in isolation or as a mutually exclusive formation: (1) there are few attempts to link the work to that which precedes or follows it, and (2) either one was in the movement or not. My goal has less to do with identifying a definitive list of members and their successors. Instead, I have endeavored to show how the engagement of revolutionary nationalist rhetoric, which lies at the base of the formation of the Black Arts Movement, actually represents a dominant artistic strategy in the Post–Civil Rights era. Through the lens of the investigation of nationalism, one discovers a wide-ranging group of artists attracted to political radicalism that are also interested in producing experimental forms. They hope to transfer the radical energy from the social world to the realm of artistic production.

My primary motivation has been to interlace QOCC with the analysis of nationalist rhetoric. I employ QOCC as a method that illuminates (1) how marginalized subjects can critique *and* identify with dominant ideologies and (2) how such ideologies are made up of contrasting ideas that can put different adherents in conflict. For some thinkers, Black nationalism has helped to provide the language of radicalism and social change; for others, it is often characterized by strains of sexism and homophobia that weaken

its progressive potential. Therefore, my move to craft a critical framework through QOCC and nationalist thought might be a surprising one. However, it is important that queer theory and Black nationalism not be thought of as necessarily incompatible. Seemingly strict protocols in regard to racial and gender expression stimulated significant conversations about the boundaries of Black identity. In addition, nationalist conceptions of racialized collectivity and solidarity appear prominently in the art and social commentaries of Black women as well as Black gays and lesbians. The project of the chapters of *Radical Aesthetics* is to *queer* nationalist rhetoric, meaning to locate critiques of limiting lines of thought embedded within the discourse and to highlight elements of nationalism that resonate with marginalized subjects. The goal of queering has less to do with focusing on sexuality in nationalism than on worrying the presumed limits of nationalist thought. The two sections (and each of the chapters) of the book explore the upsetting of the rhetorical paradigms defining Modern Black Nationalism, and in doing so, they track the emergence of aesthetic radicalism.

By grounding aesthetic radicalism in QOCC, I emphasize its ability to reveal multiple kinds of identification and affiliation. This perspective makes it possible to recognize how one can simultaneously embrace and denounce nationalism, creating the opportunity to view the ideology as layered. To simply reject nationalism would mean to render invisible and inaccessible the social analyses and critiques that it helped to stimulate. My aim has been to elucidate how artists negotiate this contentious political terrain. In addition, my argument has shown that QOCC is not only relevant to texts with sexual content or to queer-identified persons. It can enrich our understanding of nationalism in the late twentieth century even in the midst of some essentialist conceptions of identity. Moreover, QOCC encourages critical perspectives that shed light on the examination of racial and sexual identity, gender expression, and the social realm in multiple art forms. Consequently, it is a valuable tool for doing cross-disciplinary work, making it a method that can help set the course for further developments in cultural studies.

The preceding chapters have shown that the deep interest in Modern Black Nationalism in the social world has a decisive impact on the realm of cultural expression and that this impact is not one-dimensional. Whether one is talking about actual communities or artistic imaginings, it is unproductive to assume that dealings with nationalism must look only one way. The dynamic translation of nationalist rhetoric into artistic paradigms is not a mere incorporation of political content. Instead, aesthetic radicalism highlights how transformations of the rhetoric become the means for manipulating formal elements. The shifting terrain of nationalist discourse is a frame for

evaluating experimentation in contemporary artistic production. The four dominant nodes of Modern Black Nationalist controversy taken up in the chapters—White innocence, Black kinship, reproduction, and sex—represent sites of disruptive inhabiting, and this strategy enables artists to continue an ongoing examination of political exigencies while also affording them space for innovation. The continued incorporation of nationalist discourses yields artistic possibilities. However, it is not the case that contemporary artists are indistinguishable from those of the recent past. The strategy of disruptive inhabiting creates opportunities for difference and divergence, revision and reinvention. Such possibilities for change mean that the echoes of nationalist rhetoric in art can be difficult to locate because one does not find merely unmediated reflections or "mirrorings" of social realities. *Radical Aesthetics* offers a strategy for reading for such artistic complexity.

In the remainder of this conclusion, I build on this thinking to clarify further the relationship between revolutionary rhetoric and artistic experimentation. My objective is to extend the reach of the work done in the substantive chapters by highlighting a concern that undergirds each of them as well as nationalist ideology in general: representation. The question of how art represents political concerns has been elemental to my consideration throughout. Because the idea of representation was key to Modern Black Nationalist frameworks, it provides the basic context for the discussion in each of the chapters. For example, Adrian Piper's *Vanilla Nightmares*, Gloria Naylor's *1996*, Spike Lee's *She Hate Me*, and Darieck Scott's *Traitor to the Race* all question the conventional ways Black identity and embodiment are portrayed, and in the process, they challenge accepted understandings of what constitutes Blackness as well as political radicalism. The other artists discussed in this book offer similar subversions of representation as they take up specific nodes of contemporary nationalist thought. This book draws to its close with an exploration of how late-twentieth-century cultural producers explore the premium placed on representation to enhance the preceding analysis.

The importance of voting registration and voting in general during the Black Arts era establishes how the concept of political representation was a crucial element of Black nationalist organizing. In March 1965, in Lowndes County in Alabama, there were no Black individuals who were registered to vote. The county was 81 percent Black, and "the whites had ruled the entire area and subjugated black people to that rule unmercifully."[1] Lowndes was referred to as "Bloody Lowndes" given its record of anti-Black racial violence. Because of its history and these sociopolitical realities, this county became the site of civil rights activism. Student Nonviolent Coordinating Committee participants went there to organize, and they, along with others,

eventually formed the Lowndes County Freedom Organization, which was the forerunner to the Black Panther Party—in fact the Lowndes symbol was a black panther. Such voting campaigns asserted the Black right to the civic realm; however, these campaigns also demonstrate a commitment to the idea of representation whether social or political. Modern Black Nationalist discourse develops around desires for what one might call accurate and legitimate representation as an integral component of revolutionary action.[2]

How do artists take up the idea of representation at a moment when representation has so much political weight? As artists inhabit the rhetoric of Black nationalism, the concept of representation does become a crucial component of their projects. However, in the artistic imaginary, representation is a contested terrain that has little to do with mimetic reflection. Legible representation is crucial for political organizers. Alternatively, many cultural producers engaged in aesthetic radicalism query the meaning of the call for representation. Although representation in the political world and the idea of cultural representation—signal considerations in Black nationalist discourses—both appear to demand a stable and identifiable point of reference; artists transform this idea. The questioning of this concept is not a strategic rejection of nationalism, but rather an outcome of the disruptive inhabiting of the framework of representation.

My contention develops out of Darby English's formulation of *black representational space*, or the discourse around representation in the realm of African American art.[3] For important reasons that he meticulously tracks, consensus and constraint are key elements to the historical development of the conversations about African American art. English argues,

> in the United States many black political discourses centering on the question of integration versus segregation have instrumentalized notions of representative culture as central components. The rhetoric of black culture began being forged in consensus-building projects dating from the first decade of the twentieth century. . . . Indeed, it seems that the first public appearances of work by black artists as black art were orchestrated under these auspices. I want to view these and related subsequent developments in terms of their relation to what literary historian Sacvan Bercovitch describes as the emotional, imaginative, and conceptual allure of cultural consensus—and its dialectical twin, the fear of dissension. (50)

English makes it clear that specific social realities in the United States have made it advantageous and arguably necessary for consensus building to be a guiding paradigm within the world of art for African Americans. The premium on representation constitutes one of the elements of this shared un-

derstanding of art. That being said, English is particularly interested in how this consensus tactic encourages anxiety about dissension, or techniques that do not appear to accede to the demands of urgency. This fear of dissension can be understood as unease about work that does not clearly participate in cultural politics. He goes on to insist, "the rhetoric of consensus tactically reproduced cultural and social limits" on what was perceived to be authentic and valuable art (51). The history that informs the creation of such boundaries haunts what English calls *black representational space* (in terms of audience desires and critical responses to art) to the present day. The use of this term has less to do with the precise relationship between this space and Black cultural politics, though these politics form the context for the concept's emergence. Instead English is concerned with "the constellation formed in the accrual to black art of audience, legitimacy, visibility, and other forms of dissemination and validation" (9). It is the critical and receptive space around Black art that sets restrictive limits. His larger argument is that because of specific historical circumstances and the politics that developed in relation to these circumstances, there are a set of protocols in place for "seeing" or recognizing the meaning of Black art. Works that are situated outside of such protocols are effectively invisible or discursively in the dark—to use the language of English's title *How To See a Work of Art in Total Darkness*.

In the pages that follow, I offer a brief consideration of experimental visual texts that might be situated as in the "dark" in terms of their allegiance to the practice of representation. More importantly, these texts rely upon techniques that "queer" representation by transforming the typical means for presenting the Black body and by refusing to deliver recognizable Black identity. One of the contributions of English's argument is the move to unseat the expectations of African American art that inform its public legibility. In my reading, his goal is not to dismiss contemporary artwork's political engagement; rather, he wants to reveal what we might be missing when we presume to know and expect to see certain strategies for investigating the political realm. Aesthetic radicalism's treatment of nationalism produces works that do not simply support the demands of cultural politics; in fact, many appear to defy these expectations or criteria. The primary strategy of disruptive inhabiting means that an art object's relationship to a dominant paradigm will not always be immediately recognizable nor will it simply be a matter of embracing or rejecting. The binaristic tension between consensus and dissent that English describes in tracing the development of black representational space does not readily permit the latitude for the heterogeneity and complexity of aesthetic radicalism. There are artists that are invested in representation *and* skeptical of artistic pressures for social reflection as

well as the possibility of representational tactics at all. The overwhelming tendency toward recognizing *either* consensus or dissent impedes detecting this type of technique. The disruptive inhabiting of the nationalist premium on representation pushes against the constrictive parameters of black representational space and opens up possibilities for discerning more innovative explorations of political matters. Attending to this method provides an opportunity to offer nuance to the discursive space that English describes. I use the work of two artists to demonstrate this queering of representation: one from the Black Arts era, Howardena Pindell, and the second from later in the twentieth century, Cheryl Dunye. This connection bears out my argument about nationalist rhetoric and experimentation as well my contention about the relationship between the recent past and the present.

Howardena Pindell's visual art exemplifies the Black Arts era scrutinizing of representation. Pindell is a painter whose signature style is the manipulation of color-field techniques and optical abstraction, and she began to exhibit work in the late 1960s. In her visual and written work, Pindell has dedicated herself to exploring how social racism and political inequality have impacted the art world and shaped the experiences of racial minorities. She is most often studied in relation to feminism because of her sobering critiques of its second-wave manifestation.[4] Yet her questioning of what constitutes "Black art" and her concern about the enduring racism and discriminatory exclusivity of the world of art galleries makes her important to an exploration of the artistic discourse of representation.

Her artistic methods show her incorporation of nationalist interrogations. In discussing her early style, art critic Holland Cotter explains that Pindell's primary technique involves "disassembling the painting medium into fragments and then reconstituting it in the form of collage."[5] The early pieces *Untitled* (1970), *Untitled #4* (1973), and *Untitled #73* (1975) illustrate this strategy. In these paintings and the series in its entirety, Pindell takes a sheet of paper and punches holes into it. She then attaches these punched circles with a spray adhesive "in confetti-like layers to sewn sheets of graph paper, board or canvas" (Cotter 10). The holes are sometimes painted over as in #73 or carefully numbered as in #4. I do not read these paintings as merely illustrative of a technique of feminine "adamant decorativeness" (Cotter 11). The punched holes and the worked appearance of the canvas—showing evidence of having been sewn, heavily textured with paint, and physically manipulated—function to make present Pindell's labor-intense procedure in creating. The nonrepresentational paintings offer up Pindell's laboring body. This indirect presentation of the Black female body is key. Her technique in this series is to refuse or resist direct presentation or full figuration; there are no bodies, images, or even

recognizable objects. Nonetheless, Pindell is able to put forward a rendering of the body at work. One can read the series as an ongoing meditation on the idea of the representability of Blackness at a historical moment when both activists and artists were calling for accurate representation. Her method responds to the emphasis on representation in political rhetoric of the time period. It is less a rejection of this political premium than a strategic reconfiguration of the means of expression as well as the art object.

Figure 8. Howardena Pindell, *Untitled #4*, 1973. Mixed media on paper mounted to board. 10 × 8 inches. Signed and dated, verso. Courtesy of the artist and Garth Greenan Gallery, New York.

The question of what is represented in the work of art emerges here as central. The painting series was created in response to the ignoring of minority production in general and Black female production in particular in the art world. Pindell addresses these realities in her commentaries such as "Covenant of Silence: De Facto Censorship in the Visual Arts." She writes:

> In the reams of articles, books, editorials, and programs I have studied concerning censorship in the visual arts, there is a glaring omission from the discourse: examination of the ongoing practice of censoring out artists of color, except for reluctantly included occasional tokens. . . . The willful omission of artists of color is skillfully manipulated to appear to be benign, like some kindly mercy-killing of that which the powers-that-be feel simply not to measure up to their yardstick of "quality." Thus the artworld remains forever ignorant of the work of artists of color, limiting the scope of their own (artworld) knowledge about themselves and others. . . . I believe through direct personal experience that omission—de facto censoring of artists of color—is an act of violence, whether you erase our presence by physical violation or erase us by turning your backs on us.[6]

The problem that Pindell outlines is one of representation and visibility, the same problem outlined by activist critics in the civic realm. Throughout the piece, she traces what she sees as the ongoing and deliberate absenting of artists of color. This absenting is the subject of the *Untitled* series. The series features a purposeful avoiding of traditional representation that mirrors the "omissions" Pindell discusses. In these innovative painted constructions, Pindell employs methods of abstraction to suggest a body that is not depicted within the work itself. The fact that all of the works in the series are titled *Untitled* contributes to the sense of an ironic absent presence. The collagic series offers a critique that uses the method of the object of critique (erasure and obscuring) as its modus operandi.[7] There is an anxiety about the Black body as well as an acknowledgment of the expectation that Black art can only be legible as a medium for presenting this body. Pindell's work stages an important dilemma for Black Arts era artists: bolstering an investment in body politics as a productive artistic site while also being attentive to the histories of spectacle that surround the Black body. Making this body illegible (evoking it while also obscuring it) is a technique for navigating this theoretical quagmire. Her collagic method questions the value and even the possibility of representation. The series situates Black nonrepresentational art as the reimagining of the political imperative of representation rather than a mere refusal of it.[8]

This tactic signifies both an exploration of and disengagement from the act of mirroring; it is a *visual* disruptive inhabiting of representation. The reluctance to represent or to reproduce exactly becomes an elemental component of Black Arts logic in its recasting of nationalist rhetoric. Amiri Baraka's collaborative work with Fundi (photographer Billy Abernathy) in the 1970 volume *In Our Terribleness* displays the complex engagement of the notion of representation with which Pindell and the other artists wrestle. This book of poetry, musings, and photographs relies on sometimes platitudinous and superficial understandings of nationalism while also providing important theorizations of the relationship between and among language, imagery, and contemporary Black identity.[9] The book opens with a silver-coated page, which functions as a textual mirror. This mirror-like page, however, provides less a reflection than a distortion of the reader/viewer's face. Words ("In Our Terribleness") interrupt the visual plane thereby rendering the poor reflection even more abstract as one's eyes shift focus from the indistinct image to the impressed words. The construction and presentation of the volume distorts the idea of representing a stable, recognizable subject. The text projects a subject that is unrecognizable, and this projection frames the poetry and the photographs contained therein. The unrepresentable character of racial identity is explored in this volume. The illegibility of figuration emerges prominently in Pindell's series. Pindell, who is not normally considered in relation to the Black Arts era, employs a method that is in line with interrogation of nationalist principles. These strategies take up the idea of representation itself and are not driven by a need simply to document social realities or a particular experience. Mimetic reflection in art is the idea that comes under scrutiny, which allows the work to push against conceptual restraints on how African American art relates itself to the realm of politics. Pindell disorders the protocols of representation echoing the defining ideas in Larry Neal's essay on the Black Aesthetic "Some Thoughts on the Black Aesthetic," which I discuss in the introduction.

Notwithstanding the concurrent connection between Pindell and Baraka, part of my goal has been to illuminate how later artists take up disruptive strategies like Pindell's. Cheryl Dunye's 1996 independent film *The Watermelon Woman* questions representation in regard to Black identity in the context of the political emphasis on the Black art-as-mirror metaphor as it attempts to recover the history of Black lesbian existence.[10] Dunye is an important contributor to queer cinema as well as one of the most important Black independent filmmakers of the late twentieth century. Her work has consistently explored lesbian life in contemporary U.S. culture and the

place of desire in the context of social and political dilemmas. *The Watermelon Woman* follows Black lesbian filmmaker Cheryl—played by Dunye herself—in her attempt to document the life of the 1930s Black actress Faith "Fae" Richards.[11] Cheryl is disturbed by the dearth of Black women's stories in cinema though their images abound in popular culture. She looks to films from the 1930s and 1940s to document how Black women found space for themselves in the industry. Cheryl is able to piece together Fae Richards's life through archival research and interviews.

The source of much of the critical discussion of the film has been the fact that it is a fictional documentary—Fae Richards, the "Watermelon Woman" never existed.[12] The last frame of the film reads "Sometimes you have to create your own history. The Watermelon Woman is a fiction."[13] Dunye constructs her experimental film using the methods of a documentary filmmaker (Cheryl goes to archives, interviews scholars, and tracks down living people) to create her own fictionalized version of a documentary. She takes advantage of the reader's expectations that these techniques are mechanisms for realistic representations and manipulates them to call into question our assumptions about Black art's role in depicting accurately Black lived experience. It is not simply that the historical figure of the film is a fiction; like Gloria Naylor in the novel *1996* discussed in chapter 2, Dunye fictionalizes her own late-twentieth-century life. She reimagines her present through the medium of her filmed Black lesbian body. Moving beyond attempting to tell a story or trace a history, this double fiction indexes the difficulties of representing the lives of racial and sexual minorities even at the present moment as it also exposes our desires to have those stories presented. Similar to Pindell, Dunye's strategy refuses the prioritizing of documenting social realities and Black experience in favor of undermining the possibility of mimetic reflection.

This film is an important example of feminist historiography in cinema;[14] however, it is also significant as an exploration of the elasticity of nationalist rhetoric. *The Watermelon Woman*'s engagement of nationalism comes across most explicitly in the portrayal of Tamara, Cheryl's best friend. Tamara is another Black lesbian, whom Dunye presents as a parody of a nationalist. She is a butch-styled lesbian who avows retrograde masculinism (she is always chasing women and is focused on sex),[15] discourages relationships with White people (her pro-Blackness is primarily expressed as the criticism of the White characters), and is a consistent critic of governing power structures (even when that power structure is a Black video store manager rather than the state). Although one might read this characterization as a flat rejection of nationalism, it represents a challenge to constraining expressions of it. In

the process of lampooning familiar essentialist constructions that can result from nationalism, the film as a whole takes on the imperative of representation that black representational space demands.

The nationalist premium on the re-presentation of a coherent Black subject is one of the structuring concerns and reference points of the film. *The Watermelon Woman* questions the feasibility of the nationalist imperative of "turning inward" toward Blackness. Employing the form of documentary *and* directing the camera onto herself, Dunye enacts this turning inward strategy. This turning inward to the racialized self does not result in the presentation of a stable Black subject; both Fae and Cheryl are fictional constructions. Dunye literalizes the paradigm in order to subvert it. Identity becomes unrecognizable in a film about the importance of documenting and archiving Black selfhood. Because the form of the documentary suggests mirroring, Dunye confronts the concept of mimesis, hoping to unseat it as a priority. The mirroring of the self in the film creates a confusion of Black personhood as opposed to a clear expression of it. One wonders, where is the boundary line between Cheryl the character and Dunye the director? What is the purpose of fictionalizing the self? Who is the subject of the (fake) documentary? Ultimately, the means and modes of representing the self are the dominant concerns of the film. A political discourse of representation emerges in this fictionalized documentary that emphasizes denial and illegibility. While Pindell refuses to offer a body, Dunye offers a body only to insist that it is not actually there. She queers the filmic medium of the documentary as well as the language of nationalism, recalling filmmaker Marlon Riggs's techniques in *Anthem*, which I use to frame the introduction along with Neal's essay.

In inventing Fae Richards, Dunye indicates that both the past and identity are inaccessible. The inaccessibility and indeterminacy fundamental to the filmic structure fuel critical readings of the film. Andrea Braidt's contention that the film is a "queer ethnography" is helpful in parsing this notion of inaccessibility.[16] *The Watermelon Woman*'s focus on Black lesbian existence by a Black lesbian ostensibly substantiates the idea of a *queer* ethnography. The fact that the film expresses Black lesbian identity through falseness also feeds into this idea of a queer work. Mark Winokur extends the queer reading to Dunye's inclusion of her (fictionalized) self in the film.[17] Dunye's self-presentation inserts ambiguity into her own Black lesbian identity, especially because it is depicted by and through the enigmatic and ultimately fictive Fae. These multiple levels of mediation that Dunye is determined to make elemental in her work demonstrate the unrepresentability of the same identity that she hopes to capture.

Dunye's imaginative construction of Fae depends on a particular system of representation of Blacks that Whites have put into place. In her films, Fae Richards performs as a recognizable figure in U.S. popular culture: the "mammy." This character exists only because of a long history of White constructions of Blackness and Black womanhood in particular. During the Black Arts era, visual artists Joe Overstreet and Betye Saar both reinterpret the mammy figure Aunt Jemima as a militant fighter reflecting nationalist critiques of Black stereotypes in the public sphere.[18] Instead of reimagining this formulaic figure of racial categorization, Dunye situates the mammy as a chief conduit for accessing Black female identity. As the racialized name *Watermelon Woman* continually reminds the viewer, Dunye envisions Black lesbian existence by placing in the foreground a limiting White construction of Blackness. From her perspective, one must first come to terms with this construction to get to the Black body because such constructions shape the social understanding of Black identity. The Black lesbian body—and by extension the Black body in general—is subject to mediation by fantastic ideas that impose racial and sexual meaning. Such mediation implies that representation itself is a fraught endeavor.

Dunye's goal is not to say that there is no pressing need to represent Black identity, but rather to insist that the premium on authentic representation may not achieve its goals because of prevailing social conceptions of minority bodies. We expect (perhaps even demand) to see accurate depictions because of Dunye's chosen form *and* because of the cultural expectations that continue to surround Black art—as Darby English details. The emphasis on such representation remains steadfast into the twenty-first century due to the link made between artistic production and the political context of Black lived experience. Dunye directs her attention to this pressure that political analysis can place on expressive culture. She refuses our desires to have her art serve as social mirror; we are met only with fabrication and the inauthentic. The film makes us aware that representation always rests upon a set of inherited frameworks shaped by racism and sexism, especially in regard to visual culture. The idea that art can do the political work of making a population's people socially legible as themselves comes under close scrutiny. The film does not argue that fiction is the only tool available for recovering Black lesbian lives. Instead, Dunye exposes the trick that we play on ourselves in thinking that mimetic representation is possible or even progressive. She symbolically turns the camera on us—and the assumptions we make about art's role—just as she does with herself in making the film. The trick of the film is thought to be the fact that it is a fiction: what you think is real is not.

Perhaps the actual trick is that the audience becomes the subject in place of Fae. We are denied Fae Richards, but through Dunye's distortion of the protocols of representation, we are shown ourselves (or our expectations). Both Dunye and Pindell trouble accepted methods for representation and manipulate representation as a nationalist imperative of legitimacy by engaging and then destabilizing it. In doing so, they queer representation and provide examples of how contemporary visual culture addresses political questions as aesthetic projects.

Howardena Pindell, Cheryl Dunye, and the other artists examined throughout *Radical Aesthetics* produce work that demands that the critical community reassess how contemporary African American artistic production locates itself in relation to both political discourses and conceptions of identity. The ongoing engagement of Modern Black Nationalism throughout African American artistic culture might not always be readily apparent. However, when contemporary work is put in conversation with work produced during the flourishing of late-twentieth-century revolutionary nationalism, one can recognize how the technique of disruptive inhabiting is an attractive strategy for artists working in the Black Arts era as well as for those working into the twenty-first century. One can connect these two periods through common methodological approaches: a genealogy emerges through methodology. Articulations of Black nationalism may have been meant to mobilize political activism and a general reimagining of the social body, but appeals for revolutionary identity also instigated questioning of the subjects they sought to produce. From this perspective, nationalism becomes legible as a site of unending examination and multivocality instead of one of certainty and homogeneity. One finds that cultural producers who heed the nationalist call of revolution and transform it into art often generate radical ways of thinking that embody *and* exceed the original political rhetoric of nationalism.

Notes

Introduction

Epigraphs: Larry Neal, "The Black Arts Movement," in *The Black Aesthetic*, ed. Addison Gayle, Jr. (Garden City, NY: Anchor Books Press, 1971), 247.

This statement is the refrain in Marlon Riggs's 1991 film *Anthem*. The film is collected on the compilation *Boys' Shorts* (Santa Monica, CA: Strand Home Video, 2004).

1. See Neal, "The Black Arts Movement." "Some Thoughts" appears in *The Black Aesthetic*, 12–15.

2. The piece sketches out the many possible forces that give shape to Black life: music, desire, dance, terror, worship, heterosexual social pressures, love, activism, and ethics. There are also two lists of historical and mythical names, including Shango, Brer' Rabbit, Signifying Monkey, Moms Mabley, Bessie Smith, James Brown, Malcolm X, Garvey, and Du Bois. The names outline histories of entertainment and protest, which together help to constitute the context for Black subjectivity.

3. One might also read this listing as a creative interpretation of the Black Panther Party's "Ten-Point Program."

4. Riggs produces this short film after his well-known 1989 documentary *Tongues Untied*. Stefanie Dunning's book discusses how to read this earlier film through a frame of Black nationalism in *Queer in Black and White: Interraciality, Same Sex Desire, and Contemporary African American Culture* (Bloomington: Indiana UP, 2009).

5. B. Ruby Rich explains this concept in "The New Queer Cinema," *Sight & Sound* 2.5 (1992): 30–35.

6. Larry Neal offers this understanding in "The Black Arts Movement." James Smethurst provides a detailed examination in *The Black Arts Movement* (Chapel Hill: U of North Carolina Press, 2005).

7. This move also recognizes the critical disagreement about which actors were actually a part of the Black Arts Movement, who were marginal participants, and who were complete outsiders to the movement.

8. Wilson Jeremiah Moses, *Classical Black Nationalism* (New York: New York UP, 1996).

9. Nineteenth-century thinkers Maria Stewart and David Walker represent fore-runners to what Moses sees as Classical Black Nationalism.

10. Moses, *Classical Black Nationalism*, 20.

11. Evelyn Brooks Higginbotham, *Righteous Discontent: The Women's Movement in the Black Baptist Church, 1880–1920* (Cambridge: Harvard UP, 1993).

12. Marcus Garvey's papers detail his belief system as well as his professional activities. They reflect connections to earlier thinkers and those who would follow him. See *The Philosophy and Opinions of Marcus Garvey* (New York: Arno P, 1968).

13. William Julius Wilson, *The Golden Age of Black Nationalism* (Hamden, CT: Archon Books, 1978).

14. See Martin Summers, *Manliness and Its Discontents: The Black Middle Class and the Transformation of Masculinity, 1900–1930* (Chapel Hill: U of North Carolina P, 2004), 21.

15. Quoted in Michelle Stephens, *Black Empire: The Masculine Global Imaginary of Caribbean Intellectuals in the United States, 1914–1962* (Durham, NC: Duke UP, 2005), 88.

16. See Garvey, *The Philosophy and Opinions*, 310–20. Anthony Dawahare offers a comparison of Garvey's thought to Du Bois's in *Nationalism, Marxism, and African American Literature Between the Wars* (Jackson, MS: U of Mississippi P, 2003).

17. Journalist Cyril Briggs established the African Blood Brotherhood (ABB), a small but important nationalist organization, in 1919. The ABB was founded as a kind of secret society that "alternately courted and sparred with" Garvey's UNIA. See William Van Deburg, *Modern Black Nationalism* (New York: New York UP, 1996), 34). Its members became the first Black communists in the United States. Active recruitment began to decline when Briggs linked the organization to the Communist Party of the United States, and the ABB dissolved in 1925. The American Negro Labor Congress, which was a communist instrument for attending to African American concerns, took its place. However, its organizing framework displaced more traditional nationalist ideologies. Briggs's ABB represents an important attempt to link nationalist thought to communism, which would get taken up later in the century. Minkah Makalani provides an in-depth discussion of the ABB in the book *In the Cause of Freedom: Radical Black Internationalism from Harlem to London* (Chapel Hill: U of North Carolina P, 2011). In addition, Claudrena Harold offers a valuable history of the proliferation and then decline of Garveyism in the U.S. South from 1918 to 1942. See *The Rise and Fall of the Garvey Movement in the Urban South* (New York: Routledge, 2014).

18. See Martha Lee, *The Nation of Islam* (Syracuse, NY: Syracuse UP, 1996).

19. See Dawn-Marie Gibson, *A History of the Nation of Islam* (Santa Barbara, CA: Praeger, 2012).

20. For considerations of the link between religious doctrine and economic self-sufficiency, see Gibson, *A History of the Nation of Islam* and Dennis Walker, *Islam and the Search for African-American Nationhood* (Atlanta, GA: Clarity, 2005).

21. The NOI became increasingly politically active in the late twentieth century, particularly after Louis Farrakhan revived the organization in 1981 after Elijah Muhammed's son Warith Deen Muhammed dissolved it in 1976. Farrakhan's 1995 Million Man March represents an explicit attempt to situate prominently NOI beliefs in the public sphere and to address both Muslim and non-Muslim audiences.

22. See James Smethurst, *The New Red Negro: The Literary Left and African American Poetry, 1930–1946* (New York: Oxford UP, 1999); William Maxwell, *New Negro, Old Left* (New York: Columbia UP, 1999); Cedric Robison, *Black Marxism: The Making of the Black Radical Tradition* (Chapel Hill: U of North Carolina P, 1983); Barbara Foley, *Spectres of 1919: Class and Nation in the Making of the New Negro* (Urbana: U of Illinois P, 2003); Bill Mullen, *Popular Fronts: Chicago and African-American Cultural Politics, 1935–46* (Urbana: U of Illinois P, 1999), and Robin Kelley, *Hammer and Hoe: Alabama Communists during the Great Depression* (Chapel Hill: U of North Carolina P, 1990).

23. Kelley, *Hammer and Hoe* 13.

24. A number of scholars such as Mary Helen Washington, Barbara Foley, and William Maxwell have sought to uncover the Black literary engagement with the Left at midcentury. Although there are disappointments with the Left, artists and activists attempt to use its ideology to advance the Black Freedom struggle.

25. See Claudia Jones, "On the Right to Self Determination of the Negro People in the Black Belt," in *Words of Fire: An Anthology of African American Feminist Thought*, ed. Beverly Guy-Sheftal (New York: New Press, 1995), 67–77. Carole Boyce Davies and Denise Lynn both discuss the significance of Jones's essay. See Boyce Davies, *Left of Karl Marx: The Political Life of Black Communist Claudia Jones* (Durham, NC: Duke UP, 2007) and Lynn, "Women and the Black Radical Tradition," *Binghamton Journal of History* (Fall 2002), https://www.binghamton.edu/history/resources/journal -of-history/woman-blk-trad.html.

26. See Alan Wald, "'Triple Oppression' to 'Freedom Dreams,'" *Against the Current* January/February 2013: 24–27; and Mary Helen Washington, *The Other Black List: The African American Literary and Cultural Left of the 1950s* (New York: Columbia UP, 2014).

27. See Aldon Morris, *The Origins of the Civil Rights Movement* (New York: Free Press, 1984); August Meier and Elliott Rudwick, *CORE: A Study in the Civil Rights Movement* (New York: Oxford UP, 1973); Patricia Sullivan, *Lift Every Voice: The NAACP and the Making of the Civil Rights Movement* (New York: Free Press, 2009); Clayborne Carson, *In Struggle: SNCC and the Black Awakening of the 1960s* (Cambridge: Harvard UP, 1981); Iwan Morgan and Phillip Davies, *From Sit-Ins to SNCC: The Student Civil*

Rights Movement in the 1960s (Gainesville: U of Florida P, 2012); David Garrow, *Bearing the Cross: Martin Luther King, Jr. and the Southern Christian Leadership Conference* (New York: William Morrow, 1999); and Barbary Ransby, *Ella Baker and the Black Freedom Movement* (Chapel Hill: U of North Carolina P, 2003).

28. In the essay "The Black Arts Movement," I discuss how the disappointment with the social conditions following the Civil Rights Act contributed to the rise of Black activist nationalist groups. See GerShun Avilez, "The Black Arts Movement," in *Cambridge Companion to American Civil Rights Literature,* ed. Julie Armstrong (New York: Cambridge UP, 2015), 49–64.

29. In "The Black Arts Movement," I explain, "Activists found that local governments failed to enforce the 1965 Voting Rights Act and that neither the 1964 Civil Rights Act nor the Voting Rights Act did much to impede the social abuse of Black American citizens, as the shooting of James Meredith in Mississippi illustrates. In addition, the social uprising that occurred in the Watts neighborhood of Los Angeles, California, in 1965 stands as a testament not only to police mistreatment, but also to the inevitable outcome of the stifling practices of segregation in American society and the ongoing neglect and constriction of inner-city communities in the face of so-called legislative advances. These social conditions led to the rise of Black activist nationalist groups such as the Black Panther Party for Self-Defense, whose members strove to protect and improve the conditions of their communities" (50).

30. See Peniel Joseph, *Waiting Till the Midnight Hour: A Narrative History of Black Power in America* (New York: Holt, 2006) and *The Black Power Movement: Rethinking the Civil Rights-Black Power Era* (New York: Routledge, 2006).

31. See Frantz Fanon, *The Wretched of the Earth* (1963. New York: Grove, 1993); Stokely Carmichael, *Black Power: The Politics of Liberation* (1967. New York: Vintage, 1993); Angela Davis, *The Angela Davis Reader,* ed. Joy James (Malden, MA: Blackwell, 1998); and Elaine Brown, *A Taste of Power: A Black Woman's Story* (New York: Anchor, 1994).

32. Given my interest in nationalism and artistic radicalism, it is worth noting that there is a recognizable link between aesthetic innovation and Black nationalism. Marcus Garvey's bolstering of nationalist logic extended to aesthetic considerations. A reimagining of sartorial presentation accompanied the UNIA's expressed desires for community building. Photographs of the 1920 UNIA convention parade illustrate how male members of the organization (the African Legion) were appareled in highly militaristic dark-colored uniforms with epaulettes, swords, capes, and medals for higher ranked individuals. Garvey himself appears in the dress of a general or an emperor with an identifying plumed hat, an article of clothing so crucial to the visual presentation and memory of Garvey that Colin Grant titles his 2008 biography of the leader *Negro with a Hat*. In addition, the UNIA parades often featured the Universal African Black Cross Nurses, a female auxiliary of the UNIA. The Black Cross Nurses appear in all-white garments with black Latin crosses on the caps covering their hair. Michelle Stephens describes the highly stylized adornment as the "visual

spectacle of Garveyism" (*Black Empire* [Durham, NC: Duke UP, 2005], 75). E. David Cronon characterizes the event itself as "an extravaganza not soon to be forgotten": the African Legion visually suggested that "the redemption of the Negro people might come through force" and the Black Cross Nurses symbolized the willingness of the UNIA "to come to the aid of stricken peoples all over the world" (*Black Moses: The Story of Marcus Garvey and the Universal Negro Improvement Association* [Madison: U of Wisconsin P, 1960], 62, 63–64). The manipulation of attire emblematizes the exact notion of Black unity, and the parade functions as an embodied claim to ownership of place and freedom of mobility. Through this particular concern with the aestheticization of ideology, the contemporary reader can begin to recognize a recurring trope in nationalist discourses and organizing before *and* after Garvey's particular historical moment. Garvey's interest in the visual presentations of his ideals reflects, in part, the impact of Masonic traditions on his thinking. He models the UNIA after this fraternal organization. Both Martin Summers and Colin Grant detail the influence that John E. Bruce and the stylings of Prince Hall Freemasonry had on Garvey. See Summers, *Manliness and Its Discontents,* and Grant, *Negro with a Hat: The Rise and Fall of Marcus Garvey* (New York: Oxford UP, 2010). These texts also indicate that many UNIA members were Masons. Garvey's strategies are also highly influential later in the twentieth century. One can link Garvey's sartorial concerns specifically to those of the NOI and the Black Panthers, as Theodore Vincent shows. See Vincent, *Black Power and the Garvey Movement* (1970. Baltimore: Black Classic P, 2006). The all-male members of the Fruit of Islam, the paramilitary wing of the NOI, wear identical blue or white outfits with caps that have "NOI" on them. The all-female Muslim Girls in Training is an educational program that encouraged traditional religious dress for women with white robes for Sundays. The Black Panthers are well known for wearing black berets, black slacks, black leather jackets, and powder blue shirts, which Leigh Raiford describes as the "Panther uniform" (*Imprisoned in a Luminous Glare: Photography and the African American Freedom Struggle* [Chapel Hill: U of North Carolina P, 2011], 130.) This uniform symbolized solidarity and marked the group as countercultural revolutionaries visually. The point here is that Garvey's work is enmeshed in a tradition of Black collective consciousness and mobilizing as well as in attempts to determine aesthetic practices that communicate that consciousness. Through Garvey's visual spectacle, one is able to recognize the long arc of nationalist logics and aesthetic mindfulness in the twentieth-century social world—particularly in regard to public masculinist expression.

33. See previous note.

34. Ron Karenga's US organization (founded in 1965) and the *Kawaida* movement were designed to cultivate African American cultural traditions. For discussions of Karenga and *Kawaida*, see Amiri Baraka, *Kawaida Studies: The New Nationalism* (Chicago: Third World P, 1972) and William L. Van Deburg, *New Day in Babylon: The Black Power Movement and American Culture, 1965–1975* (Chicago: U of Chicago P, 1993). Discussions of the convention can be found in Harold Cruse's collected

writings (*The Essential Harold Cruse*, ed. William Jelani Cobb [New York: Palgrave, 2002]).

35. In 1965, LeRoi Jones announced the creation of the Black Arts Repertory Theatre and School in Harlem the day after Malcolm X's assassination. Through this organization, Jones attempted to use creative expression to radicalize the poor of Harlem and find ways to cope with social loss. The Free Southern Theatre, founded by John O'Neal, Doris Derby, and Gil Moses in Mississippi, had similar ambitions; participants in the troupe would later include writers such as David Henderson and Tom Dent. The important Southern poetry and theater collective BLCKARTSOUTH would later develop out of this organization.

36. See Van Deburg, *Modern Black Nationalism*.

37. See Maxine Leeds Craig, *Ain't I a Beauty Queen: Black Women, Beauty, and the Politics of Race* (New York: Oxford UP, 2002) and Ronald L. Jackson's *Scripting the Black Masculine: Identity, Discourse, and Racial Politics in Popular Media* (Albany: SUNY, 2006).

38. See Wahneema Lubiano, "Black Nationalism and Black Common Sense: Policing Ourselves," in *The House that Race Built* (New York: Vintage, 1998) and "Standing in for the State: Black Nationalism and 'Writing' the Black Subject," in *Is It Nation Time?: Contemporary Essays on Black Power and Black Nationalism,* ed. Eddie Glaude (Chicago: U of Chicago P, 2002), 156–64.

39. See Jeffrey Ogbar, *Black Power: Radical Politics and African American Identity* (Baltimore: Hopkins UP, 2004).

40. Katherine Tate, *From Protest to Politics: The New Black Voters in American Elections* (Cambridge: Harvard UP, 1993), 160.

41. Michael Dawson, *Black Visions: The Roots of Contemporary African American Political Ideologies* (Chicago: U of Chicago P, 2003), 133–34.

42. Melayne Price, *Dreaming Blackness: Black Nationalism and African American Public Opinion* (New York: New York UP, 2009), 162.

43. See Van Deburg, *New Day in Babylon*.

44. Ibid., 171.

45. Because the relationship between the world of art and the world of political rhetoric prevails in my analysis, I am in conversation with Richard Iton's conception of the Black fantastic. Like Iton, my argument develops out of the contention that crossing the line between art and politics has potential to disrupt social meanings. However, instead of using this transgression to remap the formal political arena, my consideration of aesthetic radicalism demonstrates that the contemporary artistic engagement of nationalism yields innovative projects that test formal boundaries of genre as well as conceptual means for articulating identity. See Iton, *In Search of the Black Fantastic: Politics and Popular Culture in the Post-Civil Rights Era* (New York: Oxford UP, 2008).

46. Disruptive inhabiting is, in part, a reworking of José Esteban Muñoz's concept *disidentification*. He defines this idea as a "survival strategy" by which disempowered subjects negotiate dominant ideologies and social formations by identifying and

counteridentifying with them. He suggests that disidentification strategies—particularly performative ones—can help to create counterpublics and oppositional ideologies. My use of disruptive inhabiting shifts the focus. Disruptive inhabiting pertains specifically to the critical evaluation of nationalist ideological rhetoric and is employed both by those who are empowered by this rhetoric and those who are disempowered by it. The emphasis is less on minority survival tactics than on the means by which different Black subjects relate to a defining social logic. Moreover, the focus is not on articulating oppositional ideologies, but rather on revising from within. See Muñoz's *Disidentification: Queers of Color and the Performance of Politics* (Minneapolis: U of Minnesota P, 1999).

47. Roderick Ferguson, *Aberrations in Black: Toward a Queer of Color Critique* (Minneapolis: U of Minnesota P, 2007).

48. See Patricia Hill Collins's discussion in *Black Feminist Thought* (New York: Routledge, 2000); and Kimberlé Crenshaw's "Mapping the Margins: Intersectionality, Identity Politics, and Violence against Women of Color," *Stanford Law Review* 43.6 (1991): 1241–99.

49. See Sheena Howard, *Black Queer Identity Matrix: Towards an Integrated Queer of Color Framework* (New York: Peter Lang, 2014); Phillip Brian Harper, "The Evidence of Felt Intuition: Minority Experience, Everyday Life, and Critical Speculative Knowledge," in *Black Queer Studies*, eds. E. Patrick Johnson and Mae Henderson (Durham, NC: Duke UP, 2005), 106–23; and E. Patrick Johnson, "'Quare Studies,' or (Almost) Everything I know about Queer Studies I learned from my Grandmother," *Black Queer Studies*, 124–57.

50. I discuss the implications of positionality as a feature of QOCC at length in chapters 2 and 4.

51. Ferguson, *Aberrations in Black*, 3.

52. See Muñoz, *Disidentification*.

53. See Smethurst, *Black Arts Movement*.

54. See Amy Abugo Ongiri's ambitious *Spectacular Blackness: The Cultural Politics of the Black Power Movement and the Search for a Black Aesthetic* (Charlottesville: U of Virginia P, 2010). Ongiri emphasizes the class dynamics of the time period, the resulting social divisions, and the artistic culture that developed out of these divisional logics. Smethurst makes an analogous argument about the Black Aesthetic functioning as a literary conduit for the vernacular and mass culture, which he describes as the "popular front."

55. See Margo Crawford, *Dilution Anxiety and the Black Phallus* (Columbus: U of Ohio P, 2008). Crawford's psychoanalytic discussion of the Black Arts recuperation of the phallus is instructive in that it leads to a consideration of a cultural concern with the social implications of sex and sexuality, the aestheticization of color, the politics of location, and the interpellation of the Black subject.

56. See Barbara Foley, *Radical Representation: Politics and Form in U.S. Proletarian Fiction, 1929–1941* (Durham, NC: Duke UP, 1993) and *Spectres of 1919* and Smethurst, *New Red Negro* and *Left of the Color Line* (Chapel Hill: U of North Carolina P, 2003).

57. Read together, it becomes clear that these critics are investigating what they have determined to be Black (Post)modernism, and they locate this artistic manifestation within Black Arts cultural production. From the vantage point that their works collectively create, Black Arts innovation describes the process of taking up of modernist techniques *as well as* the question of modernity itself and reimagining them in order to produce Black (Post)Modernism. Moreover, these three critical accounts all emphasize music and performance as the primary means to such modernist rearticulations. See Aldon Nielsen, *Integral Music: Language of African American Innovation* (Tuscaloosa: U of Alabama P, 2004); Kimberly Benston's *Performing Blackness: Enactments of African-American Modernism* (New York: Routledge, 2000); Fred Moten, *In the Break: The Aesthetics of the Black Radical Tradition* (Minneapolis: U of Minnesota P, 2003).

58. In making the argument that Black Arts era aesthetic strategies function as significant conduits for artistic and theoretical innovation within contemporary African American expressive culture, I depart from critics such as Madhu Dubey and D. L. Smith, who recognize the historic importance of the Black Arts Movement and its Black Aesthetic but view it as limiting, prescriptive, and theoretically exhausted. See Smith's "The Black Arts Movement and Its Critics," *American Literary History* 3 (1991): 93–110; and Dubey's *Black Women Novelists and the Nationalist Aesthetic* (Bloomington: Indiana UP, 1994). The work of both critics has done much to shed light on the literature produced during the Black Arts period, and each encouraged more scholarship on the period to be done.

59. See Jeffrey Ogbar's discussion of the Student Nonviolent Coordinating Committee in *Black Power*.

60. See Alondra Nelson, *Body and Soul: The Black Panther Party and the Fight against Medical Discrimination* (Minneapolis: U of Minnesota P, 2011).

61. I take this idea from Gayle Rubin's formulation in "Thinking Sex," in *The Lesbian and Gay Studies Reader*, eds. Henry Abelove and Michele Arale (New York: Routledge, 1993).

62. Jasbir Puar, *Terrorist Assemblages: Homonationalism in Queer Times* (Durham, NC: Duke UP, 2007), xv.

63. See Cheryl Clarke, *"After Mecca": Women Poets and the Black Arts Movement* (New Brunswick, NJ: Rutgers UP, 2005); Evie Shockley, *Renegade Poetics: Black Aesthetics and Formal Innovation in African American Poetry* (Iowa City, IA: Iowa UP, 2011); and Rolland Murray, *Our Living Manhood: Literature, Black Power, and Masculine Ideology* (Philadelphia: U of Pennsylvania P, 2006).

64. One approach that would have maintained the methodology of comparison over time would be to have each chapter examine two artists: one from the recent past and one from the present. While that approach would create the possibility of tracking the connections between the Black Arts era and the post–Black Arts period, my concern is that it would put the past and present artists in a mere linear or contrapuntal relationship. It is important for the argument of this book that I discuss

a number of different texts and work across genres in each chapter. My goal is to put forward an argument about artistic culture and not simply about one particular genre. The structure is an important component of the argument.

Chapter 1. The Claim of Innocence

1. Student Nonviolent Coordinating Committee, "Position Paper on Black Power," in *Modern Black Nationalism*, ed. William Van Deburg, 120.

2. Civil rights activism in the 1960s often depended upon interracial collaboration as the massive voter registration campaign during the 1964 Mississippi Freedom Summer demonstrates. That summer saw the murders of a young Black man, James Chaney, and two young Jewish men, Andrew Goodman and Michael Schwerner, who had been working together in Mississippi. However, less than two years later, the members of the Atlanta Project voted to expel White participants from the Student Nonviolent Coordinating Committee.

3. This strategy extends a longer critical history of thinking through the social significance of Whiteness. A decade earlier in the essay "Stranger in the Village," James Baldwin contends one can learn who the White man is by considering how he imagines the Black man. Black Arts era writers are less interested in determining who the White man is, but they do recognize the value of assessing how this subject, the arbiter of social meaning, imagines Black people in hopes of creating new modes of expressing Black identity. See "Stranger in the Village," in *Notes of a Native Son* (1955. *Collected Essays*, ed. Toni Morrison [New York: Library of America, 1998]), 123.

4. Carolyn Gerald's essay was originally published in the journal *Negro Digest*, but it was later included in the seminal anthology *The Black Aesthetic*, ed. Addison Gayle (Garden City, NY: Anchor Books, 1971), 349–56.

5. Phillip Brian Harper's insightful reading of Black Arts poetry as relying upon questions of racial audience and an implied White listener, Black speaker, and Black overhearing community is one of the best treatments of the poetry from this period. Part of his point is that Black Arts racial thinking is dialogical; in other words, even radical modes of Black identity (and art) is imagined in a definite relationship to White people. My argument aims to uncover the possibilities for nondialogical elements of this thinking. For Harper's argument, see "Nationalism and Social Division in Black Arts Poetry of the 1960s," in *Are We Not Men?: Masculine Anxiety and the Problem of African American Identity* (New York: Oxford UP, 1996), 39–53.

6. See George Lipsitz, *Possessive Investment in Whiteness: How White People Profit from Identity Politics* (Philadelphia: Temple UP, 1998) for an account of how U.S. public policy helps to ensure a racialized hierarchy that guarantees White American access and agency socially. Following William Over's contention that African American texts can be used to reveal different conceptualizations of Whiteness, I use these artists' works to think about multiple levels of signification for Whiteness.

See William Over, "Some Do, Some Don't: Whiteness and the Treatment of Race in African American Drama," in *Complicating Constructions: Race, Ethnicity, and Hybridity in American Texts*, ed. David S. Goldstein and Audrey B. Thacker (Seattle: U of Washington P, 2007), 207–26.

7. See Thomas Ross, "The Rhetorical Tapestry of Race: White Innocence and Black Abstraction," *William & Mary Law Review* 32.1 (1990): 1–40.

8. My use of racialized innocence stands in contrast to Robin Bernstein's discussion of innocence in *Racial Innocence: Performing American Childhood from Slavery to Civil Rights* (New York: NYU Press, 2011). In this book, she argues that childhood innocence is integral to racial identity in the U.S. context.

9. Drama was a particularly important genre during the Black Arts era. Larry Neal's essay "The Black Arts Movement," which is often considered to be the foundational essay of the movement, is a piece that focuses on drama. See Neal, "The Black Arts Movement," *Black Aesthetic*, 257–74.

10. Mike Sell, Introduction to *Ed Bullins: Twelve Plays and Selected Writing* (Ann Arbor: U of Michigan P, 2006), 1.

11. See Fred Harwell, *A True Deliverance: The Joan Little Case* (New York: Knopf, 1980).

12. Angela Davis provides an early discussion and defense of Little in "The Dialectics of Rape," in *Angela Davis Reader*, 149–60. Genna Rae McNeil offers a useful analysis of the national support Little had in "'Joanne Is You and Joanne Is Me,'" in *Sisters in the Struggle: African-American Women in the Civil Rights-Black Power Movement*, eds. Bettye Collier-Thomas and V. P. Franklin (New York: New York UP, 2001), 259–79.

13. The title is a play on Rudyard Kipling's 1899 poem "White Man's Burden."

14. John Oliver Killens, *Black Man's Burden* (New York: Trident P, 1965), 6. LeRoi Jones (later Amiri Baraka) use similar language in characterizing White male mentality in his collection of essays *Home: Social Essays* (New York: Morrow, 1966).

15. One of Alligood's sons made a comparable statement at the trial. He said that he wanted to ensure that his father's name was "protected" and that justice was done. For a discussion of this element of the trial, see Harwell's *A True Deliverance*, 231.

16. See Cheryl Harris, "Whiteness as Property," *Harvard Law Review* 106.8 (1993): 1707–91; (emphasis added).

17. Bullins designs the play so that audience involvement begins before the play begins. He explains that the audience entrance to the theater should be part of the performance in that an electronic weapons detector should scan each audience member. The power of the state imagined in the play is extended to the space of the auditorium or theater.

18. See James Reston's discussion of the Free Joan Little Movement in *The Innocence of Joan Little* (New York: New York Times Book, 1977).

19. Ericka Munck's *Village Voice* review of the play makes a compelling assessment of the play's problematic relationship to women and feminism. See Ericka Munck, "Bullins: I Had My Way With Her," in *The Village Voice* (8 November 1976): 87–88.

20. There are two recent books that examine Piper's work extensively: Cherise Smith's *Enacting Others: Politics of Identity in Eleanor Antin, Nikki S. Lee, Adrian Piper, and Anna Deavere Smith* (Durham, NC: Duke UP, 2011) and John Bowles's *Adrian Piper: Race, Gender, and Embodiment* (Durham, NC: Duke UP, 2011).

21. Adrian Piper, *Out of Order, Out of Sight: Volume 1* (Cambridge: MIT Press, 1996), 117.

22. Piper initially refers to the Mythic Being as a "third world" figure and later as a "black male."

23. In 2013, Piper requested that her work be pulled from the art exhibit *Radical Presence: Black Performance in Contemporary Art*. In a letter to the curator Valerie Cassell Oliver, she stated that it is important to consider African American artistic achievement in the context of a multiethnic show. Cassell Oliver included the letter in the exhibition and posted the letter on the Radical Presence website, http://radicalpresenceny.org/. The decision to withdraw signals Piper's ongoing interest in understanding frameworks of race in the United States through cross-racial encounters, an idea fundamental to the *Mythic Being* and *Vanilla Nightmares* series.

24. See Piper, *Out of Order*.

25. The fictional character Gordon Gecko (played by Michael Douglas) proclaims that "greed is good" in the film. This statement has become a trademark of the film as well as an expression of Reaganite capitalist culture.

26. Piper offers her rationale in an explanatory essay on the series (*Out of Order* 253).

27. Benedict Anderson makes this argument in his *Imagined Communities: Reflections of the Origins and Spread of Nationalism* (London: Verso, 1983).

28. The drawings from the series that I discuss all appear in David Roediger's compilation *Black on White: Black Writers on What It Means To Be White* (New York: Schocken, 1998).

29. See Cynthia Marie Erb, *Tracking King Kong* (Detroit: Wayne State UP, 2009).

30. Given the sheer number of faces that stare out, one can also read the piece as reflecting fears about minority overpopulation.

31. John L. Jackson, *Racial Paranoia: The Unintended Consequences of Political Correctness* (New York: Basic Civitas, 2008), 86–87.

32. Jackson turns to the world of creative expression, particularly novel writing, in elaborating his point.

33. For information on the events surrounding the Smith trial, see: Maria Eftimiades, *Sins of the Mother* (New York: St. Martin's Press, 1995); George Rekers, *Susan Smith: Victim or Murderer* (Centennial, CO: Glenbridge, 1995); David Smith and Carol Calef, *Beyond All Reason: My Life with Susan Smith* (St. Louis, MO: Pinnacle, 1996).

34. *Brutal Imagination* is actually composed of two poetic cycles: "Brutal Imagination" and "Running Man." The title cycle focuses explicitly on the Susan Smith case, and the second explores the familial relationships of a Black male figure with the designation *Running Man*. The "Running Man" cycle develops around the eponymous

figure who has recently died. Many of the poems that make up the cycle are told from the perspective of Running Man's family and detail their respective attempts to deal with his death and create their own meanings of it *and* him. The speaker of the remaining poems is Running Man himself. These poems reveal his struggle to create a sense of identity in the context of his family's wishes during his lifetime. There is a textual connection between the man Smith imagines and the Running Man, who is made both present and absent by his family members, in that both are the subjects of imagining throughout their respective cycles. I focus on the first cycle but recognize the connections between the two.

35. The title of this poem resonates with Richard Wright's essay "How Bigger Got Born" (1953). Bigger himself can be read as a White creation or an artistic reaction to a composite of White conceptions of Blackness. Bigger is a forebear to Zero. Cornelius Eady, *Brutal Imagination* (New York: Random House), 2001.

36. See Eftimiades's discussion of the confession in *Sins of the Mother*.

37. The heart imagery also makes an interesting parallel to Jackson's conceptions of *de cardio* racism.

38. Lerone Bennett Jr., "The White Problem in America," *Ebony* August 1965: 1.

39. Eady recognizes the performative potential of the trope he employs. He participates in the translation of elements of the poetic cycle into a libretto for the 1999 jazz opera *Running Man*.

40. See Dorothy Roberts, *Killing the Black Body: Race, Reproduction, and the Meaning of Liberty* (New York: Vintage, 1997) and Patricia Hill Collins, *Black Sexual Politics: African Americans, Gender, and the New Racism* (New York: Routledge, 2005).

41. See Patricia Williams, *The Alchemy of Race and Rights: Diary of a Law Professor* (Cambridge: Harvard UP, 1991), 28.

Chapter 2. The Suspicion of Kinship

1. See Stokely Carmichael and Charles V. Hamilton, *Black Power: The Politics of Liberation* (1967. New York: Vintage, 1992), 36–37.

2. Epitomizing the social logic behind the proliferation of similar activist groups and nationalist calls to action, LeRoi Jones proclaims in 1966, "In America, black is a country." This assertion effectively defines *Blackness* as a singular collectivity bounded by a racialized understanding of ostensible kinship as citizenship. See LeRoi Jones, "Black Is a Country," *Home: Social Essays* (New York: Morrow, 1966), 82–86.

3. See Harper's "Nationalism and Social Division in Black Arts Poetry of the 1960s," *Are We Not Men?*, 39–53.

4. Contemporary theoretical accounts of paranoia often present it as deriving from the triangulation of postindustrial economic forces, poststructuralism, and systems theory. All of these structures destabilize the autonomous individual self by revealing modern humans to be generic, interchangeable bureaucrats, merely the subjects of a regulating discourse, or minor units in a complex power matrix. See Samuel Chase Coale, *Paradigms of Paranoia: The Cultures of Conspiracy in Contemporary American*

Fiction (Tuscaloosa: U of Alabama P, 2005); Kenneth Paradis, *Sex, Paranoia, and Modern Masculinity* (Albany: SUNY Press, 2007); Peter Knight, *Conspiracy Culture: From Kennedy to the X Files* (London: Routledge, 2000); and Timothy Melley, *Empire of Conspiracy: The Culture of Paranoia in Postwar America* (Ithaca, NY: Cornell UP, 2000).

5. See Paul Gilroy, "It's a Family Affair: Black Culture and the Trope of Kinship," in *Small Acts: Thoughts on the Politics of Black Culture* (London: Serpents's Tail, 1993), 192–207, quote on 203.

6. Hortense Spillers offers a contrasting reading of kinship in the African American context in the essay "Mama's Baby, Papa's Maybe," in *Black, White and in Color: Essays on American Literature and Culture* (1987. Chicago: U of Chicago P, 2003), 203–29. She explores how matriarchal conceptions of kinship define the social understanding of Black culture. She uses this theory to offer a critique of patriarchal interpretations of kinship. This assessment is important given that my own discussion will entail thinking through the gender dynamics that inform kinship structures. However, here I highlight Gilroy's ideas precisely because of his explicit focus on the link between Black nationalism and kinship.

7. George Lukásc, *The Historical Novel* (1937. Trans. Hannah and Stanley Mitchell. New York: Humanities P, 1965), 19–30. Jerome de Groot provides a valuable expansion of Lukásc's work in *The Historical Novel* (New York: Routledge, 2010).

8. John A. Williams, *The Man Who Cried I Am* (Boston: Little Brown P, 1967) and Alice Walker, *The Third Life of Grange Copeland* (New York: Harcourt, Brace, Jovanovich P, 1970).

9. See James Baldwin's essay "Everybody's Protest Novel," *Notes of a Native Son* (1955. New York: Beacon, 1984). Baldwin criticizes Wright and his belief that art always had a political purpose.

10. See Peniel Joseph, *Waiting Till the Midnight Hour: A Narrative History of Black Power in America* (New York: Holt, 2006).

11. See James Smethurst's discussion in *Black Arts Movement*, 248–49.

12. See Robert Reid-Pharr's discussion in *Once You Go Black: Choice, Desire, and the Black American Intellectual* (New York: New York UP, 2007).

13. The connection of the gift giving to kinship structures resonates with Marcel Mauss's scholarship. Gift exchange helps to establish social connections and circuits of trust, but they can also become tokens of rivalry. Williams's reliance on the symbol of gift giving enhances his exploration of kinship and trust from an anthropological perspective. See Mauss, *The Gift: The Form and Reason for Exchange in Archaic Societies* (1950. New York: Norton, 1990).

14. See Herman Beavers, "John A. Williams," *African American Writers*, ed. Valerie Smith (New York: Scribner's, 2001), 813–28.

15. For a discussion of the Memphis sanitation workers' strike, see Steve Estes's chapter in *I AM A Man!: Race, Manhood, and the Civil Rights Movement* (Chapel Hill: U of North Carolina P, 2005), 131–52.

16. This disillusionment is a tacit recognition that Max knew what Lillian planned to do and did nothing to stop her. Her death embodies not only his powerlessness but also his weakness. Though he blames White people, he has participated in Lillian's "hurting."

17. See Calvin Hernton, "Between History and Me: Persecution, Paranoia, and the Police." Hernton's essay is included in the collection *Even Paranoids Have Enemies: New Perspectives on Paranoia and Persecution*, ed. Joseph Berke, Stella Pierides, Andrea Sabbadini, and Stanley Schneider (London: Routledge, 1998), 166–76.

18. John L. Jackson's *Racial Paranoia: The Unintended Consequences of Political Correctness* (New York: Basic, 2008) is one of the first monographs to consider simultaneously racial identity and the affect of paranoia in contemporary American culture. Jackson explores the media's role in cultivating racial paranoia.

19. The intraracial betrayal that is manifested through the narrative arrangement is the focus of many other Black Arts era texts such as John Walker's play *The River Niger* and Barry Beckham's novel *Runner Mack*, both of which emphasize Black male homosociality and embodiment.

20. See Madhu Dubey, *Black Women Novelists and the Nationalist Aesthetic* (Indianapolis: Indiana UP, 1994).

21. Kimberly Springer, *Living for the Revolution: Black Feminist Organizations, 1968–1980* (Durham, NC: Duke UP, 2005).

22. Kay Lindsey, "The Black Woman as Woman," *The Black Woman: An Anthology* (1970. Ed. Toni Cade Bambara. New York: Washington Square P, 2005), 103–8.

23. See Louis Althusser, "Ideology and Ideological State Apparatuses," *Lenin and Philosophy and Other Essays* (1971. Trans. Ben Brewster. London: New Left, 1971), 121–76.

24. I link the critique of the family to feminist discourse here because of the analysis of thinkers such as Lindsey, but the critique of the traditional kinship structures would later become an important element of queer theory as well.

25. For example, this language frequently occurs in Amiri Baraka's poetry collections and in some of Malcolm X's early speeches.

26. See Joseph, *Waiting Till The Midnight Hour*.

27. The name *Copeland* itself indicates a particular and difficult relationship to land ("cope" and "land"); additionally, both Grange's and Brownfield's names suggest the centrality of land to their identities.

28. For discussions of the rise and politics of these two organizations, see Kimberly Springer, *Still Lifting, Still Climbing: Contemporary African American Women's Activism* (New York: New York UP, 1999); and Duchess Harris, "From Kennedy Commission to the Combahee Collective: Black Feminist Organizing, 1960–80," in *Sisters in the Struggle: African American Women in the Civil Rights-Black Power Movement*, ed. Bettye Collier-Thomas and V. P. Franklin (New York: New York UP, 2001). Combahee's "Statement on Black Feminism" offers an important synopsis of their philosophy. See *All the Women Are White, All the Blacks Are Men, But Some*

of Us Are Brave: Black Women's Studies, ed. Gloria T. Hull, Patricia Bell Scott, and Barbara Smith (New York: Feminist P, 1982).

29. The idea of men purposefully getting women pregnant in order to undermine their social power recurs in African American cultural theory. Trudier Harris references this sexist dynamic in her memoir *Summer Snow* (New York: Beacon, 2003).

30. See Toni Cade Bambara, "On the Issue of Roles," in *The Black Woman* (1970. New York: Washington Square, 2005), 123–36, quote on 129.

31. Carlene Hatcher Polite, *The Flagellants* (New York: Farrar, Straus, Giroux), 1967.

32. The confessional pair of essays that constitute the text ruminates on the historical moment of the Black Arts era in terms of Black heterosexual relationships, the state of the Black Freedom Movement, and the development of Black feminism. Wallace argues for the undeniable connection between the sexual realm and the sociopolitical sphere. Her basic contention is that sexualized racial mythologies that developed from the period of enslavement continue to buttress Black embodiment and are inscribed into Black identity and heterosexual relationships. The essays explain how Black men are understood to be hypersexualized, yet also emasculated; Black women, she contends, are imagined as "ballbreakers" (emasculating), masculinized, and sexual betrayers. This diametrically opposed constellation of images is central to Black nationalist assertions about the need for (re)instituting formulations of Black gender identity informed by androcentric heterosexuality. See Michele Wallace, *Black Macho* (1978. London: Verso, 1999).

33. See Reginald Watson, "The Power of the 'Milk' and Motherhood," *CLA* 48.2 (2004): 156–82.

34. See Alice Walker, *Revolutionary Petunias & Other Poems* (New York: Harcourt Brace Jovanovich, 1973).

35. See Tommie Shelby, *We Who Are Dark: The Philosophical Foundations of Black Solidarity* (Cambridge, MA: Belknap, 2005). I will explore the concept of positionality in relation to queer theorizing in the fourth chapter of this study.

36. Gloria Naylor, *1996* (Chicago: Third World Press, 2005).

37. Rebecca S. Wood provides an important discussion of *Bailey's Café* that presents the novel as a theoretical bridge between European and U.S. ethnoracial nationalist tradition in "'Two Warring Ideals in One Dark Body': Universalism and Nationalism in Gloria Naylor's *Bailey's Café*," *African American Review* 30.3 (1996): 381–95. Her goal is to think about the novel as an object of cultural synthesis, of which cultural nationalism becomes one component.

38. The mainstream presses Viking, Hyperion, Penguin, and Vintage published her previous novels.

39. See Jackson's *Racial Paranoia*.

40. Given that *1996* is a fictionalized memoir, I differentiate Gloria Naylor the author from Gloria Naylor the character by referring to the author as Naylor and the character as Gloria.

41. Like the character Ruth in *The Third Life of Grange Copeland,* this final alone-ness is a state constructed in part by the actions of the Black male characters in her life.

42. See Shelby, *We Who Are Dark.*

43. This essay was originally published in *Ms.* magazine in May 1974. Walker later included it in her collected volume *In Search of Our Mother's Gardens: Womanist Prose* (San Diego: Harcourt Brace Jovanovich, 1983), 231–43.

44. See "1996: Under the Watchful Eye of the Government," *News and Notes with Ed Gordon,* NPR, 23 January 2006.

45. In detailing the pervasiveness of paranoia in contemporary literary criticism and theory ("hermeneutics of suspicion"), Sedgwick argues that the hermeneutics of suspicion can be limiting and displace (or subsume) other ways of knowing: "The monopolistic program of paranoid knowing systematically disallows any explicit re-course to reparative motives, no sooner to be articulated than subject to methodical uprooting. Reparative motives, once they become explicit, are inadmissible in para-noid theory both because they are about pleasure ('merely aesthetic') and because they are frankly ameliorative ('merely reformist')" (146). The reparative approach attempts to be constructive and connective as opposed to the fragmenting nature of paranoia. See Eve Kosofsky Sedgwick, *Touching Feeling: Affect, Pedagogy, Performa-tivity* (Durham, NC: Duke UP, 2003).

Chapter 3. The Demands on Reproduction

1. See Hoyt Fuller, "Towards a Black Aesthetic," in *Black Aesthetic,* 3–11.

2. See Jennifer Nelson, *Women of Color and the Reproductive Rights Movement* (New York: New York UP, 2003).

3. This department became the Department of Health and Human Services in 1979 when the standalone Department of Education was created.

4. See Angela Davis, *Women, Race, and Class* (New York: Vintage, 1981); Dorothy Roberts, *Killing the Black Body: Race, Reproduction, and the Meaning of Liberty* (New York: Vintage, 1998); and Harriett Washington, *Medical Apartheid: The Dark History of Medical Experimentation on Black Americans from Colonial Times to the Present* (New York: Anchor, 2008).

5. The shift in the Black Panthers' policy about reproduction can be attributed to Elaine Brown's assuming leadership of the organization. See Brown, *A Taste of Power: A Black Woman's Story* (New York: Anchor, 1992). The emphasis on total health care programs encouraged the change.

6. For detailed explorations of these differing views of birth control, see "Third World Sisters: No Forced Sterilization," *The Militant* 30 July 1971: 21; "Genocide in Mississippi," SNCC Papers, reel 19; Black Women's Liberation Group, "Statement on Birth Control," in *Sisterhood Is Powerful: An Anthology of Writings from the Women's Liberation Movement,* ed. Robin Morgan (New York: Random House, 1970), 360–61;

M. Rivka Polatnick, "Poor Black Sisters Decided for Themselves: A Case Study of 1960s Women's Liberation Activism," in *Black Women in America*, ed. Kim Marie Vaz (Thousand Oaks, CA: Sage, 1995), 110–30; Robert G. Weisbord, *Genocide?: Birth Control and the Black American* (Westport, CT: Greenwood Press, 1975); Angela Davis, "Racism, Birth Control, and Reproductive Rights," in *Women, Race, and Class*, 202–21; and Jennifer Nelson, *Women of Color*.

7. Ben Caldwell, *Top Secret, or a Few Million after B.C.*, in *Drama Review* 12.4 (1968): 47–50.

8. See Toni Cade Bambara, "The Pill: Genocide," in *The Black Woman* (1970. New York: Washington Square P, 2005), 205–6.

9. See Faith Ringgold, *We Flew Over the Bridge* (Boston: Little, 1995), 146.

10. See Elsa Honig Fine, *The African American Artist* (New York: Holt, 1973), 203.

11. Lisa Farrington, *Art on Fire: The Politics of Race and Sex in the Paintings of Faith Ringgold* (New York: Millennium Fine Arts, 1999), 19.

12. See Maurice Nadeau, *History of Surrealism* (Cambridge, MA: Belknap, 1989); Helena Lewis, *The Politics of Surrealism* (New York: Paragon, 1988); and Mary Ann Caws, *Surrealism* (New York: Phaidon, 2004).

13. See Farrington, *Art on Fire*, 19.

14. See Pamela Barnett, *Dangerous Desire: Literature of Sexual Freedom and Sexual Violence since the 1960s* (New York: Routledge, 2004).

15. See Eldridge Cleaver, *Soul on Ice* (New York: Dell, 1968).

16. See Jones, "American Sexual Reference," in *Home*, 243–62.

17. See Jerry Gafio Watts's discussion in *Amiri Baraka: The Politics and Art of a Black Intellectual* (New York: NYU Press, 2001).

18. This essay first appeared in *Negro Digest*, then in the anthology *Black Woman*. See Lincoln, "To Whom Will She Cry Rape?," in *Black Woman*, 95–101.

19. This report is held in the Ellin Freedom Summer Collection at The University of Southern Mississippi in box 2, folder 19.

20. See Lisa Farrington's "Faith Ringgold's *Slave Rape* Series," in *Skin Deep, Spirit Strong: The Black Female Body in American Culture*, ed. Kimberly Wallace-Sanders (Ann Arbor: U of Michigan P, 2002), 128–52.

21. This logic parallels the idea of sphere of influence: domestic and public. Farrington is actively alluding to this spatial reasoning of gender.

22. In *We Flew Over the Bridge*, Ringgold explains, "I could get rid of my frames, the glass, the cumbersome heavy stretchers and frame my paintings in cloth. That way I could roll up my paintings and put them in a trunk and ship them in the same way I used to ship my daughter's clothes to camp" (194).

23. See Patricia Turner's *Crafted Lives: Stories and Studies of African American Quilters* (Jackson: U of Mississippi P, 2009).

24. The first three paintings are portraits of Ringgold and her two daughters Barbara and Michele Wallace.

25. Walker's anthologized story "Everyday Use" appeared in the fiction collection *In Love and Trouble* (1973. New York: Harcourt, 2001), 47–59.

26. Toni Morrison, *Paradise* (New York: Knopf, 1997). It is important to note that reproduction and concerns about lineage also emerge in *The Bluest Eye* and *Song of Solomon*.

27. Cultural critic bell hooks discusses the notion of *homeplace* in *Yearning: Race, Gender, and Cultural Politics* (Boston: South End P, 1990), 41–49.

28. The novels that constitute what has been called Morrison's "love trilogy" include *Beloved* (1987), *Jazz* (1992), and *Paradise* (1997). The novel that follows *Paradise* is titled *Love* (2003).

29. Morrison, *Paradise*, 16.

30. See Candice Jenkins, "Pure Black: Class, Color, and Intraracial Politics in Toni Morrison's *Paradise*," *Modern Fiction Studies* 52.2 (2006): 270–96.

31. See Katrine Dalsgard, "The One All-Black Town Worth the Pain: (African) American Exceptionalism, Historical Narration, and the Critique of Nationhood in Toni Morrison's Paradise," *African American Review* 35.2 (2001): 233–48.

32. Peter Kearly also points to the significance of the town's code of ethics to citizenship in "Toni Morrison's Paradise and the Politics of Community," *Journal of American and Comparative Cultures* 23.2 (2000): 9–16.

33. See Magali Cornier Michael, *New Visions of Community in Contemporary American Fiction* (Iowa City: U of Iowa P, 2006); Geta LeSeur, "Moving Beyond the Boundaries of the Self, Community, and the Other in Toni Morrison's *Sula* and *Paradise*," *CLA Journal* 46.1 (2002): 1–20; and Channette Romero, "Creating the Beloved Community: Religion, Race, and Nation in Toni Morrison's *Paradise*," *African American Review* 39.3 (2005): 415–30.

34. Mixed-race people are treated poorly in the town and any attempt to have a relationship with these individuals is discouraged. For a discussion of the significance of skin color to the narrative structure, see Margo Natalie Crawford, *Dilution Anxiety and the Black Phallus* (Columbus: The Ohio State UP, 2008).

35. The novels *Beloved* and *The Bluest Eye* stand as examples of this artistic practice.

36. Toni Morrison, "Recitatif," in *Confirmation: An Anthology of African American Women*, ed. Amiri and Amina Baraka (New York: Morrow, 1983), 243–61.

37. See Michael, *New Visions of Community*.

38. Spike Lee, *She Hate Me* (Culver City, CA: Columbia TriStar Home Entertainment, 2005). The film premiered July 30, 2004. The DVD was released the following year.

39. See Sol Stern, "A Watergate Footnote: The Selling of Frank Wills," *New York Times* 10 November 1974: 32, 106.

40. Guy Johnson analyzes the folklore behind and cultural significance of John Henry in *John Henry* (Chapel Hill: U of North Carolina P, 1929). Reynolds Nelson provides a biography of the real-life John Henry in *Steel Drivin' Man: John Henry, The Untold Story of an American Legend* (New York: Oxford UP, 2006).

41. He appears in various places throughout the century in Black American literary culture. Alice Dunbar-Nelson writes a poem about him, "Harlem John Henry Views the Armada" (1932); Stephen Henderson discusses this figure in his critical anthology *Understanding the New Black Poetry* (1973); Colson Whitehead's second novel *John Henry Days* (2001) explores the history of him; and music artist Lupe Fiasco references him in his song "Much More" from his album *Fahrenheit 1/15, Part II: Revenge of the Nerds* (2006).

42. The concept of compulsory heterosexuality came to critical attention through Adrienne Rich's "Compulsory Heterosexuality and Lesbian Existence," in *Blood, Bread, and Poetry: Selected Prose, 1979–1985* (New York: Norton, 1986), 23–75.

43. This expression circulated widely in U.S. popular culture after rappers Lil' Kim and 50 Cent debuted their collaboration "Magic Stick" on Kim's 2003 studio album *La Bella Mafia*.

44. Much has been made of the sexism and the limitations on the imagining of both femininity and masculinity in Lee's films. See bell hooks, "'Whose Pussy Is This?': A Feminist Comment," in *Reel to Real: Race, Sex, and Class at the Movies* (New York: Routledge, 1996), 227–40.

45. See David Yaffe, "Spike Lee's Blind Spots on Lesbianism," *The Chronicle of Higher Education* 50.48 (2004): B12.

46. Jasmine Cobb and John Jackson argue that hypertheatricality characterizes Lee's filmmaking in general. See Cobb and Jackson, "They Hate Me: Spike Lee, Documentary Filmmaking, and Hollywood's 'Savage Slot,'" in *Fight the Power: The Spike Lee Reader*, ed. Janice Hamlet and Robin Means Coleman (New York: Lang, 2008), 251–72.

47. See hooks, "'Whose Pussy Is This?'"

48. See Michele Wallace, "Spike Lee and Black Women," in *Invisibility Blues* (New York: Verso, 1990), 100–106.

49. See B. Barton, "Film Review: Male Fantasies about Lesbian Desire," *Sexuality & Culture* 9 (2005): 77–80, quote on 79.

50. Kara Keeling, *The Witch's Flight: The Cinematic, the Black Femme, and the Image of Common Sense* (Durham, NC: Duke UP), 132.

51. See Mark McPhail, "Race and Sex in Black and White," *Howard Journal of Communication* 7 (1996): 127–38, quotes on 128 and 132. For a consideration of McPhail's ideas, see Heather Harris and Kimberly Moffitt, "A Critical Exploration of African American Women through the 'Spike Lens,'" in *Fight the Power*, 303–20.

52. Originally, Lee planned to have the three have a group sexual encounter, but he was advised against this plotline.

53. See Susan Sontag, *On Photography* (1977. New York: Picador, 2001); and Laura Wexler, *Tender Violence: Domestic Visions in an Age of U.S. Imperialism* (Chapel Hill: U of North Carolina P, 2000).

54. See Victor Burgin, "Photography, Phantasy, Function," in *Thinking Photography* (London: McMillan, 1982), 177–216.

Chapter 4. The Space of Sex

1. See Amiri Baraka, ed., *African Congress: A Documentary of the First Modern Pan-African Congress* (New York: Morrow, 1972). At the meeting that this book documents, Akiba ya Elimu explains that one of the results of enslavement was the destruction of the Black family through the legal and social interruption of heterosexual relationships: "Black men and women were separated, given conflicting roles, and the creation of various myths assured our nation to be disunified" (179).

2. Melvin Van Peebles provides a reflective interview about his experiences making his film in the 2002 rerelease of *Sweet Sweetback's Badasss Song* (Santa Monica, CA: Xenon Pictures).

3. The film opens with a child-aged Sweetback being forced to have sex with an adult woman. As the woman climaxes, the young boy (played by Van Peebles's actual son Mario) turns into an adult (Van Peebles himself). The woman exclaims, "You got a Sweet Sweetback," and this description of his emergent sexual capability becomes the defining sobriquet for the character: in all his actions he is a "sweetback." This graphic formula for presenting the compelled intercourse posits sexual violation as the formative element of Black male identity, and it also suggests the importance of a sexual framework for the legibility of contemporary Black identity in the context of nationalist critiques of the state.

4. See Stephane Dunn's *"Baad Bitches" & Sassy Supermamas: Black Power Action Films* (Urbana: U of Illinois P, 2008).

5. See Calvin Hernton's *Sex and Racism in America* (New York: Grove P, 1966), *Coming Together: Black Power, White Hatred, and Sexual Hang-Ups* (New York: Random House, 1971), and *Sexual Mountain and Black Women Writers* (Garden City, NY: Doubleday, 1987).

6. This investment in space is prominent within the latter half of the twentieth century. Black Arts writers were particularly interested in encouraging the rise of a Black public sphere and most often expressed conceptions of Black identity through references to social spaces. Houston Baker's discussion of the rise of the Black public sphere describes the Black Arts Movement as developing out of a common interest in "publicness." See "Critical Memory and the Black Public Sphere," in *The Black Public Sphere: A Public Culture Book* (Chicago: U of Chicago P, 1995), 25.

7. Cecil Brown, *The Life and Loves of Mr. Jiveass Nigger* (1969. Berkeley, CA: Frog Books, 2008).

8. Brown, *Life and Loves*, 102–3.

9. This phrasing is a purposeful evocation of bell hooks's essay "'Whose Pussy Is This?," in *Talking Back: Thinking Feminist, Thinking Black* (Cambridge: South End Press, 1989), 134–41.

10. There is also a bar that the men hang out in the novel called "Coq d'Or," which is French for "golden cock." Brown overwhelms the reader with references to phallic imagery.

11. This meaning of the "Golden Cock" recalls Charles Johnson's argument in "A Phenomenology of the Black Body," where he insists that "cultural assumptions" about the Black man "lock[s] him into the body" (599). See *Michigan Quarterly Review* 32.4 (1993): 598–614.

12. See Eldridge Cleaver, *Soul on Ice* (1968. New York: Delta P, 1991), 205–20.

13. In his preface to the 2008 edition of *Life and Loves*, Cecil Brown explains, "Copenhagen was the Mecca for Black expatriates—an alternative to Paris" (*Life and Loves* xx). He discusses his own experiences there and how they impacted his writing.

14. See Stuart Miller, *The Picaresque Novel* (Cleveland: P of Case Western U, 1967). Both Olaudau Equiano's *Interesting Narrative* and Ralph Ellison's *Invisible Man* can be read as picaresque novels. Through this perspective, one can recognize a specific novelistic tradition in Black literary studies.

15. Dunn uses this concept to explain how the shaping of Black female identity often occurs around a sustained desire for heterosexual penetration and a general, uncritical support for enactments of phallic masculinism in *"Baad Bitches" & Sassy Supermamas*.

16. See Frederick Monteser, *The Picaresque Element in Western Literature* (Tuscaloosa: U of Alabama P, 1975).

17. See Henry Louis Gates Jr.'s introduction to the 2008 edition of *Life and Loves*. I devote most of my attention to the verbal form of the word "jive," but the adjectival form of the word also has an important resonance in the Black vernacular of the 1960s. The descriptor *jive* is used to describe that which is the opposite of "hip" or "cool." The word has a negative connotation. I believe that this second historical meaning of *jive* is also relevant. If the protagonist of Brown's novel is defined as a "jiveass," we must understand him as someone who is not "cool" or "hip" even though he tries to present himself as such. This other meaning of *jive* enhances the satirical presentation of the protagonist.

18. The story of "Efan the Bad Nigger" is a folktale about Black masculine strength and ingenuity from the time of enslavement. See William Wiggins Jr., "The Trickster as Literary Hero," *New York Folklore Quarterly* 29 (1973): 269–85.

19. Jayne Cortez, *Pisstained Stairs and the Monkey Man's Wares* (New York: Phrase Text P, 1969) and *Festivals and Funerals* (New York: Phrase Text P, 1971).

20. D. H. Melhem, "A MELUS Profile and Interview: Jayne Cortez," *MELUS* 21.1 (1996): 71–79, quote on 73 (emphasis added).

21. See D. H. Melhem, "A MELUS Profile and Interview: Jayne Cortez"; Kimberly Brown, "Of Poststructuralist Fallout, Scarifications, and Blood Poems," in *Other Sisterhoods: Literary Theory and U.S. Women of Color*, ed. Sandra Kumamoto Stanley (Urbana: U of Illinois P, 1998), 63–85; Tony Bolden, "All the Birds Sing Bass: The Revolutionary Blues of Jayne Cortez," *African American Review* 35.1 (2001): 61–71; and Aldon Nielsen, "Capillary Currents: Jayne Cortez," in *We Who Love to Be Astonished*, ed. Laura Hinton and Cynthia Hogue (Tuscaloosa: U of Alabama P, 2002), 227–36.

22. See Tony Bolden, "All the Birds Sing Bass" and *Afro-Blue: Improvisations in African American Poetry and Culture* (Urbana: U of Illinois P, 2004).

23. Cortez, *Pissstained Stairs*, 43. Neither of Cortez's books that I discuss is paginated. The page numbers I cite I count out myself from the first page of text following the copyright information.

24. Many writers imagine homosexuality as dangerous to Black communal formations throughout the Black Arts era and such thinking continues to the present. Eldridge Cleaver's infamous criticism of James Baldwin in *Soul on Ice* revolves around Baldwin's homosexuality. The image of the homosexual as a threat became so ingrained that the reverse comes to be true in the social logic of some writers: the betrayer is a homosexual. It is for this reason that LeRoi Jones (later Amiri Baraka) describes Roy Wilkins, whose politics did not match Jones's, as an "eternal faggot" in the 1966 "Civil Rights Poem." See Jones, *Black Magic* (Indianapolis: Bobbs-Merrill, 1969), 140. The cultural conceptions that undergird these elements of literary culture feed into later analyses of Black culture such as those by Frances Cress Welsing or Molefi Asante that find no place for Black homosexual subjects. These examples in particular help to elucidate how the critique of homosexuality as a viable (and nonthreatening) identity for Black individuals rises out of a deep and unyielding investment in heterosexism.

25. Mel Edwards explained this motivation to me in a personal phone conversation on 21 May 2015.

26. Alice Walker explores how reproductive intimacy can be dangerous in *Third Life of Grange Copeland*. Reproductive intimacy does not necessarily safeguard the racial community, as Ben Caldwell's one-act play *Top Secret* illustrates. I consider Walker's novel in chapter 2 and Caldwell's play in chapter 3.

27. Marlon Ross's discussion of the sexual invective in cultural nationalism provides a relevant context for this idea. See "Camping the Dirty Dozens: The Queer Resources of Black Nationalist Invective," *Contemporary Literary Criticism* 23.1 (2000): 290–321.

28. Phillip Brian Harper discusses how a physical body *not engaged* in sex can be read abusively for intimations of sexual intimacy in "Playing in the Dark: Privacy, Public Sex, and the Erotics of the Cinema Venue," in *Private Affairs: Critical Ventures in the Culture of Social Relations* (New York: NYU Press, 1999), 60–88.

29. See Michael Warner, *Publics and Counterpublics* (New York: Zone Books, 2005), 40. Warner goes on to explain how this understanding of "public" is instrumental to the first wave of the feminist movement. Cortez's conceptualizations of public space in the poem also suggest the relevance of liberal conceptualizations to Black Arts era thinking as well.

30. Malcolm X was assassinated on February 21, 1965; Lumumba was murdered on January 17, 1961. For discussions of their respective murders and what each meant for African Americans in particular, see Peniel Joseph, *Waiting Till the Midnight Hour: A Narrative History of Black Power in America* (New York: Holt, 2006) and James Meriwether, *Proudly We Can Be Africans: Black Americans and Africa, 1935–1961* (Chapel Hill: U of North Carolina P, 2002).

31. Cortez, *Festivals and Funerals*, 9.

32. See Angela Davis, *Blues Legacies and Black Feminism: Gertrude "Ma" Rainey, Bessie Smith, and Billie Holliday* (New York: Vintage, 1998).

33. See Wallace, *Black Macho*.

34. Giovanni's poem appears in Toni Cade Bambara's anthology *The Black Woman* (New York: Washington Square P, 1970), 9–11.

35. See Ann Allen Shockley, *Loving Her* (New York: Bobbs-Merrill, 1974); Anna Lee, "A Black Separatist," in *For Lesbians Only*, ed. Sarah Lucia-Hoagland and Julia Penelope (London: OnlyWomen P, 1988), 83–91; Audre Lorde, *Zami: A Biomythography* (Berkeley: Crossing P, 1982); Alice Walker, *Color Purple* (New York: Washington Square P, 1982); Barbara Smith, *Home Girls: A Black Feminist Anthology* (1983. New Brunswick, NJ: Rutgers UP, 2000); Joseph Beam, *In the Life: A Black Gay Anthology* (Boston: Alyson, 1986); Cary Alan Johnson et al., *Other Countries* (New York: Other Countries, 1988); Marlon Riggs, *Tongues Untied* (New Almaden, CA: Strand, 1989).

36. Barbara Smith, *Home Girls*, 112. This idea anticipates Kimberlé Crenshaw's development of feminist theory of intersectionality. See Crenshaw, "Mapping the Margins."

37. See Kara Keeling, *The Witch's Flight*; Roderick Ferguson, *Aberrations in Black*; Sharon Holland, *The Erotic Life of Racism* (Durham, NC: Duke UP, 2012); Marlon Ross, "Beyond the Closet as Raceless Paradigm," in *Black Queer Studies*, 161–89; Cathy Cohen, "Punks, Bulldaggers, and Welfare Queens: The Radical Potential of Queer Politics," in *Black Queer Studies*, 21–51; E. Patrick Johnson, *Sweet Tea: Black Gay Men in the South* (Chapel Hill: U of North Carolina P, 2011); and Robert Reid-Pharr, *Black Gay Man: Essays* (New York: New York UP, 2001).

38. Cheryl Clarke, *Living as a Lesbian: Poetry* (Ithaca, NY: Firebrand P, 1986), 73.

39. See Angela Davis, *Angela Davis: An Autobiography* (New York: International P, 1974); Huey Newton, *To Die for the People* (New York: Random House, 1972); and Assata Shakur, *Assata: An Autobiography* (New York: Lawrence Hill, 1987).

40. Darieck Scott, *Traitor to the Race* (New York: Plume, 1995).

41. The term *queer space* is most often employed as a way to discuss the precarious positioning of gay, lesbian, and transgender social spaces and the politics of gentrification in regard to these locations. See Rinaldo Walcott, "Homopoetics," in *Black Geographies and the Politics of Place*, ed. Katherine McKittrick and Clyde Woods (Toronto: BTL P, 2007), 233–45; Gordon Brent Ingram, "Marginality and the Landscapes of Erotic Alien(n)ations," in *Queers in Space: Communities, Public Places, Sites of Resistance*, ed. Gordon Brent Ingram, Anne-Marie Bouthillette, and Yolanda Retter (Seattle: Bay P, 1997), 27–52; Judith Halberstam, *In a Queer Time & Place: Transgender Bodies, Subcultural Lives* (New York: New York UP, 2005); and Lauren Berlant and Michael Warner, "Sex in Public," in *Publics and Counterpublics* (New York: Zone, 2005), 187–208.

42. Scott, *Traitor to the Race*, 9–11.

43. Hortense Spillers draws special attention to the ways in which Black women and their sexual experiences are effaced in this "great drama." See "Interstices," in *Black, White, and in Color* (Chicago: U of Chicago P, 2003), 153.

44. Richard Mohr's argument about the inherent privacy of sex in *Gays/Justice: A Study of Ethics, Society, Law* (New York: Columbia, 1988) is especially relevant here, but I believe that Scott's fiction also ruminates on those moments when sex has an undeniable and significant publicity as well.

45. Jean-Ulrick Désert, "Queer Space" in *Queers in Space: Communities, Pubic Spaces, Sites of Resistance,* ed. Gordon Brent Ingram, Anne-Marie Bouthillette, and Yolanda Retter (Seattle: Bay P, 1997), 17–26, quote on 21.

46. See Scott, "Jungle Fever?," *GLQ* 1 (1994): 299–321, quote on 301.

47. See Glave, "Regarding a Black Male Monica Lewinsky: Anal Penetration and Bill Clinton's Sacred White Anus," in *Words to Our Now: Imagination and Dissent* (Minneapolis: U of Minnesota P, 2005), 146–64.

48. See Tim Dean, *Beyond Sexuality* (Chicago: U of Chicago P, 2000).

49. These works resonate with Audre Lorde's ideas of the erotic and world-making in the essay "The Uses of the Erotic." See *Sister Outsider: Essays and Speeches* (Freedom, CA: Crossing P, 1984), 53–59.

50. Deborah B. Gould offers an exhaustive history of the development and activities of AIDS Coalition to Unleash Power (or ACT UP) in *Moving Politics: Emotion and ACT UP's Fight against AIDS* (Chicago: U of Chicago P, 2009).

51. Judith Butler's discussion of the "performative" and its simultaneous evocation and disruption of a regulatory matrix is especially relevant here. See "Critically Queer," *GLQ* 1.1 (1993): 17–32, and her broader discussion in *Bodies That Matter: On the Discursive Limits of Sex* (New York: Routledge, 1993).

52. See Judith Butler and Athena Athanasiou, *Dispossession: The Performative in the Political* (Cambridge: Polity, 2013), 194.

Conclusion

1. Carmichael and Hamilton, *Black Power,* 100.

2. Recent challenges to the Voting Rights Act as seen in *Shelby County v. Holder* (2013) suggest that concerns about political and even cultural representation will remain an important concern during the twenty-first century, particularly for U.S. minority communities.

3. See Darby English's *How to See a Work of Art in Total Darkness* (Boston: MIT Press, 2007).

4. Howardena Pindell's video recording *Free, White, and 21* (New York: Kitchen Video Collection, 1980) provides an example of her ongoing interrogation of feminism.

5. See Holland Cotter, "A Resolutely Global Journey: The Life and Work of Howardena Pindell," in *Howardena Pindell: Paintings and Drawings* (Kansas City, MO: Exhibits USA, 1992), 10–12, quote on 10.

6. See Pindell, "Covenant of Silence," in *The Heart of the Question: The Writings and Paintings of Howardena Pindell* (New York: Midmarch P, 1997), 32–41.

7. This obscuring of the body (or the purposeful manipulation of its presentation) is featured more explicitly in her later *Autobiography* series of paintings, which include *Autobiography: Water/Ancestors/Middle Passage/Family Ghosts* (1988) and *Autobiography: Air/CS560* (1988).

8. Kellie Jones's collection *Energy/Experimentation* (New York: Studio Harlem, 2006) is helpful in outlining Black abstraction during and after the Black Arts period and clarifying the engagement of political discourse.

9. See Amiri Baraka, *In Our Terribleness (Some Elements and Meaning in Black Style)* (Indianapolis: Bobbs-Merrill, 1970). Margo Crawford offers an astute reading of *In Our Terribleness* in *Dilution Anxiety and the Black Phallus* (Columbus: The Ohio State UP, 2008). She explains that Baraka creates a sense of hypnotism through the textual employment of photographs and reflective elements, which allow the poet to assume the place of medium for the reader's redefinition of self.

10. Cheryl Dunye, *The Watermelon Woman* (New York City: First Run Features, 1997). The film premiered in February 1996 but was released on DVD in March 1997.

11. Throughout my discussion, I refer to the director as Dunye and the character as Cheryl.

12. See Robert Reid-Pharr, "Makes Me Feel Mighty Real: The Watermelon Woman and the Critique of Black Visuality," in *F Is for Phony: Fake Documentary and Truth's Undoing*, ed. Alexandra Juhasz and Jesse Lerner (Minneapolis: U of Minnesota P, 2006), 130–40; Kathleen McHugh, "History and Falsehood in Experimental Autobiographies," in *Women and Experimental Filmmaking*, ed. Jean Petrolle and Virginia Wright Wexman (Urbana: U of Illinois P, 2005), 107–27; Laura Sullivan, "Chasing Fae: 'The Watermelon Woman' and Black Lesbian Possibility," *Callaloo* 23.1 (2000): 448–60; and Andrea Braidt, "Queering Ethnicity, Queering Sexuality: A Paradigmatic Shift in the Politics of Cinematic Representation in Cheryl Dunye's *The Watermelon Woman*," in *Simulacrum America: The USA and the Popular Media*, ed. Elisabeth Kraus and Caroline Auer (Rochester, NY: Camden House, 2000), 180–88.

13. The film did not always end this way; the statement is a later addition. The fact that Dunye added this statement only after screening the film a few times indicates the fluid nature of the film meaning and the importance of framing structures to the film's presentation.

14. Evelynn Hammonds's discussion in the essay "Black (W)holes and the Geometry of Black Female Sexuality" (in *Skin Deep, Spirit Strong: The Black Female Body in American Culture*, ed. Kimberly Wallace Sanders [Ann Arbor: U of Michigan P, 2002], 301–20) provides a way to understand the film in terms of feminist historiography. She explains how the sexualities of Black women have been silenced and erased by dominant discourses. She goes on to offer different critical methods for addressing this social erasure. She insists, "Black feminist theorists must reclaim sexuality through the creation of a counternarrative that can reconstitute a present Black female subjectivity and that includes an analysis of power relations between White and Black women and among different groups of Black women (306). One

can read Dunye's film as a cinematic attempt to create such a Black Feminist coun-ternarrative.

15. There is a consideration of the butch-femme spectrum in the discussion of Spike Lee's *She Hate Me* in chapter 3.

16. In "Queering Ethnicity, Queering Sexuality," Braidt argues that Dunye con-structs a film narrator who is neither an informer providing an insider's perspective nor an informed outsider illuminating a different culture. In this account, the queer-ness of the ethnographic method can be attributed to Cheryl's inability to be either fully in or outside of the Black lesbian lives and histories she documents.

17. See Mark Winokur, "Body and Soul: Identifying (with) the Black Lesbian Body in Cheryl Dunye's *Watermelon Woman*," in *Recovering the Black Female Body: Self-representations by African American Women*, ed. Michael Bennett and Vanessa Dick-erson (New Brunswick, NJ: Rutgers UP, 2001), 231–52.

18. See Joe Overstreet, *The New Aunt Jemima* (1964) and Betye Saar, *The Liberation of Aunt Jemima* (1972).

Index

Page numbers in italics refer to illustrations.

Communist Party of America (CPUSA), 5–6, 182n17. *See also* Marxism

community: all-Black towns, 109–12; community of writers, 65–66, 71–72, 109–11; community organizing, 10, 106, 112; covenanted community, 111–17; family-as-community, 23, 63–65, 70, 74, 90; gender conditioning/expectation and, 112–20; Nation of Islam community development, 5; queer space and, 158; UNIA community building, 184n32. *See also* kinship; solidarity

Congress of Racial Equality (CORE), 6–7

Cortez, Jayne, 24–25, 136–37, 143–47, 156, 163

Cotter, Holland, 172

Crawford, Margo, 16

Crenshaw, Kimberlé, 12

Critical Race theory, 31, 60

Cronon, E. David, 185n32

Crummell, Alexander, 4

cultural nationalism, 11–12

Dalsgard, Katrine, 111

Davis, Angela, 7–8, 37, 96, 153

Dawson, Michael, 10

Dean, Tim, 160

Delany, Martin, 4

Dent, Tom, 186n35

Derby, Doris, 186n35

Désert, Jean-Ulrick, 158, 160, 163–64

disruptive inhabiting: critique of stereotypes, 51; deconstruction of Whiteness and, 30–31; definition of, 12; disidentification as source for, 186n46; disruptive representation, 174–79; Modern Black Nationalism and, 1, 169; as QOCC strategy, 14–15; queer space and, 154–65, 203n41. *See also* aesthetic radicalism

Dolemite (1975 film), 134

Do the Right Thing (Lee), 120

Dubey, Madhu, 72, 188n58

Du Bois, W. E. B., 5

Dunn, Stephane, 134

Dunye, Cheryl, 25–26, 172, 175–79, 205n14

Eady, Cornelius, 21–22, 30, 32, 53–60, 191n34

economy: Black body in advertising, 45; economy of Whiteness, 35; post-Marxism in Black nationalism, 7–8; racialized economic disparity, 42–43; self-sufficiency

as Black nationalist theme, 6; White-controlled labor economy, 76–78

Edwards, Melvin, 144

emancipation, 4–5, 76–78. *See also* slavery

English, Darby, 170–71, 178

"Everyday Use" (Walker), 108

family: family portraiture as reproductive kinship, 130–31; family strife as critique of kinship, 67–69, 76–77; queer configuration of, 130; slavery effect on, 200n1; as societal paradigm, 73–74; solidarity as family metaphor, 22–23, 63–65; White family ideal, 68. *See also* kinship

Fanon, Frantz, 7–8

Fard, Wallace D., 5

Farrakhan, Louis, 85, 183n21

Farrington, Lisa, 99, 105, 108

fear/suspicion: Black male body suspicion, 68–69, 74; fear/suspicion of Blacks, 21, 41–42, 48, 86–87; fear/suspicion of Whites, 75–79, 84, 109–10; homosexual fear/suspicion, 86–87, 113–14, 144–46, 153–54, 202n24; ironic solidarity and, 84, 88–89; liberation from, 88–89; reproduction and, 113–20; sexuality and, 86–87, 149–50; social contagion and, 69–70; suspicion/trust as kinship issue, 62–65, 75–76, 79–80, 196n45; theories of paranoia, 192n4. *See also* subjectivity

feminism: Black feminist organizations, 9, 73; critical caricature of activists, 38–39; family as societal paradigm and, 73–74; patriarchy in kinship discourse and, 64; reclaiming Black feminine sexuality, 205n14; Second Wave Feminism, 8, 150. *See also* gender; sexuality

Feminist Series (Ringgold), 100–103, 107–8

Ferguson, Roderick, 12, 14, 152

Festivals and Funerals (Cortez), 25, 143

Flagellants, The (Polite), 79–80

Foley, Barbara, 16

Foxy Brown (1974 film), 134

Free Southern Theatre, 186n35

Fuller, Hoyt, 95

Fundi (Billy Abernathy), 175

Gammon, Reginald, 48–50, *49*

Garnet, Henry Highland, 4

Garvey, Marcus, 5, 182n17, 184n32

GerShun Avilez is an assistant professor of English at University of North Carolina, Chapel Hill.

THE NEW BLACK STUDIES SERIES

The University of Illinois Press
is a founding member of the
Association of American University Presses.

———————————————————————

University of Illinois Press
1325 South Oak Street
Champaign, IL 61820-6903
www.press.uillinois.edu